DEATH DRIVE

DEATH DRIVE

THERE ARE NO ACCIDENTS

STEPHEN BAYLEY

CIRCA

First published in 2016 by Circa Press
©2016 Circa Press Limited and Stephen Bayley

Circa Press
50 Great Portland Street
London W1W 7ND
www.circapress.net

ISBN 978-0-9930721-2-3

Cataloguing-in-Publication Data for this
book is available from the British Library

Printed and bound in Italy

Reproduction: DawkinsColour
Design: Jean-Michel Dentand

Had Volvo patented the three-point seat belt in 1927, instead of 1959, this book would have looked rather different.

CONTENTS

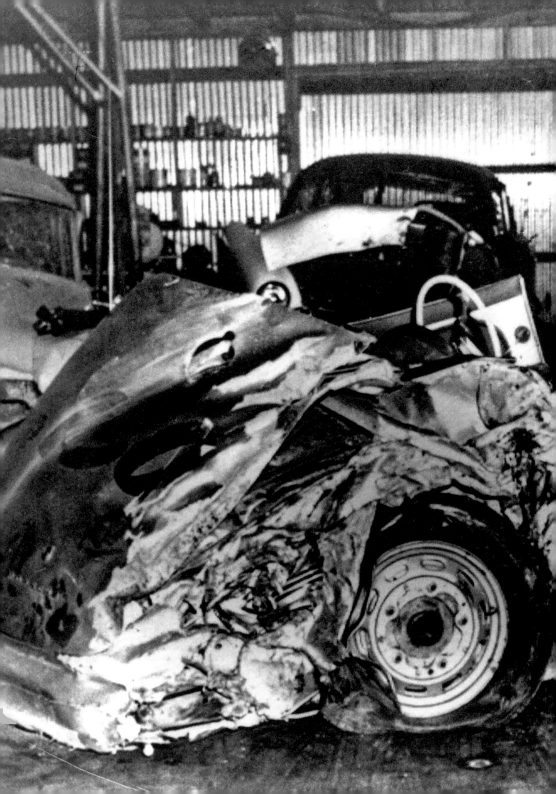

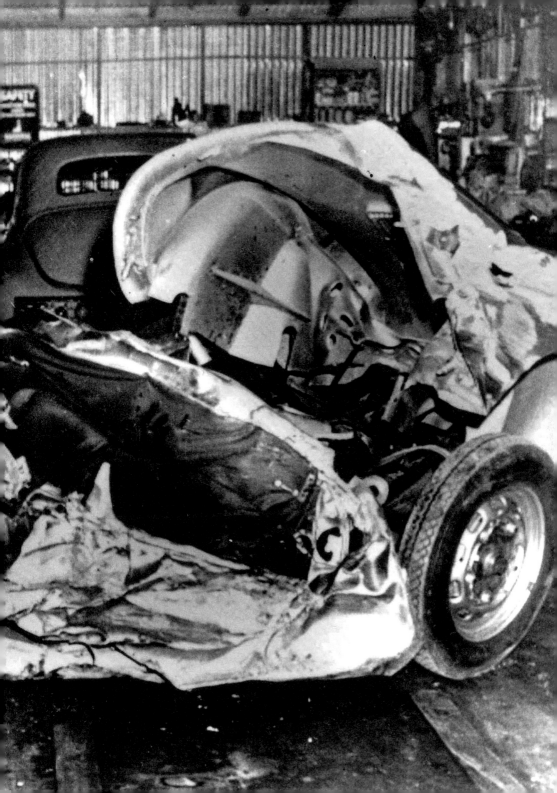

DEATH DRIVE

Cars have a talismanic quality. No other manufactured object has the same disturbing allure. More emotions are involved in cars than in anything else we make or use: vanity, cupidity, greed, aggression, social competitiveness, cultural modelling, desire and fear. But when all this mixed bag of perverse promise and certain threat ends in the catastrophe of a fatal collision, these same talismanic qualities acquire an extra dimension and stimulate a fascinated, while appalled, voyeurism. Who can take their eyes off a traffic accident? No matter how reluctant, we are fascinated. The more so if a celebrity is involved.

The train crash has acquired metaphorical dimensions. We speak of a failed encounter or a flawed negotiation as if a collision of railway locomotives: 'Well, it was frankly a bit of a train crash.' Meanwhile, aeroplane crashes terrify. 'I am not afraid of flying … I am afraid of crashing,' is something I often think. That is, surely, entirely rational. But train crashes and plane crashes are public events. A car crash, even if it happens on public roads, is essentially private. Herein are the elements of privacy, destiny and will, which fascinate.

How the car crash has acquired cultural respectability, even glamour, is the subject of this book. It is not intended to be macabre, rather to survey how man's most wonderful and most terrible everyday invention, the automobile, heir to Henry Ford's gasoline

Previous pages: James Dean, Hollywood's rebel without a cause, crashed his Porsche 550 Spyder at Cholame, California, on 30 September 1955. The site of the accident is now officially the James Dean Memorial Junction. The wreck subsequently acquired an almost religious status and went on a tour of the United States to promote awareness of road safety.

buggy, has, in death as in life, played its part in creating some of the enduring personal myths of the twentieth century, as well as some of its most haunting images. Precisely because the automobile is so democratic and so familiar, the strange, defunct aristocracy of its victims has acquired a special allure. As the following pages show, this aristocracy is surprisingly large.

Car crashes often excite mystery speculation among conspiracy theorists. In his 1968 song *Don't Pass Me By*, from The Beatles' *White Album*, Ringo Starr has the lyric: 'I'm sorry that I doubted you/I was so unfair/You were in a car crash/And you lost your hair.' For a while, this was held – by those inclined to hold these things – to be evidence of his colleague Paul McCartney's alleged disappearance or death. This sort of popular currency confirms the status of the car crash in our imaginations.

For almost everyone, the possibility of death in a car crash is a daily confrontation with both the immediate possibility and eternal enigma of sudden extinction. And, for the famous, extinction is made all the more terrifying in the harsh light of a celebrity existence that preceded the darkness. How ironic, or perhaps how inevitable, for example, that Paul Walker of *Fast and Furious*, a Hollywood series devoted to maniacal driving, died in a 2013 crash when the modified Porsche Carrera GT he was travelling in went out of control. Touchingly, he had just left a Los Angeles charity fund-raiser. Perhaps some symmetry was achieved by the calamity.

A more famous Californian celebrity died in a notorious crash in the same make of car. Indeed, James Dean's collision in 1955 did a lot to contribute to Porsche's now established reputation for speed and danger, although at the time Porsche was not well known in the United States. The remains of Dean's car (which had 'Little Bastard' painted on the tail) were trailed around the United States in road safety exhibitions. Its components were also systematically looted as they were thought to have magical properties. So, even

Paul Walker, star of *Fast and Furious*, a road-racing action series, was an accomplished high-performance driver, but travelled as a passenger in the Porsche Carrera GT which crashed and burned on Hercules Street, Santa Clarita, California, on 30 November 2013. No other vehicle was involved; the crash was blamed on excessive speed and poorly maintained tyres.

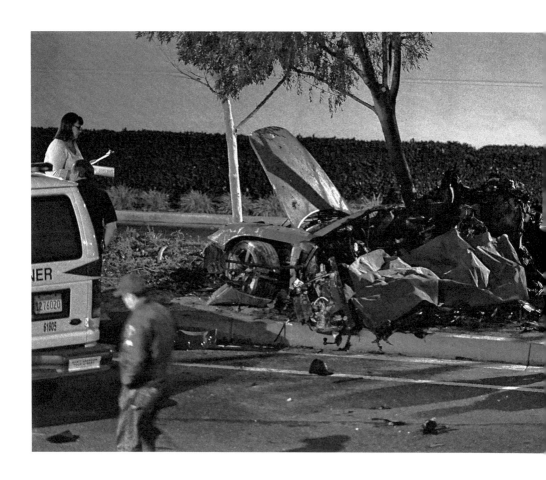

in the Eisenhower years the American public behaved in a way that a student of prehistoric anthropology would understand.

When attached to calamity, horror or tragedy, even banal cars become objects of fascination. The '49 Ford of Ed Gein appeared at the Outagamie Country Fair in Seymour, WI, in 1958. Gein was 'The Ghoul of Wisconsin', America's most repellent serial murderer (he had, for example, made a belt out of victims' nipples). His Ford became a notorious carnival attraction, scandalising the public while it engrossed them.

The car crash is a defining phenomenon of popular culture. Every crash is unique, but universal. Each episode has its own narrative arc, which travels from ambition – via notions of status, escape and self-destruction – to a catastrophic demise, often with a dynamic of genuine tragedy. After all, how could anything be more wilfully self-destructive than dangerously driving yourself to metal-bending, tyre-squealing, glass-shattering and possibly fiery oblivion?

As in all myths, the hero(in)es of *Death Drive* have confronted choices, considered or ignored threats, made decisions and are then faced with mortal consequences. Conventional narrative arcs demand satisfying emotional conclusions, but car crashes are not structured events, even if they are sometimes unsurprising ones. Besides tragedy, elements of black comedy and finger-wagging destiny are also involved.

Typical here was Friedrich Wilhelm Plumpe, who took the stage name of his home town in Germany and became FW Murnau, who then became a Hollywood Titan. A seven-foot-tall gay aesthete, Murnau made *Nosferatu*, the Dracula movie, before moving to the United States in 1926. The following year he made *Sunrise*, often said to be the greatest movie ever. Murnau established the cinema's technical repertoire of tracking shots, pans, zooms and tilts. And in 1931 his Packard 840 Deluxe Eight, the most powerful and exclusive car of its day, swerved, in a horrible tilt, to avoid a truck on the Pacific Coast Highway near Santa Barbara and he was killed. Hollywood rumour insisted that, at the time of the crash, Murnau was either giving or receiving distracting fellatio from his Filipino houseboy, Garcia Stevenson. The evidence from the crash scene was not clear, although the implications most certainly were.

Car crashes establish the reputations of people, as well as the vehicles themselves and the locale where they occurred. They have been fundamental in the process of modern legends and contemporary myth making. *Death Drive* as a whole has one very big arc: the role of the car in extending – or even creating – the personality of a celebrity. It asks: Q: Who? A: The celebrity. Q: Where? A: The site of a car crash is always a significant part of the event and soon acquires a nearly religious status. Q: Why? A: We can only speculate. Q: How? A: Sometimes we know exactly what went wrong. And … Q: So what? A: There may be no answer to this last, but that may also be because there never really was a question in the first place.

In a fatal crash, time is frozen. The car is (usually) destroyed and so too is the driver. Often, the crash enhances a level of fame – a fame possibly in decline: rather as the failing novelist in Camus's *The Myth of Sisyphus* committed suicide in order to draw attention to his neglected works. Camus was, of course, himself a victim of one of the most famous car crashes of all. And, significantly, it occurred when some critics believed the Nobel Prize-winner's best work was already behind him.

Death, as the ancients knew, is inextricably connected to sex: Thanatos and Eros, as they put it. In 1966 the artist Derek Boshier and the poet Christopher Logue published one of their 'poster-poems' entitled *Sex War Sex Cars Sex*. The speech bubble from the mouth of a tear-stained woman says: 'Please God – Let me die naked in a fast car crash with the radio turned full on!' In his 1973 novel, *Crash*, JG Ballard explored this erotic compulsion and the sinister fascination of the car crash. Three years earlier, Ballard had organised an exhibition in The New Arts Laboratory, which – sensationally – included crashed cars.

Since the car crash offers such a neat device for a novel's character development – or, indeed, extermination – it is surprising how, Ballard apart, it appears only rarely in fiction. Although there are two outstanding car-related deaths in literature, in neither case is the victim driving. The first is Myrtle Wilson, who is run over by Jay Gatsby's bright yellow Rolls-Royce (Fitzgerald doesn't say, but the best guess is a 1922 Silver Ghost, although in the

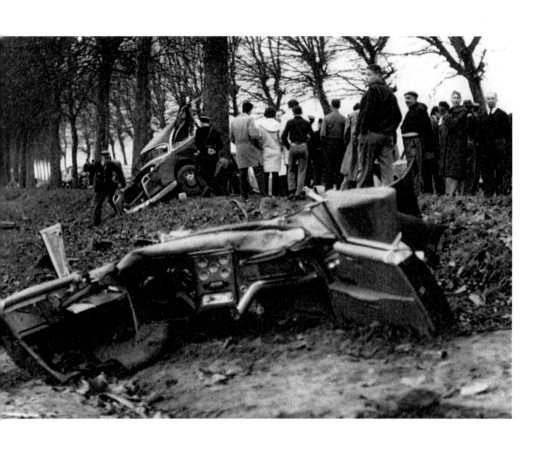

anachronistic 2013 DiCaprio film, it is a Duesenberg). The second is 'Tracy' Draco, whom James Bond first saves from suicide-by-drowning and finally marries in Ian Fleming's *On Her Majesty's Secret Service* (1963).

Tracy (Fleming, in full ironic mode, says she adapted the name from Teresa) is the victim of a drive-by shooting by Bond's arch-enemy Ernst Stavro Blofeld and his grim assistant, Irma Bunt. The cars in the story reveal something of the novel's interpersonal drama. Bond's battleship grey Bentley Continental R, with its bespoke Arnott supercharger, is outdriven and overtaken in an impromptu road race by Tracy's white Lancia Flaminia Spyder. (Fleming calls it a Zagato, but convertible Flaminias all had bodies by Carrozzeria Touring.) Bond's pleasure in the humiliation is a herald of ambitious sexual manoeuvres to come. Eros and Thanatos being very close, it is the Lancia in which Tracy later dies. Blofeld, meanwhile, drives a villainously red Maserati. Inexplicably, except on account of fee-based product placement, in the 1969 film of the book, Tracy's car became a red 1969 Mercury Cougar XR-7 with a bonnet scoop feeding its 335hp 428-inch Ram Air V-8. The fine Lancia was surely more alluring.

Roland Barthes knew that cars, even if they are not James Dean's or Tracy Bond's, are magical symbols. And when a magical symbol is destroyed, it exerts an even stronger power. What could be more sadly beautiful than Eddie Cochran's death drive? Cochran brought US rock to Britain. The subject of his best song was his yearning for a sparkling, new '59 Ford and how possession of one would ease his path to the woman of his dreams. Cochran, in banal fact, died in a slightly dreary British-made '59 Ford Consul, a Dagenham car inspired, at some distance, by the stylistic tics of Dearborn. And he died not on the road to Mission San Antonio de Padua in Salinas, California, as James Dean did, but on the A4 in Wiltshire, near Chippenham. That's not rock'n'roll.

Villeblevin, in Burgundy, is known only as the scene of Albert Camus's fatal crash on 4 January 1960, which became world news. Camus disliked driving, especially driving fast. His publisher Michel Gallimard was at the wheel of the Facel Vega HK500 when it left the road and hit a tree. Camus's last words were: 'What's the hurry, little friend?' Gallimard's final word was 'Merde!'

Carl Gustav Jung believed that there is no such thing as an innocent occurrence: our lives are driven by meaningful coincidences, a function of his concept of 'synchronicity'. And his rival Sigmund Freud coined the term 'death drive' in counterpoint to 'the pleasure principle': these opposing forces dominate our lives. Influenced by both Jung and Freud, Ballard wrote that: 'Deep assignments run through all our lives. There are no coincidences.' And there have been a lot of significant car crashes. Freud spoke of the complicated detours we all make. Most of us, busy detouring, avoid tragic destinations, even if we find comic ones instead. This book is an account of some of the most remarkably complicated detours.

What are the criteria for inclusion in *Death Drive*? One early car crash established the pattern of elegy and absurdity that is recurrent here. This was 'Boy' Capel, Coco Chanel's lover and benefactor. A polo-playing entrepreneur with a dashing military style, Capel bought Chanel her first Paris shop and his crisply cut blazers inspired her ineffable sense of transgender masculine style. But while she may have been the greatest love of his life, he married someone else. Just before Christmas 1919, married a year, he was motoring towards a liaison with Chanel. On the RN7 at Puget-sur-Argens in the Var, his Rolls-Royce burst a tyre and veered into a drainage ditch. Capel was killed and the driver badly injured. Chanel travelled through the night to see his body, but by the time she arrived, the morticians had closed the coffin. She refused to take part in the funeral at Fréjus, preferring to mourn alone the person who was perhaps the biggest influence on her tormented life and her stellar career.

In 1919 the RN7 was a country road, but now the spot where Capel crashed is in the middle of a hellish commercial area of big-box hyperstores and the racing hatchbacks of the *racaille*. His monument is a cross with the inscription: *A la Mémoire du capitaine Arthur Capel, légion d'Honneur de l'armée Britannique,*

In 1966, the artist Derek Boshier and the poet Christopher Logue created the screenprint 'poster-poem' *Sex War Sex Cars Sex*. The voice bubble is a nice synopsis of the roles that sex and death play in the romanticised car crash.

SEX WAR SEX CARS SEX
CLEANLINESS IS NEXT TO GODLINESS

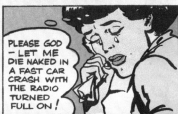

mort accidentellement en cet endroit. Were more known about the early life of this extraordinary man and his influence, he would have been the subject of *Death Drive*'s first chapter.

Another, far more famous French crash is missing. Princess Diana does not feature because, although her 1997 death in Paris – in a Mercedes-Benz S-Class in the Pont de l'Alma tunnel – became the most famous car crash of them all, she was simply a passenger, not an active collaborator in the journey. It could have been a taxi. Quite literally, possibly metaphorically too, Diana did not know where she was going. The people in *Death Drive*, to an extent, dictated the terms of their journey.

Neither Albert Camus nor Marc Bolan was actually driving the car in which they died, but each was committed to sharing the journey with the driver. For different reasons, the 1969 Chappaquiddick incident is not included. God rest her soul, but Mary Jo Kopechne only became a post-mortem celebrity. Senator Edward Kennedy, at the wheel of his 1967 Oldsmobile Delmont 88, before it slipped into the water, was already famous. And he survived.

Neither are fatal crashes of racing-drivers while at work on circuits included. They were simply doing their dangerous job. Of course there is enormous pathos in motor-racing accidents. No one who saw Ayrton Senna die on live television in 1994 will ever forget the atrocious sight. There was an almost classical sense of being witness to the dying of a young god. And there were hauntingly tragic elements here. There was the vicious rivalry with Michael Schumacher and the possible truth that the sensitive Senna had demanded the steering column of his Williams racing car be reduced in weight so as to enhance feeling, resulting in the failure of the weakened column which led to him driving straight into a concrete retaining wall at 190 miles per hour.

Such was the shock of his death, the day after the calamity, that no crimes were reported in his native and generally lawless São Paulo. Similarly, on the day of Princess Grace's funeral, following her fatal plunge off the D37, Monaco's sole prisoner was granted an amnesty. Crime, it appears, may join sex and death in a curious trinity. Senna does not feature here because he knew that a violent death was always, as it were, just around

the corner. But two racing-drivers who died in crashes on public roads are included. There is an ineffable poignancy that the grand Giuseppe Farina and the dashing Mike Hawthorn, having battled courageously in brutally dangerous racing cars, were killed while driving comfortable saloons far away from the spectators' awe-struck gaze. Clay Regazzoni, ex-Ferrari, ex-BRM, was another Grand Prix driver who died on the roads, but his 2006 crash is not described here simply because his choice of a drear Chrysler Voyager – which he crashed on the A1 Autostrada near Parma – does no credit to his heroic reputation.

One racing-driver who died on public roads is not included here. The American Francis Turner was killed in 1932 while testing Buckminster Fuller's fatally and cynically under-developed three-wheeled Dymaxion car, a vehicle that its designer held to be a herald of a technology-rich future. Despite his blowhard prophecies, Fuller had no grasp of the engineering or aerodynamic fundamentals of car design. The ludicrous Dymaxion would lift at speed, rendering steering and brakes useless, as Turner so sadly discovered. The contrast between euphoric potential and dire reality in Buckminster Fuller's technocratic universe is revealing, but Turner is omitted because, in a book concerned with big personalities, he is unknown.

Another near miss for inclusion was Pierre Boulanger, the Citroën engineer who was killed in 1950 while testing a prototype of the Véhicule de grande diffusion near Broût-Vernet, Allier. The car he was driving was a Traction-Avant with a revolutionary high-pressure hydraulic suspension system. It evolved into the celebrated Citroen DS (or *Déesse* for Goddess, if you pronounce it the French way). The Citroën DS was the car that Roland Barthes was referring to when he spoke of an object being: 'the best messenger of a world above that of nature'. Jung, of course, would have agreed, saying the message to Boulanger came, indeed, from the supernatural.

If not actually supernatural, the death of Luftwaffe ace Heinz-Wolfgang Schnaufer – 'The Spook of Saint-Trond' as his RAF victims nicknamed him, referring to his Belgian airbase – at least suggests that Nemesis, perhaps other minor deities too, survived the Second World War. Schnaufer and his Messerschmitt Bf 110 G-4 were responsible for the downing of 121 Allied aircraft, making him

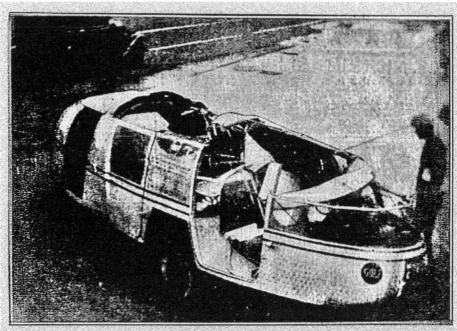

[TRIBUNE Photo.]

EXPERIMENTAL THREE WHEELED AUTO OVERTURNS; 1 KILLED, 2 HURT

Wreckage of three wheeled Dymaxion auto after accident yesterday on the outer drive. Francis T. Turner, driver, was killed, and those injured were two passengers on the Graf Zeppelin, Charles Dollfus of France and the Hon. W. F. Forbes-Sempill. (Story on page 3.)

the top scoring night-fighter pilot of the war. Towards the end of the war, he was captured by the British, who interrogated him about the use of methamphetamine and whether it might have contributed to his astonishing performance. The results were inconclusive, but Schnaufer's Messerschmitt was put on display in Hyde Park.

In peacetime, Schnaufer tried to establish himself in civil aviation, but was distracted by the demands of running the family wine business, the Schnaufer-Schlossbergkellerei in Calw, Württemberg. In July 1950, the Spook of Saint Trond drove his Mercedes-Benz 170 Cabrio to Bordeaux on a buying trip. Travelling on the RN 10 near Cestas, he collided with a Renault 22 truck loaded with empty gas cylinders, one of which is presumed to have hit him on the head, resulting in injuries to which he succumbed two days later.

In the Luftwaffe, Schnaufer had obsessively logged the grid coordinates of his victories on a *Planquadrat*. His crash occurred at precisely 44 degrees 42 minutes 04 seconds north, and 0 degrees 42 minutes 20 seconds south.

Also narrowly missing inclusion is Juscelino Kubitschek de Oliveira, the founder of Brasília and patron of that city's bold architect, Oscar Niemeyer. Suspecting, quite correctly, that Kubitschek was engaged in an extramarital romantic dalliance, his wife had Rio de Janeiro's Galeão International Airport put under surveillance to check his movements. To avoid her spies, one day in 1976 Kubitschek drove to São Paulo instead of taking his regular flight. En route, near the city of Resende, the politically ambitious Kubitschek was assassinated. A bullet was fired from a passing car, killing his driver and destabilising the Cadillac, which crashed into a truck and a bus. A restored version of the car is on display in a mausoleum-like environment in the Brasília museum … along with a period-correct Eames chair and the geometer's instruments that surveyors used to lay out the futuristic new city.

Buckminster Fuller has the reputation of a technical visionary, but his Dymaxion Car was an under-designed deathtrap. This 'zoomobile' was intended to hop off the road, fly and settle back into traffic, but instead it lifted-off at speed and became unstable, killing its driver. The *Chicago Tribune* published this photograph of the wreck outside the city's 1933 Century of Progress Fair.

And then there are the three great twentieth-century novelists killed in car crashes (Margaret – *Gone With The Wind* – Mitchell and the poet Randall Jarrell were killed in car-pedestrian collisions): Italo Svevo in 1928, Nathanael West in 1940 and WG Sebald in 2001. Of these, Sebald losing control of his dull Peugeot in rural Norfolk one quiet afternoon is the richest in downbeat absurdity, but Nathanael West's crash best fulfils *Death Drive*'s criteria. A brilliant, but troubled, man driving a notable car in a romantic location and meeting calamity in a style that suggests crashes are more inevitable than random or spontaneous. And in West's case, his own dramatic and ridiculous end – running a stop sign in El Centro, California – somehow mirrors the human folly and wretchedness that he made his subject.

Enormous improvements in vehicle safety over the past twenty years, together with changing celebrity preferences in travel, have reduced the number of fatal crashes involving culturally significant figures. No one writes pop songs or novels about crashes any more. True, The Shangri-Las' *Leader of the Pack* was actually about a motorbike accident, but its resonance is unmatched in recent years. Nor is that of Jan and Dean's 1964 *Dead Man's Curve* which describes a race along Sunset Boulevard, through a difficult ninety-degree bend, between a Jaguar E-Type and a Chevrolet Corvette. Two years later, apparently conforming to the doctrine of predestination, Jan Berry crashed his own Chevrolet Corvette Stingray (into a parked truck) at this very same stretch of road … just outside Roman Polanski's house. He would have been included here except that, happily, he survived.

There are other remarkable personalities who died in car crashes. The architect and palaeographer Michael Ventris, decoder of Linear B, died in 1956 when he hit a parked truck on his way home to Hampstead. In the same year, the cartoonist Alex Raymond, who created Flash Gordon and Rip Kirby, was killed when his Chevrolet Corvette hit a tree in Westport, Connecticut. It was raining and Raymond had been reluctant to stop lest it slow his journey. He was speeding and, reportedly suicidal, this was his fifth, and final, crash in a single month. Another architect, William Howell, who designed the Corbusian Roehampton flats for London County

Council, died in a 1974 car crash. Yet another architect, Aldo Rossi, who made his name with the design of the 1971 San Cataldo Cemetery in Modena, was killed in his car in September 1997 while driving to his holiday home on Lake Maggiore. He had been in another car crash before winning the cemetery job and his recuperation in hospital had allowed him time to ponder vital mysteries and a body in fragments needing to be reassembled. The great architectural critic Ada Louise Huxtable called San Cataldo 'unforgettable'.

Françoise Dorléac, the younger sister of Catherine Deneuve, who had starred in Polanski's *Cul-de-sac,* was rushing to Nice airport in 1967 when her Renault 10 hire car, a notably unstable machine with its swing-axle rear suspension, hit a sign on the La Provençale autoroute at the Villeneuve-Loubet exit. Witnesses saw her trying to escape the overturned and burning Renault. Her body was identified from charred fragments of a chequebook. She was said to be on the verge, or abyss, of international celebrity.

John Nash, the schizophrenic Nobel laureate mathematician, who inspired the 2001 film *A Beautiful Mind*, died in May 2015 when his taxi crashed on the New Jersey Turnpike. He was returning home from Newark Airport, having just collected a prize in Norway. His specialism was game theory.

Maybe there should be a second volume? Then again, maybe not. People drive less nowadays. The beginning and end of the celebrity car crash exactly mirrors the rise and the fall of the automobile during the twentieth century. Mobility is now in the head, not on the road. Recent research showed that a group of under-thirties would much prefer to abandon their cars than their smartphones. Significantly, the same group failed to identify a single automobile maker in its list of 'cool brands'.

The period of the great car crash might be over, but perhaps the death drive has travelled elsewhere …

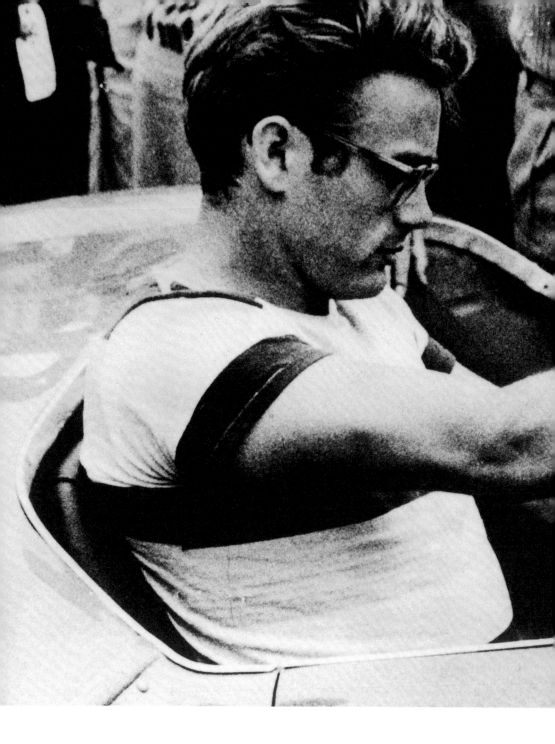

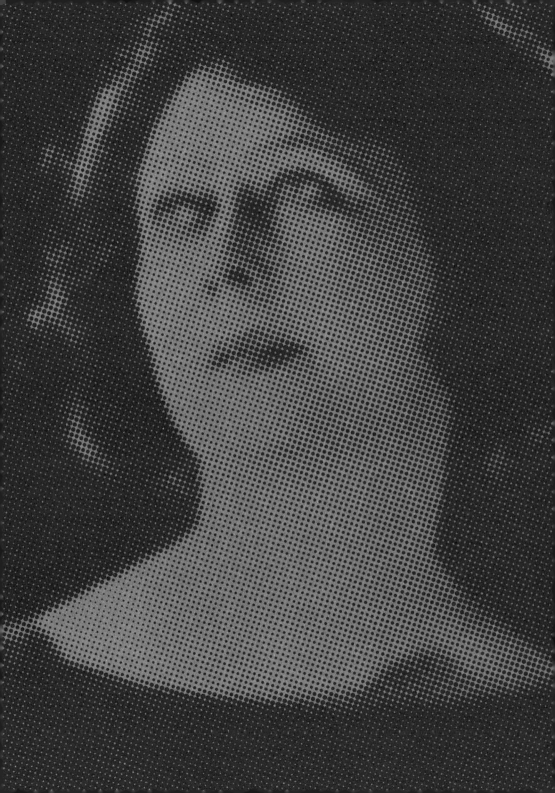

ISADORA DUNCAN 1927

Affectations can be dangerous

The American dancer Isadora Duncan was an extravagantly
free spirit. She made noteworthy and energetic innovations in
the matters of pop eugenics, interpretative dance, high-society
socialism and cheerful lesbianism. Duncan, one of her very many
admirers once said, was all the muses, and more besides, in a
single blowsy package. She was a prototype pop celebrity.

Her life was full of extraordinary achievements and strange
accidents, most of them happy ones. She was, for example,
scheduled to travel on the Cunard liner *Lusitania*'s last fatal trip
from New York to Liverpool in 1915, but missed the boat and
also, therefore, the torpedoes that sank it. Fate had scheduled
another ending.

Throughout her life Duncan invented and maintained
magnificent postures, not all of them on the stage. Indeed, it's fair
to say that she made not a great deal of distinction between the
theatre and life, overacting in every venue public and private. She
cultivated loopy theories: all movement, she believed, came from
the solar plexus. But her expressive use of the body was not limited
to the stomach area. A Communist sympathiser, once on stage in
Boston she raised a red flag, exposed a breast and said: 'This is
red! So am I!'

Although there is some dispute, as there is with all the best
stories, Duncan is the most often cited source for the anecdote
involving playwright George Bernard Shaw. She, perhaps wearing
her eugenics hat for the occasion, wrote to Shaw suggesting
that sexual reproduction between them would result in a child

with Shaw's brilliant mind and Duncan's beautiful body. Shaw rejected the offer on grounds that it might work the other and less fortunate way, the child having Duncan's airy mind and Shaw's skinny frame.

Isadora was born in San Francisco in 1877, the daughter of a once prosperous banker who was soon busy going bust. The social descent she experienced during her father's financial decline was one of several significant arcs in her colourful life. With native American initiative she was not deterred by her father's failure. As a very young woman, she began to give dance classes to raise money. However, with her own forceful character, she was not constrained by the disciplines of classical ballet routine. Rather, her dance was a new American athleticism. She just did it.

Rejecting the barre and points, and insisting on bare feet, Isadora developed an idiosyncratic personal style that depended on ideas of fantasy, freedom and interpretation. A higher cause was often cited. 'Art which is not religious … is mere merchandise,' she wrote in 1928. When today people parody dancers with caricatures of striking poses, wafting silk stuffs and sexualised gesturing, or say 'I am a tree,' as they sidestep across the stage, it is, however unconsciously, the ghost of Isadora, with her lifted forehead and far-flung arms, a true conduit of the life force, they are reviving.

Indeed, Isadora's insistence on externalising emotions might best be understood with reference to the insights of her contemporary, Sigmund Freud, who saw in most human activity a more-or-less faithful response to sexual repression. Perhaps at some level the private clients for whom she danced at home sensed occult erotic content in her leaps and contortions. But Isadora also took inspiration from the dancing figures she found decorating Attic vases in the British Museum during the London leg of her world tour, which had begun in New York and Chicago. Fully to express her connection with the ancient world, she tended

A period Amilcar newspaper advertisement. In 1921 Joseph Lamy and Emile Akar's Amilcar began manufacturing cyclecars but soon evolved to voiturettes, the generic term for light cars. Amilcar is a mangled amalgam of its founders' names.

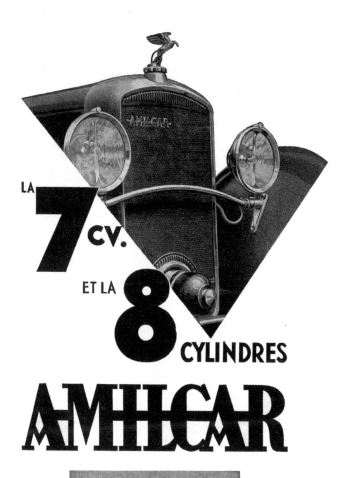

LA **7** CV.

ET LA **8** CYLINDRES

AMILCAR

LES VOITURES
DE GRANDE CLASSE
LES MEILLEUR MARCHÉ

to wear a loose-fitting Doric-style chiton, a square of draped and pinned fabric with a simple girdle that, leaving the arms bare, gave ample scope for free, expressive movement.

Her British Museum investigations took place in 1898. When she arrived in Paris, she became a muse, both practical and theoretical, to Auguste Rodin and Antoine Bourdelle. On a visit to Duncan's studio, Rodin, by some accounts an erotomaniac himself, kneaded her body like clay. This was greatly facilitated by the disinhibiting chiton she wore for such occasions. She inspired Bourdelle's bas-reliefs in the Théâtre des Champs-Élysées and in the Musée Bourdelle there is a splendid photograph of Isadora dancing with children *en plein air*.

At the dance school she established in Grunewald in 1904, her students were known as the 'Isadorables'. In 1912 she acquired the Hôtel Paillard in Bellevue in Paris's 8th arrondissement and built a temple to dance, which she revealingly called the Dionysion, a reference to Dionysos and his cult of delirium. Gaining ever more confidence, in 1917 she adopted the six Isadorables and gave them the name 'Duncan'.

This branding exercise was perhaps in sympathetic response to her first car-related tragedy. Isadora had two children. Edward Gordon Craig – the Modernist producer and illegitimate son of the actress Ellen Terry and the progressive Arts and Crafts architect, Edward Godwin – fathered the first. The second was by sewing-machine heir, Paul Singer. On 19 April 1913 both children drowned in the Seine when their chauffeur-driven car, abandoned and temporarily parked by its driver, rolled across Boulevard Bourdon and sank in the river. It is presumed that the handbrake was faulty: death by mechanical misadventure might have been the brief for an interpretative dance …

No formal grief counselling being available in 1913, Isadora developed a personal recovery strategy. She travelled to Italy. In Viareggio she stayed with Eleonora Duse, mistress of both

The 1927 Amilcar CGSS was an exquisite little sports car: the second S stood for *surbaissé*, the car being a lowered version of the basic CGS. The 1,074cc four-cylinder engine delivered 35hp, enough to give a very light car brisk performance.

Boito, Verdi's librettist, and Gabriele d'Annunzio, poet, patriot, fornicator, pioneer airman and pamphleteer. She began an affair with the poet Mercedes de Acosta, a liberal lesbian with a firm hand; de Acosta later enjoyed an infamous relationship with Greta Garbo.

In 1922 Isadora married the popular Russian poet, Sergei Yesenin. Speaking only twelve words of Russian, they at first conversed with drawings and, presumably, interpretative dance moves. Yesenin was inclined to wake up at two in the morning and recite poetry. Despite or because of this, their marriage was brief. He left her saying: 'If she follows, I will go to Siberia! Russia is big!' After writing a poem in his own blood, Yesenin hanged himself in the Hotel Angleterre, Leningrad. He was thirty. It was about this time that Isadora decided she was the plaything of Fate.

A stellar career of artistic jumping and methodical bedding was in decline. Isadora got messily drunk with Scott and Zelda Fitzgerald in Saint-Paul-de-Vence and in Paris. She became as dependent as she was once extrovert. As Nadine Dreyer explained in *A Century of Sundays* (2006), Isadora's personal statement was: 'Love is not the sacred thing poets talk about … Love is an illusion; it is the world's greatest mistake. I ought to know for I've been loved as no other woman of my time has been loved. Men have threatened suicide, they have taken poison, they have fought duels for me.' But no one would lend her $25 when she needed it.

In his 1957 memoirs, *Index to the Story of My Days*, Edward Gordon Craig writes a compelling account of the impact Isadora Duncan first had on him. A pianist had played a Chopin prelude. Silence followed and then Isadora dramatically emerged from behind a curtain and strutted a few steps to the piano, where she stood as still as a statue. In silence. After a time, the pianist played more Chopin and Isadora took a sudden step backwards, 'only just moving'. And then the music stopped. There were no pirouettes, no splits, no arms akimbo and certainly no entrechat-douze.

The *Morning World Herald*, reported Isadora Duncan's death in the edition of Thursday 15 September 1927. Even, perhaps especially, in death Duncan made unforgettably extravagant gestures. She was killed when her glamorous, billowing scarf became wrapped around the Amilcar's rear wheel, wrenching her out of the cockpit and onto the *trottoir* of the Promenade des Anglais.

STATE FORECAST

Nebraska—Generally fair today and tomorrow; cooler.

Iowa—Generally fair today and tomorrow; not so warm tomorrow and in west today.

Morni

VOL. LXII.—No. 300.

Entered as Second-Class Matter, at Postoffice, Omaha, Nebraska.

OMAHA, NEB

ISADORA DUNCAN KILLED BY FALL FROM NEW AUTO

Dancer's Neck Broken When She Is Dragged to Roadway.

LONG NECK SCARF CAUGHT IN WHEEL

Nice, France, Sept. 14 (AP).—Isadora Duncan, the American dancer, was killed in an automobile accident at 9:40 o'clock tonight. She was trying out a new automobile on the Promenade Des Anglais, when a gust of wind blew a long scarf which she was wearing around her neck over the side of the car. It became entangled in one of the wheels and dragged the dancer out of the machine into the roadway. Her neck was broken.

The dancer's body was removed to St. Roch hospital. At the time of the accident, Miss Duncan was accompanied by a newspaperwoman, Mary DeSoto Parks, who came to see her with reference to the publication of her memoirs.

In a conversation with a correspondent of the Associated Press yesterday, Miss Duncan said: "For the first time I am writing for money; now I am frightened that some quick accident might happen."

DANCER IS KILLED

This is Isadora Duncan, internationally known dancer who was killed at Nice, France, Wednesday.

PLAN 2 STYLE SHOWS NEBRASKA-IOWA WEEK

Special Displays in Omaha Stores to Be Added for Gala Week.

DEMANDS A TARI PACT ON BASIS 'GIVE AND TAK

France Says Conference Duties Is Up to America.

'IF NO RECIPROCITY, THEN NO MEETIN

Paris, Sept. 14 (AP).—Whether American government desires enter upon commercial treaty n tiations in a spirit of recipro offering to give when it seek receive, is understood to be question that the French gov ment will put in its reply on tariff question tomorrow.

If Washington wishes to take conversations on the matter that basis, the French governn will be pleased to begin then once, giving American imports the meantime, all of the ad tages of minimum rates as treaty already had been agreed

This reply is understood to ry with it the implications tha the United States government not find itself in a position to gotiate on the basis of recipro France will not be able, in fair to the countries with which t are already commercial treaties give the American goods any

'If she is speaking, what is she saying?' a bemused Craig asked himself. Isadora had provided an answer in *The Art of the Dance*, her 1928 apologia: 'We do not stand on the beach and inquire of the ocean what was its movement in the past and what will be its movement of the future.' Thus, driven by forces she could not describe but only channel, on 14 September 1927, aged fifty, Isadora was in Nice 'affecting, as was her habit, an unusual costume' according to the *New York Times*.

This costume included a long, melodramatic scarf designed by Roman Chatov, a Russian costumier who had worked in Hollywood on the Ziegfeld Follies. It was a gift from her friend, Mary Desti, film director Preston Sturges's amply eccentric mother. Desti is a corruption of d'Este, which, in turn, was a fanciful evolution of Dempsey. d'Este had been her cosmetics brand until the Italian noble household objected and a modification was ultimately required.

Isadora had affected some interest in cars, favouring a Bugatti T35. But on this occasion, her fateful ride was in an Amilcar CGSS. Amilcar was a cyclecar manufacturer established by Joseph Lamy and Emile Akar in 1921, the brand being a mash-up of their names. A cyclecar was, officially, a vehicle that weighed less than 350 kilos, could carry two passengers and had an engine with a swept volume of less than 1,100 cubic centimetres. Above those limits, a cyclecar became a '*voiturette*'. By the mid-twenties the Amilcar CGSS (Grand Sport Surbaissé) was considered one of the finest sports cars of its day: light and agile, just like a dancer. Coincidentally, just like Isadora Duncan, the Amilcar company was also in perpetual financial trouble.

The destination is unknown, but at some point, Isadora had accepted a joy ride along the Promenade from Benoît Falchetto, one of Bugatti's salesman-mechanics on the Côte d'Azur. She nicknamed him 'Buggatti' (sic). Desti was there to wave her off, shouting a warning over the Amilcar's popping exhaust note to look out for the long, trailing scarf. But it was either not heard or ignored. Within yards, the Roman Chatov scarf had wound itself around one of the Amilcar's wire wheels and, in the words of the

New York Times obituary, Isadora was 'hurled in an extraordinary manner … and instantly killed by the force of her fall to the stone pavement.' Her final career arc, wrenched by great force from car to sidewalk by unforgiving silk, was the most dramatic Isadora Duncan move of them all.

Her last words, heard through a blue haze of oil-scented smoke were: 'Adieu, mes amis. Je vais à l'amour.' Which might loosely be translated as: 'Goodbye, dear friends. I am off to love' – perhaps a reference to speed's relationship to the sexual act, not to mention her interest in Buggatti. Mary Desti, however, intent on maintaining some sort of incongruous post-mortem reputation for decorum, insisted that those same last words were: 'Je vais à la gloire.' Or 'I am headed for glory.'

A gay American expatriate novelist called Glenway Wescott was at the scene and visited Duncan's body in the morgue. He confirmed that Isadora's true intention was, indeed, love before glory. (Wescott inspired a character in Hemingway's *The Sun Also Rises* who made the narrator throw up.)

As it was, Isadora Duncan was headed instead for Paris's Père Lachaise Cemetery, where she is buried next to her children. She found a form of glory, even if Gertrude Stein had remarked sniffily of her demise: 'affectations can be dangerous'. The trademark scarf undid her.

At the time of her death, Isadora Duncan was a Soviet citizen. Amilcar ceased trading in 1939. Nice's glorious Promenade des Anglais, however, remains a road where beautiful people drive impressive cars towards their singular destinies.

JEAN BUGATTI 1939

The punishment of luxury

Fred Duesenberg was the first celebrated car maker to die in the crash of a car bearing his own name. That was in 1932. Jean Bugatti was the second, seven years later.

The Bugatti family was extraordinary. The patriarch was Carlo, Jean's grandfather, a noteworthy Milanese furniture designer of the Stile Liberty (the Italian name for Art Nouveau, acknowledging the influence on that movement of London's Liberty store on Regent Street). His sons were Rembrandt, a sculptor, and Ettore, the car designer, engineer and manufacturer. They were all prodigiously talented, well connected and cosmopolitan. From Italy, they moved to Germany, but became naturalised French when they settled in Dorlisheim, Alsace, near the site of the future Bugatti factory at Molsheim.

Gianroberto Maria Carlo Bugatti, always known as Jean, was Ettore's eldest son. His culture was one where art and engineering, high temper, great emotions, an aestheticised mysticism and a craving for beauty all coexisted. Ettore once explained his own motivation: 'Pure blood, absolute clarity, predominance of purpose, immaculate shape.' He used to 'sculpt' engine blocks in wood in order to determine whether they were aesthetically correct. His attention to detail was exigent. He acknowledged no principles other than his own.

The social and artistic connections Jean enjoyed were extraordinary. His grandfather Carlo was in the circle of Leoncavallo and Puccini, the great maestros of Late-Romantic opera. Ettore and Rembrandt were drenched in fin-de-siècle luxury, decadence

and aestheticism. The painter Giovanni Segantini, a prototype hairy Bohemian who belonged to a group called the *Scapigliatura,* or The dishevelled, married Luigia Pierina Bugatti, Carlo Bugatti's sister, so became Jean's great-uncle.

In Segantini's strange, Symbolist painting *The Punishment of Luxury*, now in Liverpool's Walker Art Gallery, the disembodied soul of a beautiful, but wanton, woman floats in Alpine scenery. The visual precision is disconcerting, but Segantini was interested in the new craft of photography and its optical precision may have influenced him.

Perhaps inspired by a Buddhist myth, Segantini's image is an unforgettable study of desire and its consequences: the painting originally had 'Lust' in the title and not 'Luxury', although the two are perhaps easily confused. He had studied Nietzsche and Gabriele d'Annunzio, but defined a pagan philosophy of his own. 'I've got God inside me,' he said: 'I don't have to go to Church.' You can visit his extraordinary museum today in St Moritz. His beautiful, haunted pictures make a fine contrast to the Russian-registered Lexus and Porsche four-wheel drives parked outside. These references bracket the short life of Jean Bugatti, scion of one of the last great independent car manufacturers.

What did he learn from his father and his uncle? Even as Ettore was thinking of valve timing, Rembrandt was making plastic expressions of desire inspired by animals. 'Nothing is too beautiful, nothing is too expensive,' Ettore Bugatti had taught his children. And no cars were ever more beautiful and expensive than Bugattis. Nor were any sculptures more full of wild animal spirit. Looking at a panther by Rembrandt, ready to pounce, dragging its loins on the floor, the hot sexual gratification explicit even in the cold, static bronze, you realise the connections between cars and animals, between cars and sculpture.

FT Marinetti, the Futurist demagogue and pamphleteer (who famously wanted Venice's waterways drained so that cars could power up the Canal Grande) had realised this too. He described d'Annunzio's mistress, the Marchesa Luisa Casati, a Bugatti familiar, as having the 'satisfied air of a panther that has devoured the bars of its cage'.

People who try to put the ineffable language of car design into words often fall back on formulae such as 'muscle under skin' and 'feline stance', or indeed anything with feral associations. But when you look at a Rembrandt Bugatti bronze and an Ettore Bugatti car, this is no longer a philosophical speculation, but a tangible fact. This interplay of animal form with artistic ambition defined the Bugatti moment. The big cats Rembrandt studied were especially interesting to a sculptor fascinated by animation. They have an intricate combination of bone and muscle with an astonishing physical efficiency. Even a domestic cat has more than 500 voluntary muscles and a skeleton of nearly 250 bones. The head alone has up to forty bones and the vertebral column over fifty. Additional suppleness and articulation come from the cat having an open shoulder joint, allowing a wide range of movement.

An understanding of this intricacy gave Rembrandt's bronzes of leopards and panthers their curious, coiled, potency. A similar otherworldly sophistication also influenced Bugatti cars. Ettore Bugatti would thread a leaf spring through a hollow axle and revolutionise racing-car suspension to create machines of unparalleled, uncompromised beauty.

This was the potent atmosphere of beauty, sex, engineering and tragedy that Jean Bugatti breathed. He was soon at work for his father and by 1932 could claim as his own the design of the Bugatti Type 41 Royale. This was perhaps the most absurdly and superlatively magnificent motor car ever made. Of the six built, only three were ever sold, as it was launched during the Depression when even millionaires and maharajahs felt a slight chill wind of restraint. The car had a 12.7 litre straight-eight engine, originally intended for an unrealised aeronautical project, and weighed a colossal 7,000lbs. The radiator mascot was an elephant, inspired by one of Rembrandt Bugatti's sculptures. The mighty engines eventually found their way into French SNCF locomotives. Seventy-nine of these were built and the last remained in service until the late 1950s.

After the Royale, Jean Bugatti concentrated on the Type 57, a more modest car than the Royale, although these things are relative. This appeared in various forms including the Ventoux, Stelvio,

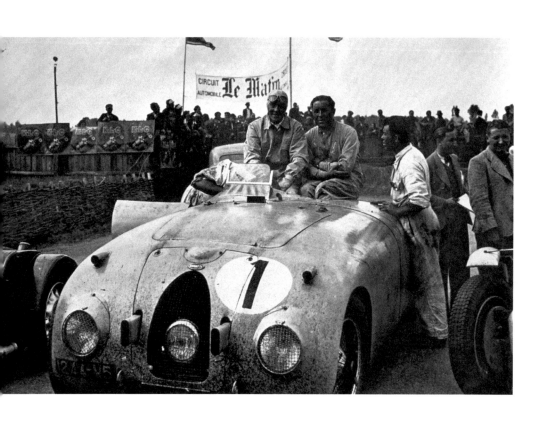

Atalante and Atlantic. Ventoux and Stelvio are mountain passes. Atalante was the athletic goddess who would only marry someone who could run faster than she could herself, while Atlantic gives an approximation of the scope of the Bugatti family's ambitions. This last had a distinctive dorsal seam as a result of the Duralumin and Elektron panels being externally riveted – evidence, if such a thing were needed, of the Bugatti family's obsession with metalworking. On the *surbaissé* (lowered) chassis of a Type 57S, the effect of this gorgeous body is of a wild cat prepared to pounce, its skeleton suggested beneath a taut metal skin. A felid machine!

Ettore Bugatti had forbidden Jean to race, fearing for his son's safety on the track, so the young man instead became committed to road-testing the factory's furiously fast cars. So, instead of dangerous driving in public, Jean became committed to dangerous driving in private. During the summer of 1939 there was a heavy programme of testing the Bugatti Tank, an aero-variant of the Type 57S, which had won the French Grand Prix in 1936 and Le Mans the following year, and again in 1939. The car had a dry sump 3.3-litre sixteen-valve, straight-eight engine making 170hp. Ingeniously, suspension damping increased with speed. From 1937, feeble cable-operated brakes had been replaced by a more effective hydraulic system.

As compensation for his thwarted racing instincts, it was Jean Bugatti's ambition to win all the speed records on land, water and in the air. To this end, the Bugatti factory had hired the Belgian engineer Count Pierre Louis de Monge to work on a record-breaking 'plane. The T100 was the result and one was prepared for the 1938 Coupe Deutsch de la Meurthe air race, Deutsch de la Meurthe being the industrialist-philanthropist who had given pioneer Brazilian aviator Alberto Santos Dumont his first award. With its extruded canopy, V-tail and in-line engines driving counter-rotating propellers in the nose, the T100 was one of the most extraordinary aeronautical general arrangements ever seen. Like the Bugatti racing-cars, it was painted an astonishing French

Jean-Pierre Wimille and Pierre Veyron won the 1937 24 Hours of Le Mans in a Jean Bugatti-designed Bugatti Type 57G Tank, serial number 01 of only three made.

43

Racing Blue. As this aircraft design evolved, Jean continued to test the aero-inspired, although – in aesthetic terms – comparatively sedate 57 Tank. Perhaps he sometimes mused on how the new discipline of flight and its keener challenges excited greater inspiration from designers. Perhaps he was beginning to think that the future of Bugatti was in the air, not on the ground.

But Jean's road-testing continued with bravado and disaster. Late in 1938 he had been in a fatal accident at Lingolsheim on the Strasbourg road. A cyclist called Alfred Rudloff had made an irregular turn in front of him. The police recorded the skid marks left as Jean braked his car in emergency. They measured 45 metres and that was itself 16 metres after the point of impact. The court found Jean's speed of an estimated 70kph to be 'absolutely indefensible' and that he was guilty of 'ignoring the most elementary principles of prudence', although it actually found the cyclist at fault. Jean Bugatti was given a three-month suspended prison sentence and made to pay reparations to Rudloff's family.

Still, the road-testing continued. On 11 August 1939, less than a month before Britain declared war on Germany, the Bugatti factory mechanic Robert Aumaître was, with his colleague, Lucien Wurmser, preparing the 57C of Jean-Pierre Wimille and Pierre Veyron for the La Baule Grand Prix. The preparation included ever more high-speed testing on country roads. Late in the afternoon, Jean Bugatti passed by the racing department and asked if the car was capable of 200kph, but Aumaître demurred saying the farm traffic on the local roads made such speeds inadvisable, even if they were achievable. 'Moreover', Aumaître added in a subsequent deposition, 'we could still hear the creaking of the brake drums as they cooled down in the shop.'

Be that as it may, Jean Bugatti decided to do tests of his own and asked Aumaitre and Wurmser to have the car ready for after dinner. At 9.00pm he set off. To prepare the neighbourhood for the exercise, Bugatti had sent his brother to Duttlenheim, the stable lad to the Duppigheim road and asked Lucien Wurmser to stake out the Esso station at Entzheim. Their job was to stop the light traffic so that a racing-car test could take place. In those happy days, such a thing was a possibility.

Aumaître was to ride with Bugatti. His job was to sit crouched in the footwell and light the instruments with the end of his cigarette, there being no dashboard illumination. He was to tap Jean on the leg when 5,000rpm was reached in the gears. It would top out at 5,500rpm in fourth, which meant a speed of 235kph. The test over, Aumaître was ready to return the car to the garage when Bugatti insisted on a last, solo run. It was to be his final drive.

The local paper, reporting two days later, noted that Jean had collided with another cyclist, a nineteen year old called Joseph Metz, who broke two fingers, but was otherwise unharmed. It was worse for Jean Bugatti. He was seen travelling flat out when, perhaps after hitting a bump after avoiding the cyclist, the car left the ground, hit a tree and left it and a neighbouring corn mill in flames. His body was found 20 metres away. Bugatti père was driven overnight, in a Royale, from the Château de Laeken in Brussels, but Jean had been declared dead on arrival at Strasbourg hospital. He was thirty.

The panthers, leopards and elephants that Rembrandt Bugatti sculpted are approaching extinction. So too are the types of car that Bugatti made famous. Jean Bugatti represents the last link to a world where the finest automobile engineering was not culturally distinct from the greatest art. The connection is not too far-fetched. In 1951, New York's Museum of Modern Art put on a show called *Eight Automobiles*, the first attempt to consider cars as works of art. 'Rolling sculpture' curator Philip Johnson called them. Any unsettled argument about whether cars might be art was shut down for good. Within the Bugatti family, sculpture and cars were forever confused, as were achievement and calamity.

After Jean's death, Ettore Bugatti became disenchanted. The company stumbled on until 1963, but the life had left it. Referring to his fanatical perfectionism, Ettore once said: 'No driver was ever killed, or even injured through the failure of a Bugatti part,' even if his priority was to make cars go fast, not stop. Perhaps, then, Jean Bugatti might have been safer on the racetrack than on the public road. And maybe if the 57 Tank's new hydraulic brakes had been superior, he might have avoided the cyclist and lived to make a more substantial contribution still to the extraordinary story of feral spirit, art and death suggested by the family name.

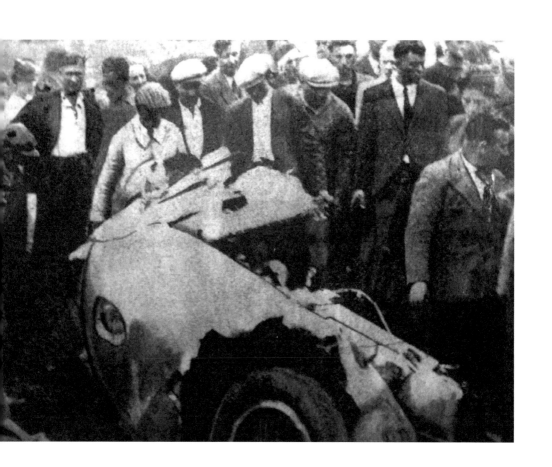

We know that Jean Bugatti liked to drive fast: 'too fast, perhaps', according to the Bugatti historian Hugh Conway, who added that 'prudence was not one of his virtues'. Prince Bertil of Sweden, himself no mean driver who claimed a Paris-Stockholm time of five hours on dirt roads, used to carouse with Bugatti at a Champs-Élysées nightclub called Scheherazade where a Mexican guitarist called Reve Reyes was a star turn. The prince recalled leaving the club at five in the morning and racing Bugatti up the Champs-Élysées in their T51s at 160kph.

Eventually, people would speculate that Jean Bugatti was suicidal. On the occasion of the Bugatti centenary in 1981, Philippe Aubert published a book in which he suggested that, on confronting yet another errant cyclist, Bugatti at first overreacted then deliberately crashed his car so that the family might benefit from the insurance settlement. The distinguished American historian Griffith Borgeson suggested something similar, but this interpretation does not really tally with the psycho-dynamics of destructive depression. Hugh Conway recalled that 'melancholia was not one of his faults'. Robert Aumaître said: 'Mr Jean had never thought of suicide, he was not a man to do such a thing. He was a fighter, courageous. I loved him very much.'

There is a monument to Jean Bugatti on the Alsace roadside where he crashed. And in 2013 there was another memorial when the modern Bugatti company – a trophy entity created by ambitious Volkswagen – named a special edition of the mid-engined Veyron hypercar after him.

Jean Bugatti was forbidden by his father to race, so slaked his thirst for speed by testing racing cars on public roads. On 11 August 1939, he was attempting to reach 200kph when, avoiding an errant cyclist, his Bugatti Type 57G Tank hit a tree near Duppigheim, Alsace. After Jean's death, the great Ettore Bugatti became disenchanted with the business.

NATHANAEL WEST 1940

The most thoroughly pessimistic man

Nathanael West was a man of great charm and profound cynicism. In fact, his cynicism was so well known in his literary and movie circle, shading even that of his close friend Dorothy Parker, that WH Auden called it 'West's Disease'.

Circumstances may have influenced the formation of this lowering personality trait. West was a novelist of strange, sometimes weird originality, and a brilliant screenwriter, but often found himself rebuffed. The Hollywood he came west to inhabit was sleazy, not glamorous, a place characterised by brothels, flophouses, cock-fighting, freaks, losers and people with 'fever eyes and unruly hands' who had come to California to die.

Genius was neglected and expediency encouraged. Failure, rejection and disappointment competed with flashes of genius to define West's professional life. He lived in a condition the English critic Alan Ross described as 'etiolated ennui'. The Hollywood experience convinced him that the noble American Dream had been betrayed. A friend described him as 'the most thoroughly pessimistic person I have ever known'. According to Ross, West nurtured a disgust that was not far from hysteria.

Nowhere is this better expressed than in his rueful black comedy, the novella *Miss Lonelyhearts*, adapted for the screen as *Advice to the Lovelorn*. The title is the pen-name of a male agony aunt, himself a melancholic drinker, who takes pity on a troubled correspondent to the extent of making love to her, although that is perhaps not quite the correct term. He is then shot by a jealous husband. So, an act of selfless charity is punished. That's revealing

of a certain point of view, bruised and poisoned. *Miss Lonelyhearts* is about self-pity, disgust and the hopeless dream of normality. Ross, in another memorable sentence, says West treats all this misery with a 'bare passion that charges the whole book with a hallucinatory fever'.

Another West masterpiece, *The Day of the Locust*, a Hollywood satire, eventually entered the canon of mid-century novels where it sits near the top of the pile, but at his death its first edition had sold only twenty-two copies. (However, he had made $35,000, perhaps the equivalent of a million today, from selling the film rights.) In *Day of the Locust* we find a bookkeeper character called Homer Simpson. 'She had only one line to speak: "Oh, Mr Smith" and spoke it badly' is eloquent of his sense of Hollywood. So too is: 'Here, you black rascal! A mint julep!' It was estimated that by 1936 West's three novels had made him $780. By 1939 he had acquired a sense of impending disaster.

Nathan Wallenstein Weinstein was born in New York's Upper West Side to a family of prosperous Russian Jews – in the construction business – whose first language was German. Although comfortably off, his early life was determined by a sequence of blags and schemes. A classic trickster, he found a place at Tufts University by forging his entry papers. He was expelled, but found his way into the very distinguished Brown University where he became interested in Oscar Wilde, the Symbolists, mysticism and Christianity.

Here, another bit of subterfuge with an assumed or stolen identity used on essays and exam papers brought him into conflict with the academic authorities. At Brown, Wallenstein met the humourist SJ Perelman who subsequently married his younger sister, creating a dynasty of cynicism and laughter. Nevertheless, Weistein did not flourish, academically speaking, and left Brown for Paris, where he reinvented himself as the more WASP-ish Nathanael West. In Paris he wrote his first novel, *The Dream Life of Balso Snell*. Truly bizarre, it concerns a young man trapped in the guts of the Trojan Horse, which he enters via the anus, described by West as a 'mystic portal'. *Balso Snell* is full of scatological reference. Harold Bloom called it 'squalid and

dreadful'. It is perhaps fairer to call it juvenile. The scatology may be contemptuous of good taste, but there are obvious flourishes of brilliance.

Refreshed by this outrage, the newly minted West returned to New York and found a job as the night manager in a flophouse called the Hotel Kenmore Hall on East 23rd Street. Here he was in a position to observe the spats and deceits of nocturnal low-lifes. He witnessed the real-life episode that became the Homer Simpson and Romola Martin spat in *The Day of the Locust*. When things became quiet, he sat behind his night porter's desk and made the notes that eventually became *Miss Lonelyhearts*.

By giving cheap lodging and distributing other favours, West entered the circle of hotel guests Dashiell Hammett, Lillian Hellman and William Carlos Williams. By 1933 West had become a contract writer for Columbia, specialising in scripts for B-movies. Eventually, Darryl F Zanuck bought the rights to *Miss Lonelyhearts* for $4,000, but it was a terrible failure. As if to emphasise this, John Steinbeck's Pulitzer Prize winning bestseller *The Grapes of Wrath* was also published in 1939. In the same year, West became a staff writer for RKO Pictures, where his movie credits include *Before the Fact*. He also wrote *Born to be Wild*, which eventually inspired the Steppenwolf song that became a counter-culture pop classic of 1967.

On 22 December 1940, West was on his way to the funeral of his friend, F Scott Fitzgerald, who had died suddenly in Hollywood only a week or so after they had spent a bibulous and convivial evening together. People said of Fitzgerald's death, the voice of all sad young men is silenced. Not quite, but the voice of another sad young man would also be silenced soon. West was driving a Ford Super Deluxe station wagon, a classic 'woodie', the assembly of whose maple frame and birch panels took place at Ford's 'timber operations' in the incongruously named Iron Mountain, Michigan. West's car was probably the Model 11A with the 221 cubic inch

Overleaf: The 1940 Ford Super Deluxe became the basis of the classic 'woodie' station wagon. Its maple frame and birch panels were assembled at Ford's 'timber operations' in the incongruously named Iron Mountain, Michigan.

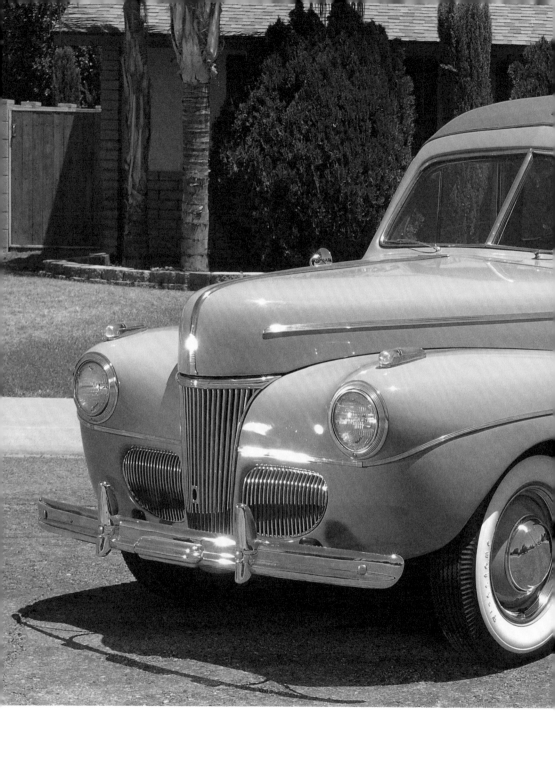

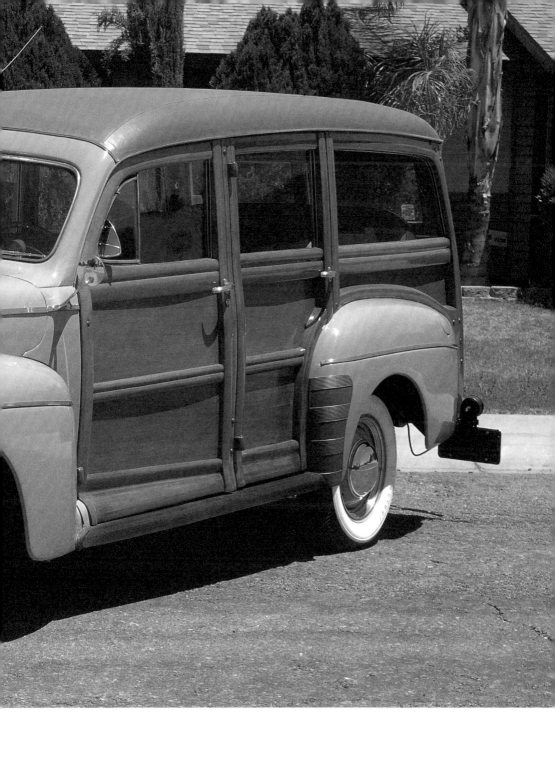

flat-head V8 making a modest 85hp. I write 'probably' simply because photographs of the wreck are indistinct.

It is worth noting that Fords of this generation later became the most popular basis for Californian hot-rodders. But West never knew this. He was not much of a car man. At least, not in the positive sense: his biographer, Joe Woodward called him, in *Alive Inside the Wreck* (2011), a 'homicidal driver'. He was, by all accounts, pitiably uncoordinated and permanently distracted, being much given to talking with and facing rear-seat passengers while at the wheel. Touchingly, his driving embarrassed him. It was his custom to be driven to parties, only to take over the wheel a few miles short of the destination in order to prove masculine credentials and save face.

The journey to Fitzgerald's funeral interrupted a quail-hunting expedition to a ranch called Les Ojos Negros between Ensenada and Mexicali. Hunting was a pleasurable release for West: he collected antiquarian sporting books and had bought a pair of matched Purdey shotguns specially for this trip, planned as a break from the rigours and frustrations of the writers' room in the studio compound.

West had stayed overnight at the De Anza Hotel in Calexico, four and a half blocks from the Mexican border. There is a lot nearby called Cars 4 Sale. Just as Hollywood was not glamorous Hollywood, Calexico is not glamorous California, although the De Anza Hotel – built in 1931 by an ambitious entrepreneur called Will R Conway – was often used by Hollywood types as a stopover on south-of-the-border hunting trips.

Calexico was originally a tent city. Further to suggest the cultural bleakness of the area where West, already disenchanted with America, spent his last night, Calexico's twin town is Mexicali, each name a conflation of California and Mexico. Places whose names are acronyms or abbreviations, Pakistan is an example, are rarely happy ones. However, to compensate for this local bleakness, the

Nathanael West and Eileen McKenney died when West failed to stop at a junction in El Centro, California and hit a Pontiac driven by fruit tramps. It was 22 December 1940, and the couple were on their way to the funeral of their close friend, F Scott Fitzgerald.

Where Two Died, Three Met Injuries Sunday

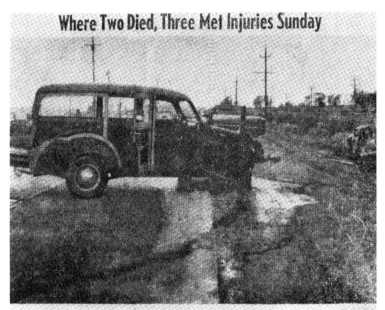

Two Hollywood residents met death in the station wagon shown at the left when it collided with a sedan, shown at extreme right, at the intersection of highway 80 and the Central Valley highway Sunday afternoon. Three persons in the sedan were injured. Speeding through a boulevard stop was said to have caused the accident. Nathaniel West, 36, Hollywood scenarist, and his wife, Ruth M. Kenney West, 30, were killed.

hotel had three dance floors and an interior-design scheme in which inlay dominated the effect.

Scott Fitzgerald had died of a sudden heart attack. West had been planning to follow his quail-hunting vacation by flying to New York for the Boxing Day Broadway opening of the play *My Sister Eileen*, inspired by his new wife, Eileen McKenney, but changed his plans to be at the funeral. This is how he found himself in Calexico. Eileen's sister, Ruth McKenney, who wrote the play, had said of their family: 'my origins are obscure, if not horrible', which suited West's dark side. The last known photograph of Eileen shows her standing by the Ford woodie, holding a dog.

West left the lobby of the De Anza Hotel with Eileen after lunch, drove north past the Cars 4 Sale lot, passed fields of lettuces, braked too late at a stop sign at the intersection of Highways 80 and 111 (at El Centro – an accident black spot) and collided head-on with a family saloon, a 1937 Pontiac driven by fruit tramps, as the seasonal farm-labourers were known. Mr and Mrs West were thrown out of the Ford and killed instantly. West was wearing a patinated leather hat and a T-shirt with fine horizontal black and white stripes. Eileen's watch stopped, crushed by the impact, at 2:55pm. West was thirty-seven, Eileen just twenty-six.

His many friends were distraught, but not surprised. West was a figure ahead of – or out of – his time. His reputation only took off after 1957 when New Directions published a compilation of his hitherto neglected novels. Despite *Miss Lonelyhearts* being published in London by Grey Walls Press in 1949, with a fine introduction by Alan Ross, he remains little known in England.

And West was defiantly apolitical. In fact, his view of the world was so bleak that politics seemed frivolous. For West there was no prospect of redemption and no 'transfiguring sense of good or evil, no compensation in the physical life', according to Ross. He wrote to Malcolm Cowley about *The Day of the Locust*: 'I tried to describe a meeting of the Anti-Nazi League, but it didn't fit and I had to substitute a whorehouse and a dirty film.' West had already declared that: 'an artist can afford to be anything but dull'. For his part, Scott Fitzgerald thought *Miss Lonelyhearts* 'quite extraordinary'.

Nathanael West may have been Homerically melancholic, but he was affable and humorous at the same time. His friend Dorothy Parker described him as 'wildly funny, desperately sad, brutal and kind, furious and patient'. His brother-in-law SJ Perelman always said kindly things about him, neglecting to mention West's frequent cathouse whoring, which led to an infected prostate gland.

West once said that it was easy to write a film script, but hell to write a novel. It was even more difficult to live the life of a novelist, as Scott Fitzgerald had already made clear. West lived and died his own tragic and funny story with an arc as curious and haunting as one of his own novels. As Steppenwolf sang: 'get your motor running/head-out on the highway/looking for adventure and whatever comes our way.'

The Dream Life of Nathanael West, his California adventure, ended in heavy metal thunder when Hollywood talent headed out on the highway, perhaps a little bleary-eyed, talkative certainly, and hit the fruit tramps. Flying through the air in those final seconds, one imagines Nathanael West might have seen the funny side of things. In death, however, he had anticipated no sense of completion. The last line of *Miss Lonelyhearts* describes the shot couple: 'They both rolled part of the way down the stairs.' 'Part of the way', is haunting. At least he did not actually die of West's Disease.

The blurred newspaper photographs make the wrecked Ford look melancholy, although it is not specially devastated: the car is still standing on all four wheels. I wonder if the Godless Nathanael West knew the Ogden Nash poem *The Beggar*, which appeared in *The Face is Familiar*, published in the year of his crash …

When the business cycle ends
In flaming extra dividends
Will He smile his work to see?
Did He who made the Ford make thee?

GENERAL GEORGE S PATTON 1945

Old Blood and Guts' Cadillac of Destiny

General George Smith Patton drove a cetacean 1938 Cadillac 75, a car with an ego as mighty as his own. It was a car that, in design terms, anticipated the gloriously absurd baroque follies of Detroit art in the fifties. It was, like its most famous passenger, big, confident, imposing and a little loud.

Some said Patton was the greatest warrior who ever lived and he had no difficulty in supplying a vivid iconography to support this ambitious claim. Though his achievements were real, including the liberation of Sicily, as head of the US Seventh Army, and rather stylishly capturing Northern France, as commander of the Third Army, his reputation was based on a camp-but-butch theatricality, as much as it was on martial expertise, a general's vision and a soldier's daring. He liked to pose for photographs with a helmet buffed to a non-essential shine, sporting aviator shades, jodhpurs and cavalry boots, with a trademark pair of pearl-handled Colt .45 'Peacemaker' revolvers hanging from his spiffy gun belt. His army Cadillac was decorated with oversized military insignia and, lest he not be noticed in his triumphal progress through the Europe he had almost personally re-conquered, Patton liked to travel with the car's siren wailing. Perhaps he made enemies in this fashion.

Patton was known and admired for his amazing profanities. 'No bastard ever won a war by dying for his country. He won it by making the other poor dumb bastard die for his,' was the opening gambit to one of his celebrated speeches to the men of the Third Army; and 'An army without profanity,' he once said, 'couldn't fight its way out of a piss-soaked paper bag.' There is a fine 1945 colour

photograph of him pissing into the Rhine, conscious, one would like to think, of the symbolism of such a gesture. And then he confessed that he sometimes got carried away with his own eloquence. He wrote a poem in 1944 called *Absolute War* and explained that profanity needed to be eloquent to be fucking effective. Despite his earthy rhetoric, Patton was also a passionate believer in reincarnation, although no reports have been discovered of his return with an explanation of his last catastrophic accident.

That so extravagant a figure, a notorious hard driver of men and machines, died as a result of a low-speed crash in suburban Mannheim is so pitiful an irony that the hinterland of the accident has excited wild speculation, becoming a locus classicus of the demented fabulism that is now known as 'conspiracy theory'. Patton, a rabid anti-Communist, was on Stalin's death list and was murdered by the Russians! His putative rival for the future presidency, General Eisenhower, had him flattened to level the field! Patton was involved in art theft! His commitment to the de-Nazification of Germany was half-hearted, so the Jews got him! Patton knew stuff that could ruin careers! In order to acquire power over the entire world, he had, while passing through a bombed-out Nuremburg, looted the Hapsburg Spear of Destiny from Hitler's Treasure House ... and dark forces wanted it back!

Historian Robert Wilcox claims to have found diaries of General 'Wild Bill' Donovan, head of the Office of Strategic Services, or OSS (the predecessor of the CIA), which suggest that an American sniper called Douglas Bazata had been commissioned to assassinate Patton. In this theory, the collision with a two-and-a-half-ton General Motors truck was staged as a distraction from the shooting. Bazata was, the theory continues, not such a good shot and Patton did not die immediately, but US officials blithely looked the other way when the NKVD infiltrated the military hospital in Heidelberg where Patton was recovering and successfully poisoned him.

This Bazata, incidentally, was an interesting figure with plenty in his culture to stimulate conspiracy theorising. He was a disenchanted and embittered Lebanese Jew with connections to the OSS (although his *New York Times* obituary describes him as the son of a Presbyterian minister). He was a flamboyant soldier

who irreverently called his colonels 'Sugar'. The recipient of four Purple Hearts, a Distinguished Service Cross and three French Croix de Guerre, after the war Bazata became a wine-maker and a painter in the Abstract Expressionist manner, enjoying a fair level of critical acclaim. His own portrait was made by Salvador Dalí, who whimsically painted him as Don Quixote. Among the collectors of his work was Princess Grace of Monaco.

Wilcox also claims that official documents about Patton's crash have been removed from US Archives, although the proof of something not existing is always a problem both in logic and in law. Nevertheless, in support of his theory, Wilcox says no post-mortem examination was made of Patton's body and his driver, one PFC Horace Lynn 'Woody' Woodring, a graduate of the Army Chauffeurs' Training School at Fort McClellan, Alabama, was dispatched to London before he could be helpfully cross-examined about the crash. Meanwhile, Wilcox asked General Motors technicians to establish the authenticity of the Cadillac 75 now on display at the Patton Museum in Fort Knox and they were unable to make any formal confirmation.

The circumstances of the crash are as follows. After his Third Army was halted at the German border, allowing Berlin and Prague to fall into the Soviet sphere of influence, Patton's prestige was damaged. He had been appointed Military Governor of Bavaria, a post to which he was so fundamentally unsuited that he was 'kicked upstairs' to command the Fifteenth Army at Bad Nauheim. The Fifteenth was a paper army, with no troops. As the commanding general, Patton's role was to chair the Theater General Board, which was tasked with researching past campaigns in order to improve military tactics and operations. It was a desk job. For a pugnacious man, it must have been demeaning. There was, however, an underlying psychological reality in his acceptance of the post. He tolerated the boredom because he found The Pentagon's vengeful and sometimes bloodthirsty de-Nazification programme

Overleaf: The 1938 Cadillac 75 seven-seater saloon was the largest automobile made by Cadillac and one of America's finest cars. Its generous size and ample power, from a 5,674cc V8, were symbolically appropriate for the private transport of a gung-ho four-star general.

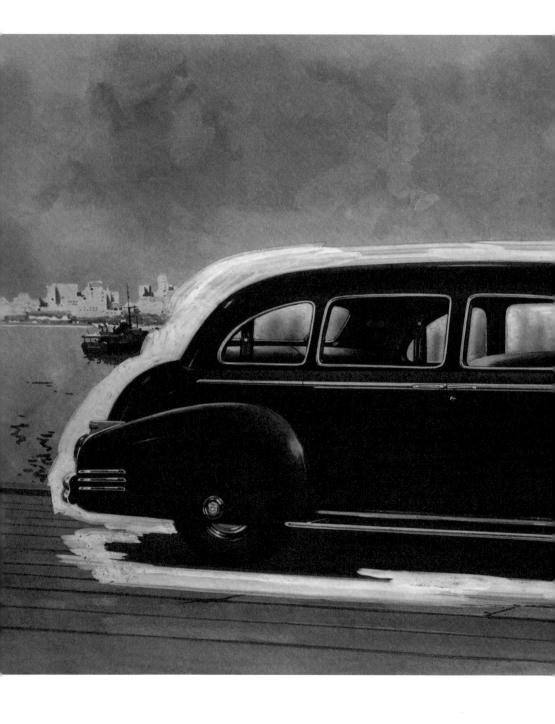

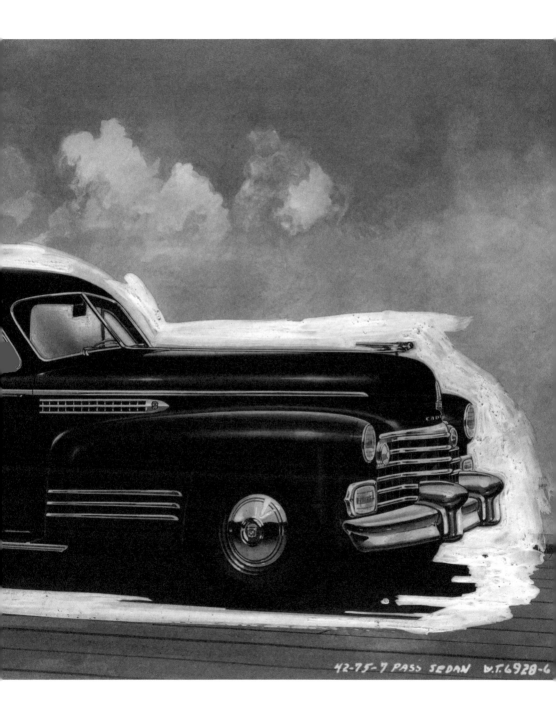

42-75-7 PASS SEDAN D.T.6928-6

unacceptable and refused to take part in it, writing to his wife Beatrice that pen pushing was 'better than being a sort of executioner to the best race in Europe'.

As a specific against the boredom of Army bureaucracy, Patton enjoyed hunting. Thus, on 9 December 1945 his driver PFC Woodring (who drove fast and was reported to have a taste for the fräuleins) was asked to prepare the Cadillac 75 for a trip that would culminate in a pheasant shoot. This Cadillac was a car that, despite its olive drab paint (buffed up to a shine in deference to Patton's tastes), was decidedly unmilitary in character. A vast automobile sculpture with abundant chrome and headlights in streamlined pods, it was one of the ever more integrated designs of Harley Earl, General Motors' Wizard of Kitsch, as he progressed towards his own post-war realisation of the sculptural possibilities of the Detroit automobile. The 75 was supremely smooth, while elegant radii disguised its formidable bulk. Its 'Synchro-Flex' flywheel was attached to a massive 346 cubic inch L-head V-8. Of course, Patton's own car had his General's four stars mounted on a red plaque on the right front fender.

A convoy left Bad Nauheim led by a jeep with Patton's Cadillac 75 following. 'Lead me, follow me, or get out of my way' was one of his *idées fixes*. On this occasion, he followed. Patton sat in the back, on the right-hand side, with his chief of staff, Major General Hobart R 'Hap' Gay beside him as usual. En route, Patton stopped to inspect the Roman ruins at Saalburg, a rare moment of introspection and contemplation. More generally, he spent journeys admiring the passing landscape and fantasising, as all generals perhaps do, about what military actions might occur there one day.

At 11.45, the convoy slowed as it approached a railway crossing near Neckarstadt to allow a train to pass. Patton, noting the abandoned vehicles along the roadside, said to Gay: 'How awful war is – think of the waste'. Distracted, Woodring glanced away

Private First Class Horace L Woodring, General Patton's driver, considers the modest damage to the Cadillac 75 after the 9 December 1945 collision with an Army truck. Both Woodring and the truck-driver returned to their outfits without disciplinary action. Patton died later in hospital. The car too was repaired and returned to service.

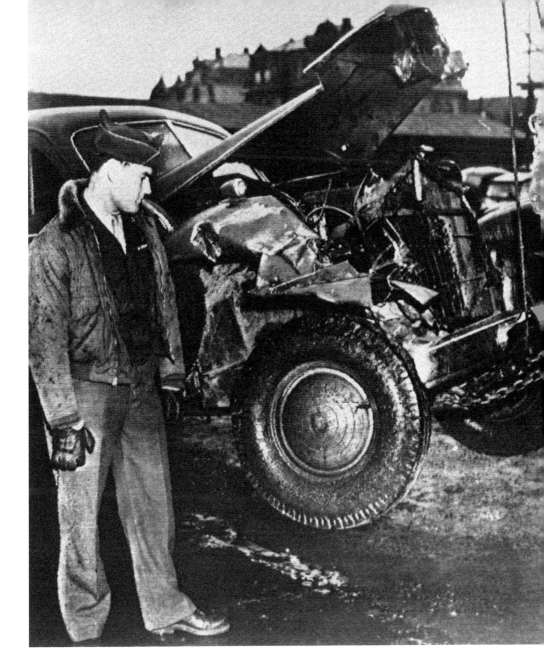

from the road. At that moment, a two-and-a-half-ton CCKW US Army truck made a sudden left turn in front of the Cadillac. The General Motors CCKW 6×6 was the mainstay of the 'Red Ball Express', the convoy system that supplied Allied forces after the Normandy invasion.

The impact was not severe, a mere fender-bender, and the Cadillac was not critically damaged. Neither Gay nor Woodring was injured. Patton, unfortunately, was not so lucky. In the deceleration, he hit his head on the metal rail running athwart the front bench seat, sustained severe head and spinal injuries and was paralysed from the neck down.

Some witnesses claimed the truck had been loitering, as if waiting for Patton's car to approach before pulling out. The truck driver, a twenty-year old from New Jersey, Technical Sergeant Robert L Thompson, was photographed grinning broadly and idiotically at the scene of the crash. He was subsequently found to be high on drugs.

Old Blood and Guts was driven to the Seventh Army's 130th Station Hospital in Heidelberg. Neurosurgeons were flown in from England and the United States and Patton's condition, while critical, was stabilised. So much so that within ten days plans were made to fly him back home where his ambition was to run the Army War College, if not bid for the presidency in the post-war elections. However, on 21 December Patton suffered a sudden pulmonary embolism and died in his sleep at 17:55. He was sixty. The General was buried 'with his men', at the US Military Cemetery at Hamm in Luxembourg, a solemn memorial to the Battle of the Bulge.

With so many neurosurgeons in attendance, the suddenness of Patton's death gave rise to speculation about deliberate neglect or malevolent interference. Although he died as the result of careless driving by a drugged-up punk, reputations of his stature cannot be contained in the banal metrics of road traffic accidents.

The most fabulous of the fantasies surrounding the crash is described in *The Spear of Destiny*, a 1973 book by occultist and fantasist Trevor Ravenscroft whose purple-hued prose and orotund cadences bring extra richness to the idea of historical kitsch. Ravenscroft explains that Hitler's Wagnerian interests

were based in a youthful pseudo-scholarly interest in Wolfram von Eschenbach's *Parzival*. And Hitler saw in the Speer des Schicksals or the Heilige Lanze on display in the Hofmuseum in Vienna the Redeemer's Spear that, with its magical powers, is central to the *Parzival* myth.

With the Anschluss of 12 March 1938, Hitler stole the spear from the museum, believing it would enhance his own powers. At this stage he seemed ignorant of the fact that the Kaiser had also possessed the spear during the Great War and it had done little to enhance his potency or endurance. Still, symbols do not have to be tested by science. Anyone possessing the spear, who then lost it, would die. This was the fate that legend attributed to Barbarossa who carelessly dropped the spear into a stream and promptly expired.

Hitler sent the stolen spear to the Katharinenkirche in Nuremburg. On 30 April 1945, Allied Forces bombed the church and the spear was subsequently recovered, along with other treasures, from the haunted ruins. The recoverer was Lieutenant Walter William Horn of the Seventh Army, an art historian who was working for the Monuments, Fine Arts and Archive Program – the subject of George Clooney's 2014 film, *The Monument Men*. Some occultists and fantasists believe that Patton himself took possession of the spear, but if so that would undermine the authority of its magic since it did little to protect him from a collision with a recklessly driven two-and-a-half-ton truck.

Patton's Cadillac 75, incidentally, was swiftly repaired and returned to active duty.

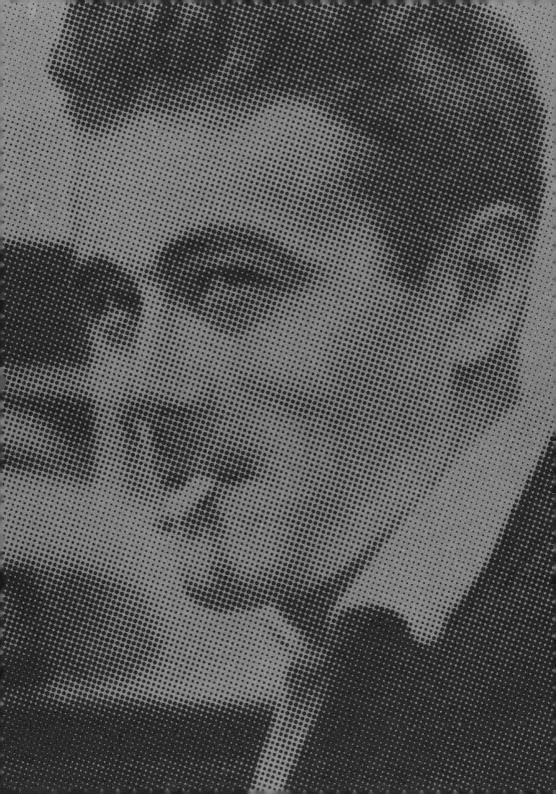

JAMES DEAN 1955

The glamour of delinquency

In *Rebel Without a Cause*, his 1955 breakthrough film, there is a scene where the impossibly handsome James Dean plays 'chicken run'. Two cars are driven towards a cliff and the first driver, whose nerve breaks, jumps out of his car, winning him the wounding title of chicken. Dean was no chicken, although he did popularise the duck's-arse, slicked-back haircut that Philadelphia barber Joe Cirello had created in 1940. It was a haircut that hinted at violence and signified style. In *Giant* – released posthumously – alongside Rock Hudson and Elizabeth Taylor, Dean played Jett Rink, a muscle-bound handyman with a greasy duck and buttons that became lasciviously undone: a Platonic bit of rough.

In character as Jett Rink, Dean took part in a US National Safety Council promotional film about road safety. The narrative concerns the dangers of driving fast and treating public roads as racing circuits. With a knowing admonition, the Rink-Dean character says: 'Remember the life you save might be mine.' Soon after, Dean was killed in a crash, sparing him, in the words of veteran New York film critic Pauline Kael, the miserable fate of 'being just another actor'. He was twenty-four and had made just three films.

Dean was an exemplary, thoughtful, tough-but-sensitive, bad boy possessing what Kael described as the 'glamour of delinquency', even as he read his favourite author, the gentle Antoine de Saint-Exupéry. His acting technique was primitive and unrefined. Kael spoke of 'strangulated speech … confused efforts and gestures' and a 'beautiful desperation'. But he created

something far more powerful than a stage or cinema presence: he created a prototype of talented, ruined youth. His awkwardness magnified, rather than diminished, his personality.

With his 'Dream as if you will live forever. Live as if you'll die today,' Dean spoke to a new generation, the first to experience the prosperity of America in the Eisenhower years and the first to find remedies against smug suburbanism in sex, drugs and speed. The career-move of his dramatic death achieved a version of immortality for Dean that acting success could never have. Live fast, die young and leave a lot of mythology. Soon after his death, documentaries began appearing about him. One of the earliest was Robert Altman's *The James Dean Story*, of 1957, the celebrated moviemaker's very first feature film.

Cars and bikes were important to Dean. His career ran in parallel with the California sports car cult, when importers realised the attraction that light, powerful and manoeuvrable European roadsters would have for West Coast hedonists enjoying lots of sunshine and high net worth. Under the Sports Car Club of America (SCCA), racing became highly professionalised. Dean first bought an MG-TD, graduated to a Porsche Speedster, a cut-down 356, and nine days before he died, traded in that Porsche for a pure 550 racer which he entered for an SCCA road race at Salinas, John Steinbeck's home town. There is a fine example of the 550 in the Porsche Museum at Stuttgart, but the most lasting memorial to this exceptional car is the afterlife of the wreck James Dean left in the desert sun.

Late in 1954 Porsche decided to make a short-run of its successful 1100cc 550 Le Mans racer to sell to its customers. A simple two-page brochure announced the availability of the Porsche 550/1500 RS Spyder, those initials standing for 'Renn Sport' or 'sports-racer'. 'Spyder' is an old term from the Italian

It was a condition of selling a Porsche 550 Spyder to a rebellious twenty-four-year-old film star that an official mechanic accompanied him. This was Rolf Wütherich who suggested to Dean that they run-in the new car en route to the Salinas Races where Dean was competing. It was a fatal suggestion. Wütherich survived the crash, but suffered long-term psychological injuries. He died in a crash of his own in Germany in 1981.

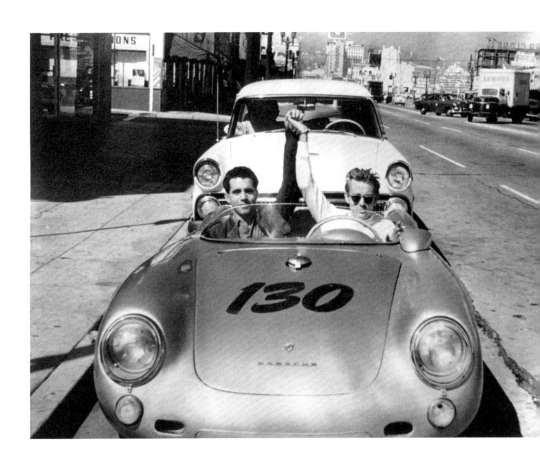

coachbuilding trade, which was a little erroneously insisted upon by the influential US importer Max Hoffmann. It was Hoffmann too who persuaded Mercedes-Benz to sell the 300SL *Flügeltürer* (Gull-wing), thus he is an individual with a certain distinctive responsibility for creating the American reputation of the modern German sports car.

One of the first production 550s appeared at the Earl's Court London Motor Show of October 1954. It had a 1500cc engine making only a modest 110hp, but with its aluminium body by Wendler and space-frame chassis, the entire car weighed only 1,320lbs, giving it astonishing performance. The 550/1500 RS Spyder cost $5,790 – twice as much as a standard 356. Dean bought one of five delivered to dealer John von Neumann. It was painted silver, the German national racing colour. He also bought a new Ford Country Squire station wagon to tow the car to races.

Contemporary comment on the 550 is revealing. The Porsche historian Karl Ludvigsen said people were 'amazed by its abilities' and Griffith Borgeson, writing in *Sports Car Illustrated*, described 'the savage, lunging character of the car under full throttle'. 'Up to 5000rpm', Borgeson said, 'it feels like one of the thrustiest machines you've ever driven, but then the cams hit their stride and the power really comes on.' The 550 had performance to push drivers back into their seats when accelerating or to hurl passengers out of them when braking.

Every road-tester commented on the amazing stopping power. Even though the 550 had only old-school drum brakes, which tended to fade, it was capable of amazing deceleration. In *Road & Track*, a bible of the sports-car cultists, Hansjörg Rendel wrote: 'It is easy to frighten almost any passenger unfamiliar with this car by approaching a corner at full throttle and, apparently, braking when it is much too late.' But there was some criticism too. Despite steel webbing used to strengthen the space frame, 550s suffered from a lack of torsional rigidity: if you jacked-up a 550, you could neither open nor close the doors. The great US sports-car racer Ken Miles said this flexibility led to persistent and worrying oversteer, the technical term for a car that tends to be tail-happy.

Miles told *Sports Car Graphic* that the 550 felt 'loose' and found that on bumpy roads drivers experienced 'considerable wheel fight and frantic flapping of the front wheels, which were apt to be pointing in every direction except that in which the car was going. Miles, evidently not happy with the 550, said it could never be driven with real precision 'because you were never quite sure where in the turn the car would finish up'. Another 550 characteristic was, at 2.3 turns lock-to-lock, exceptionally quick steering. And it was also very low. So low in fact that one German racer drove an example underneath level-crossing barriers. So low too that James Dean's reputed last words before his collision were 'Hey, that guy's gotta see us'. Gotta did not come into it.

Dean was already an experienced racer, winning places at Palm Springs and Bakersfield road races in the Speedster earlier in 1955, but the 550 Spyder was a more demanding proposition. In what was surely one of the stranger meetings in Hollywood's strange history, Dean showed off the 550 to Alec Guinness after a chance encounter at the Villa Capri restaurant. In his autobiography *Blessings in Disguise* Guinness said he found the weapon-like Porsche 'sinister' and told the younger actor, with resonant prophesy: 'If you get in that car, you will be found dead in it by this time next week.'

Got in it Dean did. On 30 September, he left Hollywood for the Salinas races, which were scheduled for the weekend. Because the 550 was brand new and he needed acclimatising, he decided not to tow the car with the Ford Country Squire, but to drive it himself. Preparation had not gone much beyond having George Barris, a Los Angeles hot-rod craftsman, paint the legend 'Little Bastard' on the Porsche's tail. Dean's passenger was his dedicated Porsche mechanic, Rolf Wütherich. In proper celebrity fashion, the photographer Sanford H Roth, on assignment for *Collier's* magazine, followed the Porsche in convoy in the Ford station wagon.

Overleaf: The photographer Sanford H Roth, on assignment for *Collier's* magazine, was in the convoy led by James Dean through the California desert. In this way, the short, but unforgettable, relationship of James Dean with his Porsche was meticulously documented.

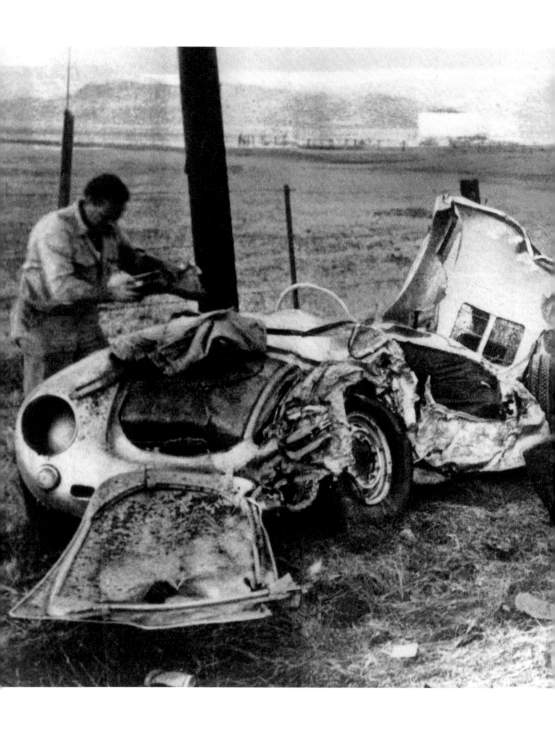

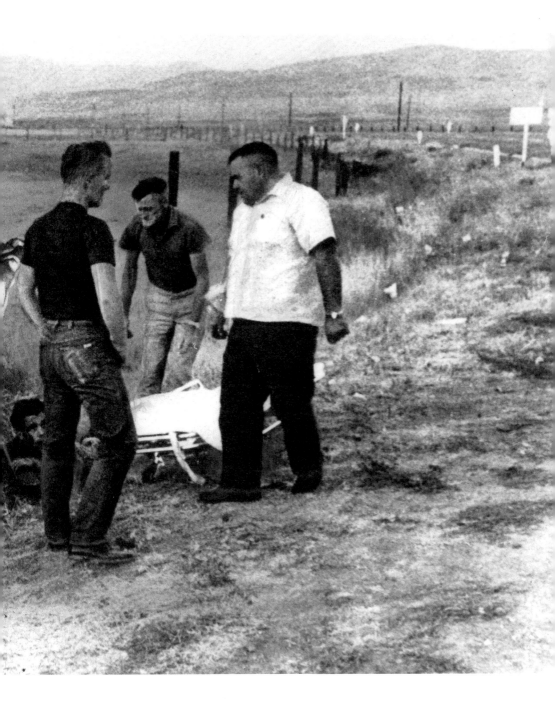

The route was north on the Golden State Freeway towards Bakersfield, where Dean was given a speeding ticket. He was doing 65mph in a 55mph zone. Then the Porsche and the Ford wagon bypassed built-up Bakersfield and followed the well-known racers' route to Salinas on Route 466 via Paso Robles. Dean was driving fast, overtaking slower traffic en route. As he approached the junction of Route 466 and Route 41 near Cholame, a 1950 black-and-white Ford Tudor saloon made to turn left and crossed the centre line …

Dean's Porsche was estimated to be travelling at 85mph when it hit the big Ford head-on. The fragile Porsche was mangled and the heavy Ford Tudor was pushed an estimated 39 feet from the point of impact. Roth, arriving about ten minutes later in the lumbering Ford wagon, took photographs of the crash scene: the Porsche had flipped and landed back on its wheels with Dean still trapped inside. Wütherich was thrown clear and found lying on the hard shoulder by the arriving California Highway Patrol. At 6.20 Dean was declared dead on arrival at the Paso Robles War Memorial Hospital. He was twenty-four.

The driver of the Ford was twenty-three-year-old Donald Turnupseed, a student at California Polytechnic, who was only bruised by the crash. Afterwards, he is reported to have hitchhiked home. It was the first Porsche celebrity crash and contributed significantly to Porsche's reputation for speed and metaphysical danger. For the rest of his life, Turnupseed was haunted by the calamity and, apart from a single newspaper interview after the crash, refused any public comment. He died in 1995. Wütherich died in a car crash all his own in Kupferzell, Germany, in 1981.

A ghoulish fascination still surrounds the crash and its circumstances. Dean's remains can be found in Park Cemetery in Fairmount, Indiana. The Porsche's remains, however, became part of a circus with its dismembered parts being treated with the reverence of medieval relics, possessed of magical properties and able to confer benefit or hurt on those who touched or possessed them. George Barris, the Los Angeles hot-rodder who had painted 'Little Bastard' on the tail of Porsche 550-0055, bought the wreckage, minus the engine and transaxle acquired by specialist

Porsche collectors, and used it in a macabre series of public exhibitions beginning in 1956. After being shown at a road safety exhibit in Miami in 1960, the wreck of the Porsche disappeared and has never been found.

Meanwhile, the Cholame junction where Dean's Porsche hit Turnupseed's Ford has been remodelled to make sight lines safer. The photographer Sanford Roth died in Rome in 1962 while working on the set of the movie *Cleopatra*. Roth's archive of James Dean photographs, which established the dead star's iconography, was acquired by a Kobe businessman called Seita Ohnishi, who also built the stainless-steel memorial at the California crash site. On Dean's grave in Indiana there is an inscription from Saint-Exupéry that says: 'What is essential is invisible to the eye.'

Possibly, but in 2012 a Porsche 550/1500 RS similar to Dean's was sold at the Amelia Island auction in Florida for $3.685m.

JACKSON POLLOCK 1956

The New York School of drinking

To a degree that may have affected the balance of Jackson Pollock's mind, or, at least, his commitment to drinking, 'Jack the Dripper' was an invention of the US media who, after 1945, acquired an appetite for a homespun American artist-hero, to counter the undermining continental malaise of 'Modern Art'. The Holy Writ of Modern Art had been laid-down in New York when the Museum of Modern Art (MoMA) was founded in 1929. Native art was more or less ignored: MoMA was full of imports and had a commitment to European sophistication that, if they had known or cared about it, might have alienated the vast US continental hinterland.

It is a truism that the formal narrative of post-war American painting has Abstract Expressionism front and centre and many Abstract Expressionists were, like Mark Rothko and Barnett Newman, for example, Jewish exotics who originated from beyond the Pale of Settlement. So too were the critics who championed them. So, a fearless and tough boy from the cowboy country of Cody, Wyoming, was a happy invention. His rise from dirt farm, lumberjacking and jumping Oklahoma freight trains to New York salon satisfied many of the demands of celebrity's arc. Of course, Pollock's gloriously anarchic drip-paintings and his loutishly rambunctious way of life as a heroic drunk-depressive had little potential to placate suburban anxieties about national decorum and mollify ripening xenophobia.

Still, for a while, the pseudo-event that was Jackson Pollock held good and made splendid copy. He was rebarbative and argumentative. His school years were a 'damnable hell' and he

was expelled. He did time in jail. He once said 'people have always frightened and bored me'.

In 1943 the collector and gallerist Peggy Guggenheim put him under contract to her Art of This Century gallery. MoMA bought its first Pollock in 1944. In 1945 Pollock married the painter Lee Krasner and they established themselves in East Hampton, a sophisticated Long Island resort. Six years later, *Life* magazine devoted a major feature to him and asked, rhetorically, if Pollock was America's greatest painter. In 1950 Hans Namuth began a series of superb documentary photographs that further lionised Pollock and helped to give the world the concept of 'action painting'. Pressure on the artist increased and so too did his drinking.

By 1956 Pollock was dissipated and spent: a stellar reputation was in decline. Even his champion, the art critic Clement Greenberg, said: 'Jackson knew he had lost the stuff'. Lee Krasner had left him and biographer Jeffrey Potter described him as going around in a 'death trance', although this might have been confused with an alcoholic stupor. He did not 'drip' at all for the first half of 1956, but compensated by doing a great deal of brawling and drinking. A favourite haunt was Jungle Pete's on Fort Pond Boulevard in East Hampton, near his and Krasner's cottage at 830 Springs Fireplace Road on Accabonac Creek in the hamlet of Springs. He was known in the area as boorish and aggressive and nasty when drunk. People would buy him drinks just to see what stupid thing he would do next.

Indeed, this reputation had preceded him in Manhattan where he was a regular at the Cedar Street Tavern on University Place, a haunt of the Beat poets – called 'know-nothing Bohemians' by the neoconservative pundit Norman Podhoretz – and their various pilot fish, including the great painters. Allen Ginsberg, Gregory Corso, Jack Kerouac and Frank O'Hara could all reliably be found here. Kurt Vonnegut uses the Cedar as a meeting-place for artists in his novel *Bluebeard*.

Here Pollock was able to engage in famously aggressive misbehaviour with fellow artists. Standards of misdemeanour were competitive: Kerouac enraged management by pissing in an ashtray. As his reputation grew, students would arrive at the saloon and

want to touch Pollock as if he were a magic charm dispensing occult favours. Yet his behaviour and moods deteriorated. According to Fred and Gloria McDarrah in *Glory Days in Greenwich Village* (1966), Pollock was eventually banned from the bar after he ripped a lavatory door from its hinges and threw it at Franz Kline. The puerile competitive culture of these convivial New York School painters may be inferred from a remark Willem de Kooning made after Pollock's funeral: 'It's over. I'm number one'.

Added to the pressure of expectations, the torment of his fame and the requirement it brought to be forever productive, Pollock had anguished relationships with the dominant women in his life. Lee Krasner enjoyed in her own right a sound critical reputation as a painter (she is one of the few women to have been given a full-scale MoMA retrospective). She was also a scrupulous, perhaps even exigent, critic of her husband's work. At the time they met, Pollock was only just emerging from the tutelage of Thomas Hart Benton, a folksy figurative painter with a regional sensibility. With Krasner, Pollock became a metropolitan celebrity and the ultimate embodiment of that High Modern ideal: the Dionysiac abstract artist. With Krasner, he enjoyed a fair attempt at contented domesticity. He enjoyed griddlecakes with bacon and maple syrup for breakfast and Krasner said he was 'very fastidious about his baking – marvellous bread, cake and apple-pies. He also made a great spaghetti sauce', according to Robyn Lea in *Dinner with Jackson Pollock*.

Ruth Kligman entered his life as Krasner exited. A one-time Seventh Avenue model with ambitions to enter the New York art scene, she was sent by a painter friend to the Cedar Street Tavern, holding a paper map of the establishment with Jackson Pollock's favourite bar stool helpfully indicated. Boldly, she made her introduction. Soon, she was his mistress.

His very last painting was made for Ruth Kligman in July 1956. Known as *Red, Black & Silver*, it is used on the jacket of the US edition of Kligman's contentious 1974 autobiography, *Love Affair: A Memoir of Jackson Pollock*. Kligman, who died in 2010, was a 'muse' who acquired, besides her infamous Pollock, more than seven hundred pictures by Kline, de Kooning and Warhol.

Make a Date with a "Rocket 8"!

"88"

THE BIG NUMBER WITH THE NEW LOW PRICE FOR 1950

The hottest number on the highway—
the most talked about car in America—
that's the famous Oldsmobile "88"!
Now at an even lower price for 1950!
"Rocket" Engine action—most thrilling ever!
Futuramic styling—fleet, smart, distinctive!
Whirlaway Hydra-Matic*—superbly smooth!
Now all yours at the lowest cost ever!
Take a demonstration drive tomorrow.
Just call your Oldsmobile dealer and . . .
make a date with a "Rocket 8"!

Compare it with any other car on the road
for performance—for driving ease—
for *value.* You'll be dollars ahead when
you rocket ahead in Oldsmobile's "88"—
at 1950's new low price!

**Whirlaway Hydra-Matic Drive, at reduced price, now optional on all Oldsmobile models.*

A General Motors Value

OLDSMOBILE

Red, Black & Silver has its own convoluted history, almost a miniature of Pollock's own baroque life story. Once only given the status of 'Attributed to Jackson Pollock' it has, after a campaign by the Kligman Estate trustees, been accepted by the Pollock-Krasner Authentication Board. This, on the basis of a polar-bear hair, identical to the polar-bear rug in the Kligman-Pollock household, being found embedded in the paint. While in her 1974 biography Kligman makes no mention of the episode, in later life she insisted that as soon as she arrived in what had hitherto been the Krasner-Pollock house, and installed her clothes in the wardrobe, she told Pollock: 'Show me how you make a painting', and *Red, Black & Silver* was the result.

On the night of 11 August 1956 Pollock and Kligman drove to a concert, or to a party, accounts differ, taking a beauty parlour assistant called Edith Metzger with them. Pollock's car was a light blue Oldsmobile Rocket 88. The Oldsmobile ads, written by a young Elmore Leonard, had a copy line that said 'Make a Date With a Rocket 8'. The 'Rocket' engine, in fact a perfectly ordinary, if large, Detroit V8, suggested the popular enthusiasm for space adventures. With melodrama characteristic of the age, Golden Rocket, Jetstar and Starfire all appeared as nameplates on related Oldsmobile models.

The aggressive, pouting open grille was suggestive of jet propulsion, or so the ads said. Certainly, with its enormous 303 cubic inch engine and a relatively small body, it was one of the fastest cars of its day, the winner of the 1950 Carrera Panamericana road race. And it was presented as a self-consciously advanced product to gratify consumers who wanted, vicariously, to enjoy rocketry. Behind the trailing edge of the front wheel arch there was a bold chrome legend that said 'Futuramic'. The four-speed Hydramatic transmission, meanwhile, articulated Oldsmobile's commitment to 'simplified driving'. Notably, the Oldsmobile inspired what might be the very first rock'n'roll number, *Rocket 88* by Jackie

Oldsmobile's advertising agency encouraged customers to 'Make a Date with a Rocket 8'. Indeed, the car made many friends, inspiring Jackie Brenston and his Delta Cats' *Rocket 88*, perhaps the very first rock'n'roll record.

Brenston and his Delta Cats which was recorded, with feedback and buzz guitar, in Memphis in 1953. Jimmy Liggins and His Drops of Joy's *Cadillac Boogie* has a similar claim. What's certain is that car nameplates fuelled the imagination of early rock'n'rollers. But it was a world of fugitive identities: the Delta Cats were also known as Ike Turner's Kings of Rhythm, Brenston himself being Turner's saxophonist.

Pollock had been drinking all day when he slid into the Rocket 88's driver's seat. At 10.15 he lost control of the car at a gentle curve on the open, tree-lined road. He was doing an estimated sixty to seventy miles per hour. The car left the road, hit some trees and flipped. Pollock and Metzger were killed, but Kligman was thrown clear and survived, quite literally, to tell the tale. The crash occurred only a mile from Pollock's home, but there was enough time for Metzger to start screaming 'Stop the car! I want to get out!' Quite unnecessarily, Kligman added that Pollock had his foot on the floor and was 'speeding wildly'.

With a symbolism that perhaps only Pollock's several Jungian analysts could decipher, Kligman sent her twin sister, Iris, dressed in facsimile, to the funeral. After Pollock's death, Kligman promptly started an affair with Willem de Kooning. He said, using a favourite figure of speech of draughtsmen, she 'really puts lead in my pencil' and did a painting of her called *Ruth's Zowie*, referring to the gasp of astonishment she made on seeing the picture. Franz Kline, alluding to her busy social life called her 'Miss Grand Concourse'. The poet Frank O'Hara called her 'Death Car Girl'.

Krasner received the call about the accident in Paris. Returning to New York to assume the role of Artist's Widow, which the critic Harold Rosenberg elaborated on with some wit and much precision in a 1965 *Esquire* essay called 'The Art Establishment'. Krasner now became 'the official source of the artist's life story, as well as his private interpretation of that story ... The result is that she is courted and her views heeded by dealers, collectors, curators, historians, publishers, to say nothing of lawyers and tax specialists'. Accordingly, Krasner, the wife once spurned, but drawn back by tragic history, was dismissive of Ruth Kligman and sceptical of her claims to true intimacy with the dissipated master. She told

Vanity Fair that Kligman's memoir should really be called 'My five fucks with Jackson Pollock – because that's all there were.'

The crash scene, showing the upturned car, was highly publicised and helped confirm the popular notion that artists are born under Saturn and that heroes must die young. And, in what was a bad year for him, creatively speaking, Jackson Pollock's reputation as a great American painter was firmly cemented. The bad boy, the Death Car Girl and the wounded wife became history.

In Ruth Kligman's *New York Times* obituary, there is a story about Franz Kline talking to her in the Cedar Street Tavern about the travails of being a painter. 'They think it's easy', Kline said. 'They don't know it's like jumping-off a twelve-storey building every day.' Pollock did not have a tall building, but he had a lofty reputation, a drunken depression, pushy, avaricious dealers in New York and women haggling in the back of his car while the true mentor, his wife, was away in Europe. And he was driving too fast. The dealer Betty Parsons once said that Pollock was born with 'too big an engine inside him'. There was too big an engine in his car as he spun out of control. In every respect, Jackson Pollock could not slow down. He was dead at forty-four.

DENNIS BRAIN 1957

Uncertainty and untidiness intrude

The French horn has always been a very sophisticated instrument, unlike the Triumph TR2, which was rather crude.

Dennis Brain's TR2 was painted apple green and registered SXX 3 in June 1955. The horn had its origins in the simple hunting bugle, but valves of increasing complexity were added during its evolution and these allowed for ever-greater chromatic range. The Triumph, on the other hand, had very little subtlety and made a stirring noise. With the necessary improvisations and economies of post-war austerity, it was based on an old Flying Nine chassis, but fitted with more modern Triumph Mayflower suspension and a robust Standard Vanguard engine. When a BRM engineer tested a prototype, its nose-heavy handling made it what he called a 'death trap'. It was rapidly re-engineered, given an even more powerful engine, and launched at the Geneva Salon de l'Automobile of 1953.

For all its crudity and bad manners, the TR2 was one of the great British sports cars of the 1950s – a sleeves-rolled-up, chunky forearms kind of car, which provided a pleasing, one-dimensional sort of performance for men using hair-grooming products. Visually, its body by Walter Belgrove was one of those designs by which its decade (perhaps even its century) will always be remembered: bluntly uncompromising, but nonetheless seductively charming. When someone with access to the true nature of brain chemistry analyses what 'sports car' means, the Triumph TR2 will be an important part of the evidence and the solution.

If straightened out, the modern French horn would be almost sixteen feet long. The great virtuoso of the French horn was Dennis

Brain who is said to have blown a perfect note aged only three – a creation myth if ever there was one. Similarly, Vasari said that a youthful Giotto was able to draw a geometrically perfect circle without mechanical assistance. Whatever the mythology, Brain enjoyed the sheer pleasure of handling the instrument, preferring a mixture of mellow, old brass with modern valve gear. 'One goes for compromise,' he said, but in fact he did not.

Brain came from a family of horn players. His father, Aubrey, had been the first person to record a Mozart horn concerto. The young Dennis made his first concert appearance in 1938. The horn repertoire is small: four Mozarts, two Haydns and one Brahms are the great masterpieces, although during Brain's career significant new works began to appear, including Benjamin Britten's *Serenade* which he eventually worked on. Brain was soon master of them all and needed diversions besides his music. 'If I live to be a hundred,' he told Roy Plomley when appearing as the castaway on the BBC's *Desert Island Discs*, 'I shall have to play the same works.' Maybe such constraints are damaging to a virtuoso instrumentalist. By every account, Brain was an inspirational performer, a musical alchemist adept at turning brass into gold. He was the only member of the Philharmonia whom the haughty Herbert von Karajan addressed by his first name.

In the event, this feared fugue of repetition never had time to develop because a crash intervened and one of Britain's, indeed the world's, greatest horn players was dead aged just thirty-six. Did he end his life in an agony of tedium, or was he exhilarated by his success? Was he careless or exuberant? His *Desert Island Discs* appearance reveals an individual of some whimsy. Brain told Plomley that he liked making pancakes and mending electrical fuses, but, best of all, he liked 'motoring' because 'one travels quite a bit'. And in those forgotten days of empty roads and unrestricted speeds, 'motoring', a term that could then be used without irony, offered clear benefits over public transport. A Triumph TR2 would have been an instrument of liberation on the empty dual carriageways of 1957.

But for a celebrated musician to take an interest in cars was disconcerting. Slightly aghast at Brain's confession, as if the

Archbishop of Canterbury had admitted playing full-contact five-a-side, Plomley asked if he took his motoring at all seriously: 'rallies, that sort of thing?' rather as he might have asked the Archbishop if he liked showering with men. No Brain did not, but nor did he disavow his passion for cars and the culture surrounding them. The extent to which the automobile had entered imaginative life in the 1950s can be inferred from its influence on this virtuoso musician alone.

Indeed, setting aside The Bible and Shakespeare, he chose for his Desert Island Reading matter 'an inexhaustible supply of back-numbers of motoring magazines'. Having mastered the, admittedly small, horn repertoire, Brain liked to keep copies of *Autocar* on his music stand. Maybe it was here, while distractedly puffing his way through Mozart, that he read the original road tests of the racy Triumph TR2. The pictures would have been in that nice soft-focus gravure.

The archive recording of *Desert Island Discs* reveals an amiable and relaxed-sounding individual, although Brain had a reputation among his peers for being slightly careless. He also had a cavalier aspect and was not without ego, but no one disputed his mastery of the music. His fluency was legendary. And Brain soon became a public figure, unprecedentedly so for a mere horn player. James Morris, covering the ascent of Everest for the *Times* in 1953, wrote: 'Marching through Sherpa country, it did not in the least surprise me listening to the radio one day to hear Dennis Brain playing the Mozart Horn Concerto, to find a whole posse of film men bursting through the tent flaps to hear him too.' When news of Hilary and Tenzing's successful ascent of Everest reached London, Brain was playing at the Coronation of Queen Elizabeth II.

Speed fascinated him, perhaps providing a source of adrenalin which music did not stimulate. Brain never actually flew during his service in the RAF, performing in morale-raising concerts at the National Gallery and elsewhere, but a colleague later said of him: 'He flies in that sports car of his!' The producer, Walter Legge, recalled Brain driving him over a wintry Saint Gotthard Pass in a huge and unwieldy Hudson. Legge said: 'It was only when driving that Dennis shed his irresponsible endearing boyishness.'

THE TRIUMPH SPORTS

The Triumph TR2, while not an accurate instrument, provided 'commendably high performance' in its road test, according to the monthly *Motor Sport* magazine, perhaps one Brain had read when he tired of the weekly *Autocar*. Its 1991cc four-cylinder engine was undersquare and provided ample accelerative torque and would power the car to a top speed of about 107mph, astonishing for its day when a family saloon would struggle to reach seventy. It had revolutionary Girling disc brakes at the front which were described as 'excellent' and several amusing extras including self-parking wipers and, *Motor Sport* possibly being ignorant of the Brain connection, 'blatant two-tone horns'.

Every well-designed detail of the TR2 satisfied the Jungian archetype of 'British sports car'. There were wire wheels and an athletic stance. The flat, raked screen suggested purposefulness. There was no frivolous decoration. Instead, it looked a little like a stripped-back racing car. The TR2 also had sporty bucket leather seats, with contrasting piping, which *Motor Sport* found 'not particularly comfortable'. To add a measure of functionalist lightweight purpose, the TR2's dramatically cut-down doors had their catches released by dangling leather cords rather than handles. Pendant pedals doubtless made heel-and-toe gear changes rather awkward, but perhaps not for a driver with Brain's superb coordination.

Motor Sport was impressed by the muscular performance of the Triumph, but had some reservations about certain aspects of its road behaviour. The unassisted steering was heavy while parking, but became 'almost too light at speed', even in this nose-heavy car. This same steering was also found to be a little 'dead' in its responses, meaning, like a corpse, it was not quick to respond to stimuli. Nor was the TR2 much of a virtuoso in road-holding and handling: 'corners can be taken fast, but a tendency to dart about spoils absolute precision, which vagueness of the steering does nothing to mitigate. If provoked, the back wheels will break away

An apple green 1955 Triumph TR2 identical to the car that horn virtuoso Dennis Brain crashed outside the de Havilland factory in Hatfield on 1 December 1957. This classic English sports car of the fifties had muscular performance, but treacherous handling.

in a conventional tail-slide.' And 'when trying hard' *Motor Sport* cautioned, 'uncertainty and untidiness intrude'.

So these were the mixed bag of characteristics defining Brain's sports car. What does it tell you about his tastes? Maybe his playlist from *Desert Island Discs* reveals something of his character. There are the big classical standards, Richard Strauss's bombastic *Ein Heldenleben*, for example, but also more quirky choices: Moritz Moszkowski's *Guitare* is a rarity and nor have many of Roy Plomley or his successors' guests chosen Liszt's *Gnomenreigen*. But Brain also played Frank Sinatra's *You Go To My Head*, Mitch Miller and His Orchestra's *Horn Belt Boogie* and Tommy Dorsey's *Well, Git It!* Before the advent of Pop, these would have seemed idiosyncratic, indicating a heterodox interpretation of self, a personal estimate of an individual musician who did not want to be thought of as only a classical soloist.

On 1 September 1957, Brain was driving back to London from Edinburgh where had he taken part in an orchestral concert, conducted by Eugene Ormandy, in which Tchaikovsky's *Pathétique* symphony formed the centrepiece of the programme. On arrival in London, he was booked to record a Strauss capriccio with Wolfgang Sawallisch, who that year had become the youngest conductor at Bayreuth. Wagner aside, Sawallisch was something of a Strauss specialist.

The distance from Edinburgh to London is about four hundred miles. Traffic was far lighter in 1957 than it is today, but Brain's apple green TR2 had those uncomfortable seats, a hard ride, was noisy and the weather protection was primitive. As he drove, was he rehearsing his Strauss piece from memory? Certainly, the TR2's lo-fi radio would have been uselessly inaudible and crackly at speed. Even an enthusiastic driver would have been suffering some fatigue. In any case, Eugene Ormandy (with whom he was scheduled to play the following week) had said how tired Brain had been looking. In Edinburgh, he had fallen asleep during rehearsals.

Perhaps careless or, becoming bored, Brain decided to test the car a little bit. Possibly the blatant two-tone horns had been used. On the limit, the TR2 was known to be a handful. And in heavy rain that dead steering would not be a helpful corrective to a tail slide.

Near the old Art Deco De Havilland Aircraft factory at Hatfield, on the A1 where it meets Wellfield Road, less than twenty miles from the family home in Frognal, Hampstead, Brain's TR2 left the road and hit an oak tree, killing him instantly.

A couple driving north at the time of the crash described seeing the headlights appear and disappear as the car rolled. And then extinguished permanently. The impact was so heavy that the car's leaf springs were embedded in the tree. The horn was thrown out, but Brain was not. A certain untidiness had intruded.

Brain was so busy he even missed his own father's funeral in 1955. He hated trains and drove himself whenever he could, racking up 36,000 miles in one year alone. Reflecting on this punishing concert schedule, Brain had said his Desert Island luxury would be 'not taking a French horn' (although he actually chose a 'typewriter and paper' so as to catch up with all the letters he had never written, but had no ambitions to write a book).

Brain's instrument, a Model 90 manufactured by Alexander of Mainz, was restored by Paxman's of Covent Garden and since 2001 has been in the collection of The Royal Academy of Music at York Gate in London. Thus restored, the instrument no longer bears the damage it sustained in the crash.

On Brain's headstone in Hampstead is the Declamation from Hindemith's Horn Concerto; 'My call transforms/The Hall to autumn-tinted groves/What is into what/Has been.' On the day after his crash, the audience at the BBC's Promenade Concert in The Royal Albert Hall was asked not to applaud in his memory. The organisers replaced the programmed Strauss with Schubert's 'Unfinished Symphony'.

MIKE HAWTHORN 1959

Thank God that's over

If he were still alive, Mike Hawthorn – who won the 1958 Driver's World Championship wearing a bow tie at the wheel of an Italian racing red Ferrari 246 – would still today be a mere eighty-eight. His image is forever the smiling, debonair, tousle-haired blond with the suggestion of a pint of bitter. Despite the Ferrari connection, you think of him as British Racing Green. Perhaps with a top-note of Brylcreem.

But he died, aged twenty-nine, in an absurd motor accident. According to police records, his British Racing Green Jaguar 3.4 Mark I – VDU 881 – had exactly 12,028 miles on the clock when he lost control on a slick Hog's Back, the notorious blind bend on the A3 south of Guildford, a point you reach just as you escape the gravitational pull of London and approach the bosky Surrey Hills. This master of international motor sport was travelling too fast.

Spinning, the car hit a bollard, bounced off a Bedford truck, and then ended its journey and his by demolishing a tree. The nearside front door impacted first and pushed the sill beyond the centre-line of the car. Engineers examining the wreck found the car was in third gear and the police estimated it had been travelling at 80mph. Just days before he crash, Hawthorn, who had never been seriously hurt in an actual race, had told a reporter: 'The roads are getting proper death traps. The racetrack is safer than the road between London and Farnham.'

It was around midday on 22 January 1959, and Hawthorn was on his way from the Tourist Trophy Garage in Farnham to the Cumberland Hotel at Marble Arch, where he was due to have a

meeting. The garage had been built by Hawthorn's father Leslie – an engine-tuner from Yorkshire. The Farnham site was chosen for its convenient location close to the Brooklands circuit, the spiritual home of British motor racing.

In his autobiography, *Challenge Me the Race*, Hawthorn describes how early experiences at Brooklands made him passionate about racing cars: 'The first motor races I ever saw were at Brooklands. I was only a very small boy, but to me it was heaven to watch the cars thundering around those towering cliffs of concrete … to wander along the lines of brightly coloured cars in their stalls in the paddock, to jump as an exhaust snarled suddenly and to sniff the aroma of Castrol oil.' The romance was dramatic and uncomplicated.

The police report says traffic was light on the day of Hawthorn's crash, although there was heavy rain and strong, gusty winds. What seems to have happened is that at some point early in the journey, Hawthorn encountered team-owner and Stirling Moss's patron, Rob Walker, who was driving from Somerset to London in a fabulous *Flügeltürer* Mercedes-Benz 300SL. They made eye contact. Hawthorn gave him a cheery two fingers and an improvised race followed.

Rob Walker was evasive about the precise circumstances: 'I suddenly saw the back of his car break away. He was thirty to fifty yards ahead of me then. I was very surprised because I could not see any reason for it at all. It was only a very slight break away. I did not think much about it … it was Mike Hawthorn and such a thing was quite normal for him. I expected him to correct it. He did not slow at all and to my impression the speed increased all the time. The tail went further out to the point of no return when even Mike Hawthorn could do nothing about it.'

An improvised race on unrestricted roads may have been normal behaviour for the racing fraternity in 1959, but Hawthorn's circumstances were abnormal. Disenchanted, he had abandoned

The debonair Mike Hawthorn, Britain's first World Champion racing-driver, with a pair of 1750 Alfa Romeos outside his Tourist Trophy Garage, in Farnham, Surrey. His last, uncompleted, journey was from here to London's Cumberland Hotel.

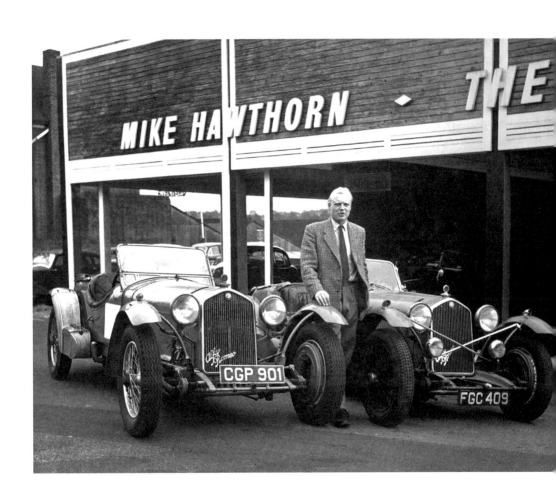

the sport that made him famous. He had also been diagnosed with a terminal kidney condition, giving him perhaps only months to live. Perhaps in these circumstances you do not lift off. Perhaps you choose to brake late. Possibly, you no longer care. The *Daily Express* headline announcing his death read: *Mike's Last Mile*.

This is an elegiac story full of tragedy. Hawthorn had only narrowly claimed the 1958 World Championship. He won only one Grand Prix to Stirling Moss's four, but his five second places gave him the points to secure the title, which he duly did at the Ain-Diab circuit in Casablanca, Morocco. Motor racing, like most sports, provides many metaphors of life itself: Mike Hawthorn was not always the fastest driver, but his reliability got results.

In fact, Hawthorn's actual race stats in no way account for his coruscating reputation: we have to understand his smile and his personality, the very model of the raffish sportsman, to appreciate that. Hawthorn could claim just three Grands Prix wins and one Le Mans victory. Then after Morocco, he promptly announced his retirement, traumatised by the fiery death of his close friend Peter Collins, the man he called 'mon ami mate', directly in front of him at the Nürburgring.

These were days when motor racing was as dangerous as it was romantic ... and it was very romantic indeed. Hawthorn had already been shocked by Luigi Musso's death at Reims in July and by his father being killed in a road-going Lancia on the way to an event at Goodwood. Hawthorn had also been upset when he accidentally drove his Ferrari over the eager pet boxer dog who leapt up to meet him on return to the Farnham garage.

Hawthorn was recognised as fearless, but towards the end of his racing days a grim and fretful fatalism had overtaken him. The great motor-racing historian Doug Nye said: 'At this time, Mike was bitterly fulfilling his commitments. "Thank God that's over", he would snarl as he stepped out of a hot and stinking car. "That's one more race I won't have to do again".' The sensitive side of his complex

Previous pages: Hawthorn's British Racing Green Jaguar was registered VDU 881 on 3 October 1957. It was the 806th right-hand drive Jaguar 3.4 Mark 1. Hawthorn used the car on both road and track: here he is at Silverstone, racing Tommy Sopwith in another Jaguar.

nature was revealed in his autobiography and in the charming motor-racing fictions he wrote for young boys, stories about a driver Carlotti Smith and his evolving career.

Jaguar had been part of Hawthorn's short and glamorous life. He had won Le Mans '55 in a beautiful D-Type, but in ugly and controversial circumstances: an inexplicable braking manoeuvre by an American driver called Lance Macklin in an Austin Healey caused a collision with Pierre Levegh's Mercedes which was launched into the spectators, killing more than eighty of them in motor-racing's worst accident. The Mercedes-Benz team promptly withdrew from the race. Hawthorn pitted in distress and intended to retire, but Jaguar's team manager Lofty England insisted that he drive on. He did and Jaguar claimed a sour victory.

The French press attacked Hawthorn for what it regarded as callous careerism. Back home, sections of the English press also vilified their hero for being excused National Service on health grounds while still fit enough to race, travel and date photogenic models. Perhaps the gods noticed and returned to visit Hawthorn, Guildford and the A3.

Hawthorn's Jaguar 3.4 Mark I was one of the great cars of its day, favoured by the better sort of criminal as a getaway car. It was the first modern Jaguar, although such terms are relative. A modestly sized and nicely proportioned sports saloon, it was the first Jaguar with unitary construction. There was wishbone front suspension and at the rear was an abbreviated version of the D-Type's underpinnings with weird, inverted semi-elliptic springs that worked like trailing arms. Rear track was fully 4.5 inches less than the front, giving the car a strange aspect. This was good for high-speed stability, but made for shocking understeer. Hawthorn had modified his own car with spacers on the rear axle, which increased the track, but, perhaps, reduced both the stability and that same understeer. Next thing you know …

There can be few expressions more redolent of 1959 and the bow-tie era than 'sports saloon'. The term suggests both cosy architecture and brisk athleticism, together with a hint of winking and nudging raciness and a ghost of cigar smoke. On the news feed in my office I can see a headline that says: 'Cape Town opens

first gay mosque.' I doubt whether sports-saloon drivers of the day would have understood that.

Hawthorn's Surrey was a world of pine-scented private roads, gin and tonic, loose-fitting underwear, approximate dental hygiene and amiable bigotry. Hawthorn's address was Greenfields, Folly Hill, Farnham. His neighbours perhaps did not much discuss abstract art or modern jazz thereabouts. John Coltrane? Jackson Pollock? No, not really. Few of the assumptions of prosperous middle-class life in Farnham had been much interrogated by 1959. Four years before The Beatles' first LP, it was the optimum moment for dashing racing-drivers to be cultivated here. And it was the optimum moment for creating interesting cars such as the Jaguar Mark I that crashed on the Hog's Back.

A twelve-year-old Patrick Head, later the Technical Director of the Williams Formula One team during its years of pomp, was sick, off school and in bed in late January 1959. His parents were friends of Hawthorn, who visited the young Patrick to cheer him up. Head recalls he was making a Kiel-Kraft balsa-wood flying model aircraft and Hawthorn sat on his bed, drinking a scotch and soda and chatting about cars and 'planes. The World Champion offered young Head (a) a little whisky and (b) the promise of a ride in his de Havilland Chipmunk, a trainer used for aerobatics, the following weekend. But that was a weekend he did not live to see. Nearly sixty years later when I discussed it with Patrick over lunch at Goodwood, he was still talking about the sense of loss and disappointment Hawthorn's tragic death and broken promise had caused. It was a schoolboy's personal loss, but one that the whole nation felt.

Lofty England himself examined the Jaguar and found that the steering was functioning accurately, the tyres properly inflated and the brakes working. VDU 881 was taken back to the Jaguar works in Coventry and broken up, although its engine was sold on to the German racer, Peter Lindner. Soon after the crash, the A3 was turned into a dual carriageway.

The wreck of Mike Hawthorn's Jaguar VDU 881 on the Hog's Back near Guildford. What remained of the car, then still owned by Jaguar, was retrieved by the company. This stretch of the A3, once a notorious accident black spot, has since been realigned.

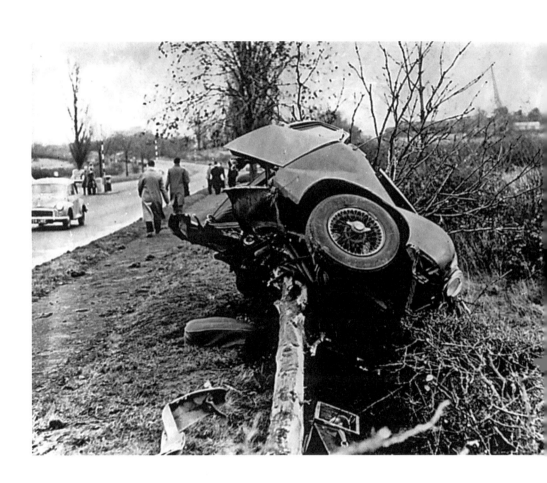

ALBERT CAMUS 1960

'What's the hurry, little friend?'

Lourmarin, on the old *route nationale* between Marseille and
Apt, is routinely described as one of the most beautiful villages
in France. It is the sort of place that appears in travel guides and
picture books. Dusty blue shutters, bougainvillea in flower baskets,
cobbled streets, terracotta pantiles. That sort of thing. Albert
Camus, the 1957 Nobel Laureate, footballer and Existentialist –
characterised by *Life* magazine as the 'action-packed intellectual',
and by the French as 'un homme engagé' – had a house here.

Incongruous, perhaps, that such a rugged and austere and
frankly fatalistic philosopher chose to live in such picturesque
circumstances. Then, maybe it is not incongruous at all: Camus
had been greatly influenced by growing up poor in Algeria. This
informed his principled morality, but perhaps also enhanced his
appetite for undemanding pleasures. Certainly, an unbending
philosophy that confronted the most disturbing enigmas of
existence offered little solace. By contrast, Lourmarin offered
a great deal. With Camus and Lourmarin, absolute honesty
met vertiginous prettiness.

As a souvenir of this strange liaison, you can find a rue Albert
Camus in Lourmarin today. It is a busy tourist passage: le Ratelier,
at 2 rue Albert Camus, is, for example, a popular pizza restaurant.
Le Ratelier did not exist in Camus's day. Instead, his preferred
restaurant was the dining room of the Hôtel Ollier. It was here
that Camus and his wife, Francine, entertained his publisher
Michel Gallimard and his wife, Janine, their house guests, for
lunch on Saturday 2 January 1960.

Gallimard's reputation was based on the haute vulgarisation of avant-garde thought. Besides Camus, authors included Jean-Paul Sartre and André Gide. Michel himself was a fine combination of leftishness and hedonism whose contribution to the publishing house was social and creative, leaving the business side of book manufacturing to a more practical brother. Still, this strategy of high-mindedness mixed with populism had made Gallimard the second largest publisher in France.

Gallimard and Camus were close: it was a personal relationship as well as a professional one. They spoke often and a recurrent conversational topic between them was Camus's distaste for long car journeys. Since a return trip to Paris was imminent, this was discussed at Saturday lunch. Camus insisted he much preferred the relaxation of the train from Avignon's old Gare Centrale (not today's out-of-town TGV stop). Cars made him nervous. Fast cars more so. It was the train that Francine Camus chose for her own journey to Paris.

Nevertheless, on Sunday 3 January 1960, Albert Camus, the Gallimards together with their daughter Anne and Janine Gallimard's Skye terrier, a dog called Floc, left Lourmarin for Paris by car. Somehow, Camus had been persuaded to travel by road. The night before, perhaps as a result of a hangover after a big lunch, Camus had been reported looking unsettled and morose when he visited the local Renault garage in Lourmarin, where he signed a copy of *L'Étranger* for its proprietor. The inscription says 'To M Baumas, who contributes to my returning frequently to beautiful Lourmarin'. This, as events showed, was an elegiac inscription. Camus would not return alive.

The car Michel Gallimard persuaded Albert Camus to travel in was a Facel Vega HK500, the most outrageous French automobile *folie*. Gallimard's car was black with a beige leather interior and he had bought it from the factory in September 1957, a detail suggestive of a special commitment to the type and, indeed, to its flamboyant créateur. The manufacturer, Jean Daninos had more than industrial credentials: he was comfortable in the creative world. Indeed, he rather sought it out. His brother was the popular humourist Pierre Daninos, author of *Les Carnets du Major*

Thompson, the story of an ancien régime Englishman's experiences coming to terms with modern French life which became Preston Sturges's film *The French, They are a Funny Race*.

The Daninos fortune was made from metal-pressing fridges and the contract supply of car bodies to the mass market: dull, but lucrative, stuff. By 1954 Jean Daninos had made enough money to start his own car company. He chose the name Facel Vega for its debut at that year's Paris Salon de l'Automobile. Facel is an acronym of the family metal-bashing business' name (Forges et Ateliers de Construction d'Eure-et-Loir), while Vega is the second brightest star in the northern celestial hemisphere. Like Camus and Lourmarin, the name Facel Vega was a nice conjunction of the matter-of-fact and the special.

The Facel Vega HK500 was a gorgeously handsome and extremely luxurious car. Its plush interior was a world away from its contemporary, the Citroën DS. Instead of plastics and modernism, everywhere was wood and leather. Every technical enhancement imaginable in the fifties was available: it was, for example, one of the first cars to be offered with a radio 'phone. In artistic terms, the Facel's bodywork was a startling mélange of French and American culture. These were, of course, the days before France had acquired a disdain for US culture. So, there was a Detroit-style wraparound windshield and plenty of chrome, there was a deeply dished steering wheel. There were even little tail fins and every other detail was artfully contrived as expressive. Aesthetically, the HK500 has more in common with a Ruhlmann chiffonier than a Cadillac.

It was an exceptionally heavy car and needed a huge imported Chrysler V8 to move its gross 4,000lbs. But, while huge, the proportions had an essentially French elegance. This strange combination of American brute force and French sophistication, deluxe *pistonnage*, attracted Picasso and Dean Martin as

Overleaf: Facel Vega was an ambitious and glamorous project by Jean Daninos who made his fortune pressing steel panels for fridges. At 4,000 lbs and with a 360hp Chrysler V8, it was exceptionally heavy and exceptionally fast. Just 489 were built; three of those cars were driven by Pablo Picasso, Dean Martin and Stirling Moss.

FACEL
VEGA

PARIS

EXCELLENCE

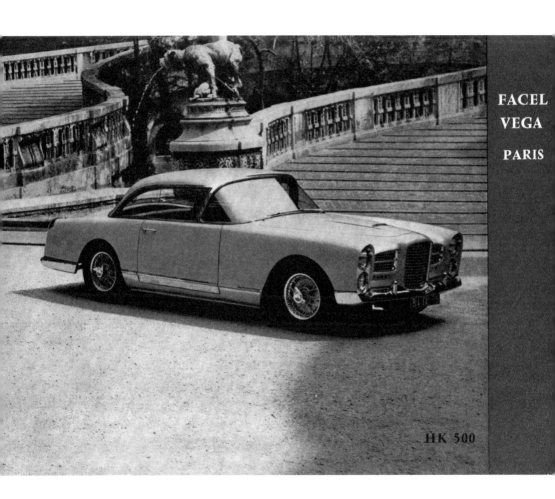

FACEL

VEGA

PARIS

HK 500

customers, as well as France's leading literary publisher.
In 1956, the year that Camus's epochal *La Chute* was published,
the HK500 was fitted with an even bigger 330 cubic inch Chrysler
'Hemi' engine. It was by an easy measure the fastest four-seater
car in the world. The American accent of the Facel Vega would
have seemed chic, not vulgar, in the Paris of the period.

Jean Daninos had a keen eye for publicity and flirted with
celebrities. He had made Stirling Moss a brand ambassador
and gave him the use of a HK500. Unlike Camus, Moss – not
unexpectedly – preferred car travel to any other form and drove
his Facel Vega across Europe to his various racing commitments,
image-building the while. Moss, familiar with these things, was
nonetheless impressed by the enormous power of the Facel.

There is a not fully researched relationship between power,
speed and sex. Jackie Collins was also the owner of a Facel Vega.
Writing to historian Martin Buckley to explain the fascination of
this car, Collins said 'Getting behind the wheel of a Facel Vega
is like having great sex – you want the moment to go on forever'.
Camus was infamous for his helpless flirtations and epic infidelities.
Did he sense in Michel Gallimard's car some of these occult erotic
possibilities? Maybe, but they turned out to be short-lived.

Facel Vega's management was aware of its own responsibilities
in selling this potent, opulent and possibly even dangerous car.
No one now knows whether Michel Gallimard ever bothered to
read the owner's manual, but its advice to drivers is like a forensic
analysis of the potential dangers of *la vie en route*:

> 'At high speed be careful:
> to hold the steering wheel with both hands except when
> shifting gears
> to keep as close as possible to the centre of the road
> not to overtake on the brow of a hill
> to reduce speed over the brow of a hill as a car might
> have stopped on the far side
> not to look at anything else but the road
> not to change the radio programme
> not to smoke'

The distance from Lourmarin to Paris on the RN7 and RN5 is a little less than 500 miles: a lovely sequence of Orange, Avignon, Lyon, Mâcon, Beaune, Chalon, Saulieu, Avallon, Auxerre, Sens, Fontainebleau and then the capital. It contains many brows and blind bends. Camus had commitments to meetings in Paris, but was in no hurry and the whole party was determined to eat well on the trip. They lunched at Orange, a quiet *ville romaine*. The first night they stopped at Paul Blanc's Au Chapon Fin at Thoissey, the sort of restaurant Michelin Rouge said, in its ineffably French hierarchy of categorisation, '*mérite un détour*' and, in the case of Gallimard and Camus, a lay-over as well. They ate foie gras, a fricassée of chicken with mushrooms and *crêpes parmentière*. Camus did not sign the hotel's *livre d'or*, but he did sign the official police registration card. It was the very last thing he wrote.

Paul Blanc later recalled that he thought Gallimard's Facel, one of two he found in his car park that night, had a worryingly worn tyre. Whether he warned his customer is not known, but continuing the journey on Monday morning, Madame Gallimard later remembered that author and publisher had enjoyed a macabre (and predictive) conversation about the advantages of being embalmed. One of these advantages being that, after their demise, the stuffed bodies could forever remain in Janine's salon for the benefit of her company. At this grisly proposition, Janine simply shuddered '*Quelle horreur*'. Distracted, perhaps, by the prospect of embalming, Michel Gallimard began to drive more quickly. Janie remembered that this unsettled Camus who said to him 'Hey, little friend, who's in a hurry?' Perhaps Gallimard slowed down.

They next stopped in another two-star Michelin restaurant, the Hôtel de Paris et de la Poste in Sens, about 116km from Paris. Michelin says this is: 'a traditional inn with a provincial atmosphere'. Nowadays, the kitchen is busy 'reinterpreting classic cuisine'. In Camus's day, it was more *cuisine de grand-mère*: bourgeois, in other words. They ate *boudins noirs aux pommes reinettes* and shared a single bottle of Burgundy.

The journey from Sens continued along dead straight roads lined with the beautiful, but intimidating, arbres de lineage. The road was quiet, but it was drizzling. Janine later recalled

that in the moments before the accident she could remember
no explosion or screech, although Michel Gallimard might have
said 'Merde!' She did recall a violent wobble and the car leaving
the road. They were near a hamlet called Petit Villeblevin, a place
of no distinction. Memory eradicated the accident itself, but the
next thing she remembered was sitting in the mud, calling for
Floc. The dog was never seen again.

Gallimard's Facel Vega hit one tree, then another, wrapping
itself horribly, and with great force, around the latter. Newspaper
photographs showed that the out-of-control car had ripped-up the
damp tarmac road surface for about 150 feet. The reports said the
debris was scattered over a 500-foot radius. Most of this debris
was on one side of the road; the hot, but dead Chrysler engine was
on the other. The only witness was a camioniste who said he had
a little earlier been passed by the distinctive car of Camus's 'little
friend' travelling at about 150kmh, evidently – despite the Nobel
Laureate's preferences – in a hurry.

The women sitting in the rear were unhurt, but Camus was
negatively accelerated through the windscreen and died instantly
of a broken neck. It took the pompiers two hours to release his
body. Michel Gallimard was initially conscious enough to ask: 'Was
I driving?' but died of a brain haemorrhage five days later. Bizarrely,
the local doctor attending the accident was called Marcel Camus.
As JG Ballard later said, there are no coincidences. But there are
deep assignments. In Albert Camus's bag investigators found a
manuscript of Le Premier homme, a school translation of Othello
and a French translation of Nietzsche's Die fröhliche Wissenschaft.
Unbearably, in his pocket was the train ticket he had intended to
use for the return trip to Paris with Francine and their two children.

What had happened? Gallimard was an experienced driver with
a reputation for speed. Jean Daninos much later claimed that his
Paris service manager had warned Gallimard not to drive on worn

Michel Gallimard's Facel Vega HK500 possibly suffered a tyre burst, left the road and hit a tree
at about 80mph, breaking apart in the process. Wreckage was spread over a 500-foot radius,
the engine being found on the opposite side of the road to the main body of the car. Gallimard's
passenger, Albert Camus, was killed instantly. Gallimard died later in hospital.

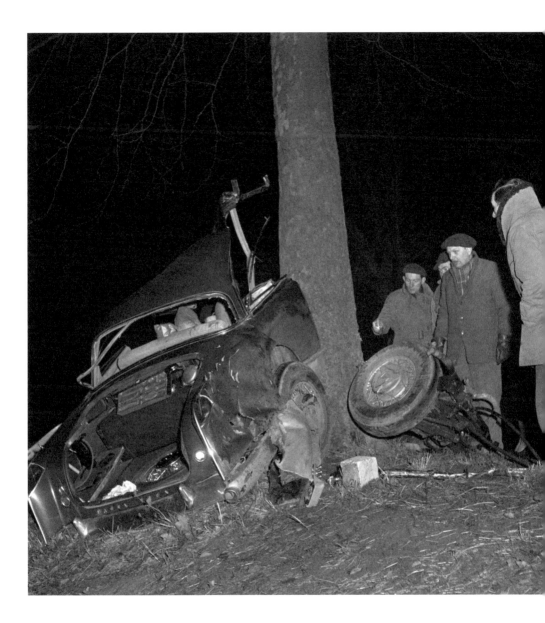

tyres and recalled the publisher saying: 'I'll change them when I get back.' An old tutor of Gallimard's, René Étiemble, prepared, in the French way, a dossier after the crash and discovered from service records that a rear wheel on the publisher's car had twice suffered seized bearings. If such a thing happened at speed on a damp road, the Facel Vega would have gone hopelessly out of control. Étiemble claimed to have warned Gallimard: 'This car is a tomb.'

The heavy HK500 was additionally liable to brake fade and its great weight led to several incidents when spokes on the handsome Dunlop wire wheels failed. These were consequences of Daninos's industrial showmanship: for all its majestic presence and divine power, the Facel Vega HK500 was not dynamically competent. The successful Belgian racing-driver Paul Frère said 'Daninos was not really an engineering man, he was more of a stylist.'

The crash was world news. André Malraux, the fabulous French Minister of Cultural Affairs, sent his *chef adjoint du cabinet* to represent *la République* at the crash scene. He was briefed to respect Camus' world view and not to allow any inappropriate religious interference or associations in the necessary processes. More practically, Daninos sent the American racing-driver, Lance Macklin, acting as a consultant to Facel Vega, to investigate the accident. Meanwhile, Camus's corpse was at rest in the local Mairie. An Algerian journalist who paid homage at Villeblevin said 'under the light of a naked bulb, he had the expression of a very tired sleeper'.

It took time for the authorities to find Francine Camus, who had been back at her teaching job in Paris for three days. She was eventually driven to Villeblevin accompanied by a howling motorcycle escort; the scene she found at the Mairie she described as something from *L'Étranger*. In 1967, the Villeblevin authorities raised a monumental fountain in Camus's memory. It is inscribed with some lines from *The Myth of Sisyphus*: 'The struggle toward the summit itself suffices to fill a man's heart.'

That a gastronomic trip of such felicity ended in a ridiculous disaster and the genuine absurdity of Camus's own death was soon noticed. A man who boldly confronted extinction and the banality of existence, but who was scared of driving fast, was killed in a

luxury car that was being driven too quickly. The *New York Times* wrote that it was a 'grim philosophical irony' that Camus should have been killed by a 'chance impact'. Had he not written that while 'there can be nothing more scandalous than the death of a child', there can be 'nothing more absurd than to die in a car accident'. The *New York Times* continued to explain that 'the central theme of his thought was the proper response of the thinking man to the plight that is posed by the gift of life'.

Camus was often vague about time. After all, his most famous lines are: 'Mother died today. Or, maybe, yesterday; I can't be sure.' The dashboard clock of the wrecked Facel Vega, in which Camus so absurdly died, read 1.54 or 1.55, people dispute. Anyway, Albert Camus is now back in Lourmarin, interred in the local graveyard. Absinthe grew over his grave at first, but was replaced by rosemary. The accent on Cemetière goes the wrong way. His old comrade and then antagonist, Jean-Paul Sartre, wrote a dark eulogy: 'The Absurd might be that question that no one will ask him now, that he will ask no one, that silence that is not even a silence now, that is absolutely nothing now.'

Facel Vega went out of business in 1964. The autobiographical novel *Le Premier homme* was only published in France in 1994, Camus's daughter being concerned that, at a time when her father's reputation was already in decline, its questionable quality might compromise remaining esteem. Jean Daninos died in 2001. In 2009, Nicolas Sarkozy proposed the Panthéonisation of Camus, that he should be re-interred under the dome of Soufflot's Sainte Geneviève, beneath the magnificent inscription 'Aux Grands Hommes'. But Camus's son, Jean, said such grandiosity would be inappropriate as a memorial to the author of *The Rebel*. So, Albert Camus is still in Lourmarin. Sometimes, people who visit the grave are reminded of that novelist figure in *The Myth of Sisyphus* who committed suicide in order to draw attention to his work. Others feel that life is absurd. Death even more so.

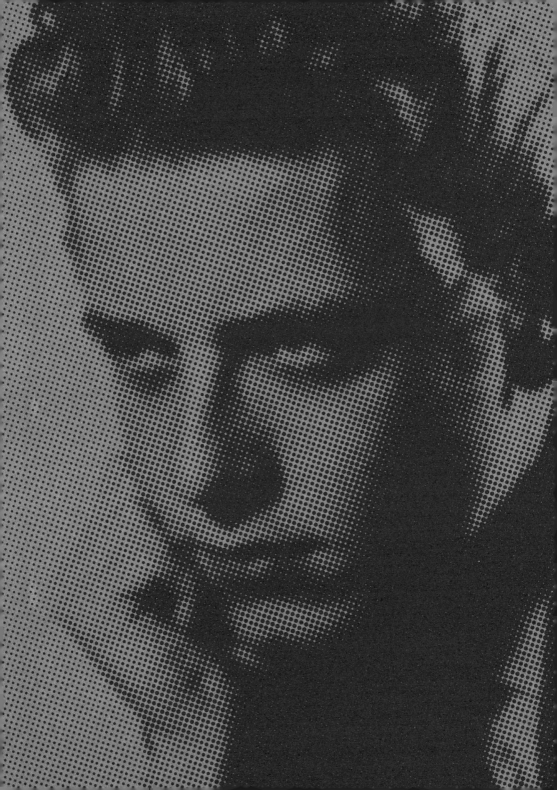

EDDIE COCHRAN 1960

Get me that girl and we'll go ridin' around

Eddie Cochran, with his greasy cow's lick and eroticised postures and catchy tunes, was one of rock's first real auteurs, a singer-instrumentalist both writing and performing his own remarkable material. (*Rolling Stone* magazine ranked him as number eighty-four in a list of the world's all-time great guitarists.)

Thus, as a performer with talent to match ego and an incandescent presence, he was an influence on The Beatles in more than one sense. At the audition where he worked his way into John Lennon's band, Paul McCartney performed a version of Cochran's *Twenty Flight Rock*. There was a trilogy of big hits in Cochran's short life: *Summertime Blues*, *C'mon Everybody*, both 1958, and *Somethin' Else* from 1959. It is the last one that's the most beautiful and tragic.

In all of pop, there is no better, no more appealing, manifesto of teenage yearning, desire, cupidity (and eventual reward) than Cochran's *Somethin' Else*. The irresistibly thumping, foot-tapping and hip-twirling rockabilly beat perfectly matches lyrics where ownership of a car becomes the equivalent of the sexual possession of a desired woman.

The first line is a simple declaration, which somehow suggests the auteur's loneliness and desperation: 'A look a-there, here she comes.' He is carefully observing her, but he is unacknowledged. In line three, he admits: 'Wanted to date her since I don't know when.' Of course, 'date' is a demotic period euphemism for something more feral. Then comes the worst most plangent expression of teenage anguish. In lines four and five he explains

'But she don't notice me when I pass', yet he is certain, in that anguished teenage way, that she has been free with her sexual favours with all his friends: 'She goes with all the guys from outa my class.' Yet, despite this torment of humiliation and frustration, he remains loyal to the chivalric ideal of courtly love. He will continue to admire her from afar because 'She's sure fine lookin', man, she's something else.' It's aesthetics that ultimately move him.

In the second verse, the singer-songwriter's longings are now focused on a car that is just as unavailable as the girl, so maddeningly tantalising. He feels the car, as the girl, should properly be his. He will enjoy it and it will, in turn, enhance his life. It's personal. Because: 'There's a car made just for me/To own that car would be a luxury.' Then there's a downbeat turn when he admits he is too poor actually to run the car of his dreams: 'But my dollar can't afford the gas.' Besides, the car he is longing for is inappropriate to one of his social, as well as financial, station: 'A brand-new convertible is outa my class.' So the car is just as lovely yet as inaccessible as the girl: 'That car's fine lookin' man, it's something else.'

The song develops into a miniature of the American Dream as the auteur works hard, makes money and achieves his goal. In the third verse, he has made impressive progress: 'Worked hard and saved my dough/I'll buy that car that I been wanting so.' And, when he owns the car, the girl will become his, because she will be attracted to the vehicle too: 'Get me that girl and we'll go ridin' around/We'll look real sharp with the flight top down.' But, like Milton's Sonnet 23 where the poet dreams both that he can see and that his wife is alive, only to wake up and find that neither is true, the Cochran-auteur figure has been dreamin' as well.

Only in the fourth and final verse are car ownership and sexual gratification at last realised. Eventually, the auteur acquires a car and, thus empowered, pursues, to his own surprise and delight, his date: 'But here I am a knockin' on her door.' He has even been bold enough to park his car outside her home: 'My car's out front and' – as the girl

The British Ford Consul Mark II saloon was launched in 1956. Designed by Detroit's George Walker, it took stylistic cues from Ford's US Thunderbird and Fairlane, bringing a bit of automobile Americana to a country just discovering rock'n'roll.

A PRODUCT OF FORD MOTOR COMPANY LIMITED, DAGENHAM, ENGLAND

'ROCK' STAR DIES IN CRASH

● PICTURED ABOVE: Singer Eddie Cochran. LEFT: The wreckage of the car after the crash which killed him.

By NED GRANT

AMERICAN rock 'n' roll singing star Eddie Cochran, 21, died yesterday after a car taking him to London Airport crashed.

Among the three other passengers in the car when it crashed at Chipnham, Wilts, on Saturday night were two Americans—"rock" singer Gene Vincent, 25, and girl song writer Sharon Sheeley, 20.

Last night Miss Sheeley—she wrote the hit song "Poor Little Fool" when she was seventeen—was in "fair" condition with a fractured pelvis in hospital at Bath, Somerset.

Her mother, Mrs. Mary Sheeley, sobbed in Hollywood last night when she heard of the crash.

The news was broken to Mrs. Sheeley by the mother of Ritchie Valens—the "rock" star who was killed at the age of sixteen last year in an air crash soon after recording one of Sharon's songs.

Mrs. Sheeley said: "Eddie Cochran and Sharon had been

Sharon Sheeley

going steady since they met two years ago.

"Eddie was the first and only boy friend Sharon ever had. They were terribly in love, and were planning to marry. They were unofficially engaged."

The car's owner, George Martin, of Hartcliffe, Bristol, was unhurt.

Cochran—with Sharon, Gene Vincent and the fourth passenger, Camberwell theatrical agent Patrick Thompkins 39—was taken to hospital.

America-bound

Just after four o'clock yesterday afternoon, Cochran died.

Cochran—his record hits have included "Summertime Blues" and "C'mon Everybody"—was travelling from Bristol, where he was starring in variety, to catch an America-bound plane at London Airport.

He had been in Britain since January, appearing on the stage and in T V shows—including ITV's "Boy Meets Girls."

Gene Vincent, whose first big song hit was "Be-Bop-a-Lula" planned to fly with Cochran.

He said in hospital last night: "I hope to be out in two or three days."

● Cochran's last record will be issued according to schedule in the next few days, his British impresario, Larry Parnes, announced yesterday. It is called "Three Steps to Heaven."

The toll: 33 dead 632 injured so far

AT least thirty-three people have been killed and 632 injured on the roads since the Easter Holiday started on Good Friday.

And last night the Automobile Association made an urgent Bank Holiday appeal for safety on the roads.

First reports of YESTERDAY'S ACCIDENTS showed that twelve

people were killed and sixteen injured.

Provisional figures for GOOD FRIDAY and SATURDAY announced by the Automobile Association were: Twenty-one dead and 616 injured.

Last year's figures for the same two days were: Fifteen dead and 600 injured.

In their appeal last night, the A A said:

● These figures tell their own sorry story, but they do not reflect the grief and misery in thousands of homes. An all-out effort will be

required by everyone if the toll on the roads is not to be greater than last Easter.

Bank Holiday motoring conditions call for every bit of concentration on the part of drivers, cyclists and pedestrians. A second's carelessness could mean 'another lost life.

The margin of error allowed by congested roads and heavy traffic is so small that no one can afford the slightest mistake.

● BUMPER "PARADE" TO THE SEA—See Back Page.

will soon be – 'it's all mine.' And then there is the wonderful pay-off, which mixes bathos with mischief. He has the car and it has worked its romantic magic, but it's not quite the car he wanted: 'Just a forty-one Ford, not a fifty-nine.' Still: 'I got that girl an' I'm a-thinkin' to myself/She's sure fine lookin' man, wow, she's somethin' else.' This seems a fine American parable: through hard work, you achieve your goals, but there always remains something to strive for. In this case, a newer model.

The '59 Ford in the song was perhaps the fabulous, just-launched Galaxie Sunliner convertible, a 352 cubic-inch V8 extravagance with (optional) seat belts and a deep-dished steering wheel. In the visual semantics of desire, it was powerfully, even obscenely, articulate, at least by the standards of the decade. The '41 Ford was a fine car, but, by way of contrast, an altogether more humble one, not least because it was available in fewer colours. The last pre-war design (development stopped that year in favour of the military effort until 1946), certain models of the '41 had the attractive option, of special interest to the romantically inclined, of an auxiliary petrol-powered heater so as to allow ambitious drive-in movie fornication at a comfortable temperature.

In April 1960, Cochran was on tour in England, a country just then coming to uneasy terms with rock'n'roll. And rock'n'roll was already developing its own distinctive mythology of live fast and die young, a mid-century version of the Romantic era's doomed artist stereotype. Since 1959 when Buddy Holly, The Big Bopper and a teenage Ritchie 'La Bamba' Valens had been killed in a California 'plane crash (memorialised by Don McLean as 'the day the music died'), Cochran had been consumed with premonitions of his own mortality. Indeed, in 1960, Cochran recorded Tommy Dee's song *Three Stars*, a tribute to the dead threesome – an unusual example of his using someone else's material. You can hear him cry in the second verse. He told friends he wanted to give up touring and abandon life on the road,

The death of pioneer US rocker Eddie Cochran was the headline in the *Daily Mirror*, Monday 18 April 1960. 'Rock' was still a sufficiently new concept to merit inverted commas. In his hit *Somethin' Else,* Cochran wrote of a Ford: 'That car's fine looking man, it's somethin' else'. He died in a Ford Consul on the A4 near Chippenham in Wiltshire.

but accepted the invitation to tour England, as the money was good. Despite his fame and reputation, his dollar was not all it might have been.

On 16 April, Cochran had been performing at The Hippodrome in Bristol. After the concert, he hired a minicab to drive him to Heathrow Airport for the return flight to that more distant West Country across the Atlantic. He chose to sit in the back seat, next to Gene Vincent, a lesser rock star, and Sharon Sheeley, the lyricist to whom he was 'unofficially' engaged in the quaint language that persevered into the first age of rock. Sheeley later told the Coroners' Court that she was afraid of the taxi driver. She was concerned that, inflamed by the rock'n'roll aura, he would be tempted to drive too fast.

A tyre blew out on Rowden Hill on the A4 in Chippenham, Wiltshire. The car hit a lamppost. Cochran was thrown out of the car and received fatal head injuries. Rock's original auteur was now dead in a rural backwater very different from the Minnesota suburb that had fuelled his art. Sheeley told one evening newspaper that Cochran had been singing before the crash. The following day the *Daily Mirror* ran a headline saying *Rock Star Dies*. The word 'Rock' was set in inverted commas.

Police impounded the wreck and the passengers' possessions. One of the local policemen took special interest in Cochran's Gretsch 6120 electric guitar, which survived the crash. This same policeman, perhaps inspired by vicarious contact with greatness, later became Dave Dee in the sixties novelty band Dave, Dee, Dozy, Beaky, Mick and Titch. Earlier in the tour, a thirteen-year-old called Mark Feld had carried the same guitar. The instrument certainly had totemic qualities, perhaps jinxed ones too: Feld later reinvented himself as the glam rock Marc Bolan and was also killed in a car crash.

At the inquest, Sharon Sheeley was 'white-faced' and, in what we can now see as predictive rock-chick mode, 'wearing heavy dark glasses'. She 'trembled and twisted her lilac gloves nervously as she gave evidence of the fatal crash'. It was one of England's first rock deaths. Immediately, and some would say opportunistically, impresario Larry Parnes rushed out an early Cochran recording of *Three Steps To Heaven* – 'As life travels on/And things do go wrong'

– which he claimed to be a new 'disc'. The twenty-year-old taxi driver was found guilty of dangerous driving, banned for fifteen years, and fined £50.

The car in which Cochran died was, as it turned out, indeed a '59 Ford, but not the one of his dreams. Instead, it was a Dagenham-built Ford Consul Mark II with a modest top speed of 79mph. However, in death Cochran was not wholly separated from Detroit's automotive fantasies. The English Ford had been designed by the American George Walker, who was responsible for the epochal Thunderbird. Walker gave the underpowered four-cylinder car as many Detroit styling cues as the conservative English market could tolerate. Perhaps for Cochran, going home in this Americanised car was a little bit like coming home. Alas, Sharon Sheeley (who became a successful songwriter) did not recall exactly what he was singing in the moments before the impact.

There is a small memorial on the side of the A4 and another memorial stone to Eddie Cochran can be found in the old chapel of Saint Martin's Hospital in Bath, although he is buried at Forest Lawn in Cypress, California, the cemetery that Evelyn Waugh satirised in *The Loved One*.

PRINCE ALY KHAN 1960

It's about the motion in the ocean

Prince Aly Khan, eldest son of the Aga Khan III, was, unusually, passed over as leader of the Ismaili Muslims, his father preferring a younger son more attuned to the contemporary world with its threats and limitations.

But Aly Khan found professional compensation in both the military and diplomacy. His military appointments included a stint with the French Foreign Legion in 1939 followed, some will feel bizarrely, by a commission in the Royal Wiltshire Yeomanry the following year, possibly the only individual ever to have made this transition from pseudo-Bedouin adventurer to British officer material. His bravery in the Normandy D-Day Landings won him the French Légion d'Honneur. After 1945, Khan's diplomatic career included a spell as Pakistani representative to the United Nations. Irrespective of his current professional obligations, his car always carried the plates of the Corps Diplomatique.

But Aly Khan's real avocations were not the army or the embassy, but the more personal pleasures of horses, cars and women. Particularly, fast horses, fast cars and fast women. All of these he cultivated with smooth vigour. In 1937, aged twenty-six, Khan acquired his pilot's licence. During the 1950s, his travelling and partying and well-publicised extravagances helped to map the coordinates of what it was to be a playboy, although, with a nod to his religion, he drank tomato juice not liquor at cocktail parties.

'Playboy' was a term that originated in eighteenth-century London theatre to describe puerile runners, not deluxe lotharios. But by 1907 the Irish playwright JM Synge had given the word its

present associations of international pleasure-seeking hustling womaniser in his play *The Playboy of the Western World*. Aly Khan may not have known Synge's work, but this was the model he imitated. In 1953, Hugh Hefner adopted the word for the title of his girlie magazine.

Khan had a predilection for speed and adventure: on three separate occasions he broke a leg while skiing. But he was not the handsome playboy of legend. Instead, Khan was pudgy and short with thinning hair. Yet, immaculately tailored, his multi-lingual charm and the lubrication of wealth and privilege worked its conquering magic on both sexes. And Khan was avowedly cosmopolitan. Commentators were amazed by his ability to look like a Pakistani when he wore Ismaili robes in Karachi, but immediately to adapt to French or Italian ways in Rome and Paris. Even in America, someone said, he did not look foreign. Wherever he might find himself, his English was delivered with an exquisite Oxford accent.

Naturally, the Esperanto of money helped. To augment his own fortune, Khan first married a Guinness. He later married Hollywood actress Rita Hayworth, who wore Dior's New Look at her 1949 wedding in Khan's Château de l'Horizon in Cannes. Hayworth, perhaps a little wearily, said: 'Aly is very nice, but he really doesn't understand family life.' Noel Coward satirised him in his re-write of the Cole Porter classic *Lets' Do It, Lets Fall in Love*. The lines go: 'Monkeys whenever you look do it/Aly Khan and King Farouk do it/ Let's do it …' and so on. Farouk of Egypt, to establish some context for Aly, was the victim of intrusive photography that gave rise to Fellini's expression 'paparazzi'. Of course, Farouk and Khan circulated on similar paths.

Preparation for the fast women began with a period in Cairo as an eighteen year old learning the ancient Persian sexual technique known as Imsak. Essentially, Imsak, which is said to have been practised by Persian princes before the puritanism of Islam dulled that colourful culture, was the classic technique of coitus

The great playboy's 1959 Lancia Flaminia GT was one of the best engineered and most elegant motor cars of its day. Its 'superleggera' body was by Touring of Milan, also responsible for the contemporary Aston Martin DB4.

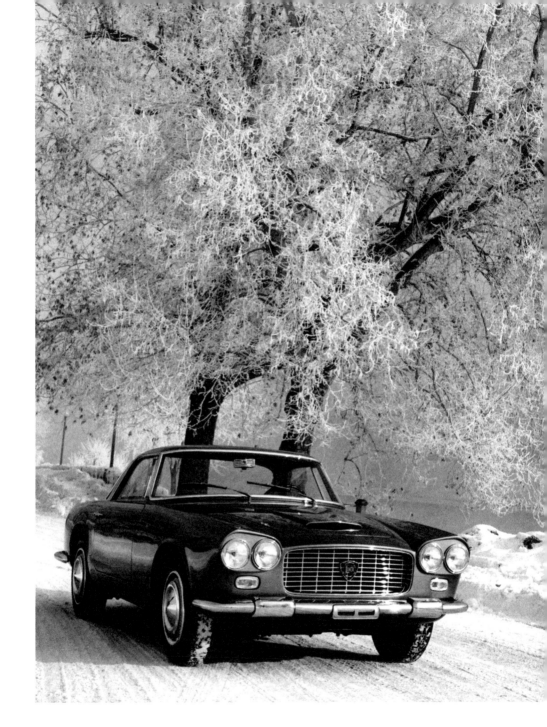

reservatus. Similar to Tantric sex or Chinese *fang shung*, Imsak advocates that for 'perfection of coition', the male should resist orgasm. It was what Sir Richard Burton, translator of the *Kama Sutra*, described with splendid and orotund Victorian pomp as 'prolongatis veneris'. Or, in a more refined version still, enjoy the voluptuous sensation of orgasm without the messy or problematic business of ejaculation. In this manner, one skilled in Imsak might pleasure an entire harem … or its twentieth-century equivalent.

On 12 May 1960, Aly Khan spent the entire day at Longchamp Racecourse in Paris, but contemporary accounts suggest that this was not a joyous day at the races. He was troubled by a sense of foreboding. He told a friend: 'Don't play my horse today, I am not feeling lucky.' After the race, he got into his Lancia Flaminia 2500 GT and set off for his brother's house near Saint-Cloud golf course.

Khan's Lancia was a coupé version of the handsome, but rather conservative Flaminia Berlina, introduced in 1958. In those days Lancia still made cars whose exquisite engineering was matched by uniquely lovely bodies. It was, quite simply, one of the most beautiful cars in the world: ideal, in fact, for a playboy. The more so because its charms were understated: it spoke of elegance rather than excess. While most Flaminias had classic Pininfarina coachwork, the body of the GT was by Touring of Milan and built, like the contemporary Aston Martin DB4, which it resembles, on the Superleggera ('Superlight') principle of alloy panels formed over a space frame. It is distinguished from other Lancias of the day by its distinctive pair of twin headlamps.

The technical specification was highly sophisticated: there was wishbone suspension at the front and at the rear a de Dion axle which also carried the gearbox, providing excellent overall weight distribution and, therefore, safely predictable handling (except perhaps for a slight tendency to oversteer under power). The car had disc brakes on all four wheels, but the engine was not especially powerful, although it was refined. Until later models, known as the 3C, received three pairs of Weber twin-choke carburettors, most drivers actually found the elegant Lancia rather sluggish.

A lot of breath control and disciplined relaxation are involved in the practice of Imsak. One modern advocate described the

experience as 'like motion in the ocean'. Maybe the restless and troubled Aly Khan was practising Imsak techniques when he was disturbed by the sound of an impact. His own. It was in suburban Suresnes, at the junction of Boulevard Henri Sellier and rue du Mont Valérien, that Aly Khan's Lancia Flaminia collided head-on with a Simca Aronde, driven by one Monsieur Bichaton, who remembered nothing of the crash. *Time* magazine reported that Monsieur Bichaton had been travelling on the wrong side of the road. Aly Khan's Corps Diplomatique plates could not buy immunity from this sort of accident.

Khan died in hospital soon afterwards. His front-seat passenger, his fiancée Simone Micheline Bodin, who modelled for Hubert de Givenchy and Jacques Fath as 'Bettina', suffered modest head and facial injuries. Bodin was pregnant at the time of the crash, but lost the baby with the effects of shock. During the obsequies and the inhumation, the Khan dynasty treated Bettina as if she were the legitimate widow.

In his 1955 biography, *Golden Prince*, Gordon Young writes that Aly Khan: 'always looked like a man restlessly searching for a happiness which for most of the time seems to have eluded him like a shadow. His life had been rich, but it never seemed complete'. This incompleteness continued in death. His body was taken by special train to be temporarily buried in the lawn outside his study at the Château de l'Horizon. Here it waited until it was transferred to a new mausoleum at Al-Salamiyah in Syria, a site of special significance to Ismailis.

Bettina returned to her original married name of Graziani and her modelling career continued. Once described as a 'a freckle-faced rail worker's daughter from Brittany', by the time of her death in March 2015 *Le Monde* was describing her as '*Rousse incandescente, elle incarne une Parisienne moderne au chic singulier.*' This is just as Aly Khan would have wanted it.

Overleaf: Aly Khan was returning from a night out in Paris, on 13 April 1960, when his Lancia Flaminia GT collided head-on with a Simca Aronde that had strayed to the wrong side of the road. Ironic that the glamorous Khan should die in suburban Suresnes.

ERNIE KOVACS 1962

Unsafe at any speed

In the first half of the 1960s, four remarkable books disrupted America's sense of itself. First was Jane Jacobs' *The Death and Life of Great American Cities*, published in 1961. This was a powerful critique of Modernist and Rationalist town-planning which Jacobs said bled the life out of towns: she argued instead for the benefits of randomness, ad-hocism and organic evolution. Next was Daniel Boorstin's *The Image: A Guide to Pseudo-Events in America*, published in 1962. Boorstin wittily lacerated America's obsession with public relations and stage-managed events. In the same year, Rachel Carson's *Silent Spring* examined the wilful pollution of rivers by cynical corporations. This book became a scriptural text of the environmental movement. These books changed America and, therefore, the world.

But most significant of all was *Unsafe at Any Speed* (subtitled *The Designed-In Dangers of the American Automobile*) published in 1965 by the public interest lawyer (and later presidential candidate) Ralph Nader, an Arab-American. By 1962 Nader had become aware that members of the public had filed more than a hundred suits against General Motors, citing dangerous handling qualities in its radical new car, the Chevrolet Corvair. He saw an opportunity for action: not chasing ambulances, but pursuing errant, tail-happy Chevys.

These formed the basis of Nader's influential volume of trenchant consumerism. Only one chapter features the Corvair, but it will always be known as 'the Corvair book' and, indeed, the book that almost ruined General Motors. Perhaps too vindictively (other

manufacturers were guilty too), Nader attacked General Motors for knowingly selling a dangerous car and for putting profit before people when the corporation refused to make meaningful modifications to the Corvair, even when alerted to the need for them. *Unsafe at Any Speed* humiliated General Motors and made the US automobile industry reconsider itself, beginning a sequence of legislation that required compulsory seat belts, crash testing and airbags. Never mind that a 1972 report by the National Highway Traffic Safety Administration found that the Corvair was no more prone to dangerous handling imbalance than its new generation 'compact' contemporaries the Ford Falcon, Plymouth Valiant and Studebaker Lark, in the year after Nader's book was published, Corvair sales fell by 50 per cent. In this way began an epochal reversal for General Motors. 'What's good for GM is good for America,' they used to say. This was very bad for General Motors and the Corvair calamity was the beginning of a loss of faith and diminished consumer confidence that ultimately led to The General filing for protection under Chapter 11 in the US Bankruptcy Code in 2009. This was the largest bankruptcy ever.

The irony here is that the Corvair was a progressive and optimistic design, altogether more optimistic and rational than the annual glut of baroque, chromium-plated barges – a phenomenon that the Germans called 'Detroit Machiavellismus'. The sporting version of the Corvair was even described as 'the poor man's Porsche'. It was in a poor man's Porsche that the television comedian Ernie Kovacs died.

The 1960 Chevrolet Corvair was an advanced design with a rear-mounted, largely aluminium, turbo-charged flat six engine. This format was a conscious imitation of Volkswagen and the general arrangement then dominating Porsche designs. Being air-cooled, the Corvair became known as the 'Waterless Wonder from Willow Run', referring to one of the manufacturing centres. It had, in the

The Chevrolet Corvair was intended as America's response to Volkswagen's output, then rapidly gaining market share. Its specification and styling had a European sophistication, but it was also unstable. Ralph Nader's 1965 *Unsafe at Any Speed* attacked the car and, by extension, the American motor industry.

now...wagons!!

and loads of other new things to like!

NEW '61 CHEVY CORVAIR!

The Corvair Lakewood 700 Station Wagon.

For '61, Corvair is more than ever to a lady's liking. You get more room—more for you, more for your luggage (the trunk space has been increased by nearly 12%). Sleeker, smarter, smoother styling. Sparkling new perform-ance. More miles to a gallon, because of a thrifty new rear axle ratio and other men-know-about-these-things improvements. And—will small wonders never cease?—wagons that'll suit you beautifully. You'll like the way our new Lakewood Station Wagon handles easy as you please. (Having the engine in the rear makes for easier steering up front, you know.) Still, it holds a real wagonload of you-name-it. And for a real member of the family, it would be hard to beat the Greenbrier Sports Wagon. It gives you up to twice the space you're used to finding in a U.S. wagon! Roomier, smarter, thriftier. What more could you ask for? Surprise! Your dealer can tell you more happy news about Corvair. Visit him soon. . . . Chevrolet Division of General Motors, Detroit 2, Michigan.

This Corvair 700 4-Door Sedan, like all Corvairs, offers a new heater (optional at extra cost) that warms everybody evenly.

corvair

days when most American cars used a heavy, separate chassis, a unitary construction and, when most American cars were sprung like carts, the Corvair had independent suspension on all four wheels. The engineer responsible was Ed Cole, a distinguished General Motors veteran, who had also designed the Corvette sports car and the popular small-block Chevy V8, the motor that transformed hot-rods, drag racing and American motor sport as a whole. It was not Ed Cole's intention to create a bad car.

On the contrary, the Corvair was something of a marvel. The Corgi Toys model of the period caught a little of its magic. I know – I had one. Pale blue, but with cream upholstery and a yellow venetian blind in the rear screen, the little 1:43-scale car seemed a distillation of American sophistication. Its styling, under design boss Bill Mitchell, was superb: a big glass-house was separated from the hull by a prominent hip-line crease that ran around the whole of the car, soon influencing NSU and BMW into more modest interpretations of the idea. The Corvair, in short, offered discriminating Americans a version of European sophistication without the stigma attaching to an unpatriotic import.

The essential problem with this car was the rear suspension. Like a Volkswagen or a Porsche, the rear-engined Chevrolet used a suspension design known as a 'swing axle'. This was a crude device whose simplicity obviated complex and expensive universal joints, but whose shortcomings meant that, on the rebound, or in extreme cornering, the inside rear wheel could tuck in and lethally destabilise the car. A rear axle rebound strap was an unadvertised, but recommended, after-market option. When alerted to the problem, Chevrolet's engineers lazily and cynically suggested wildly different tyre pressures front and rear.

With soft fronts and hard rears, it was felt the basic problem could be overcome. And in theory this was correct. But an ancillary problem was that US customers were used to pumping up their tyres to identical pressures front and rear and were reluctant to change

Genial television personality Ernie Kovacs' Corvair skidded in the wet and wrapped itself around a telegraph pole at the junction of Beverly Glen and Santa Monica Boulevard, Los Angeles. Kovacs was killed instantly. It is thought he was distracted by trying to light one of his signature cigars.

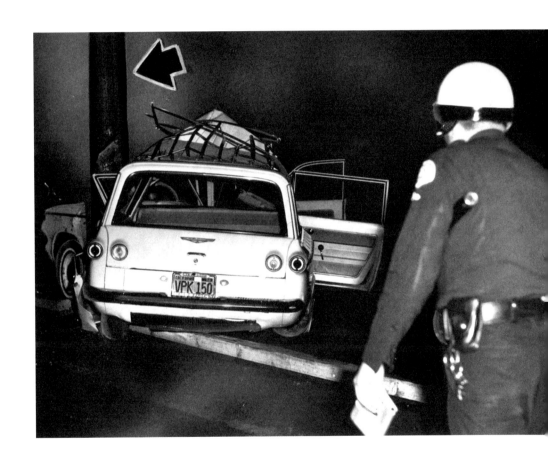

their habits. With the tail-heavy car fatally unbalanced, this meant a Corvair, driven hard, might roll over or spin on any demanding corner. Especially in the wet, as Ernie Kovacs discovered. 'It's been real' was his catchphrase. This was. And he was dead.

Ernie Kovacs was one of the great innovators in American television. His surreal improvisations, reveries, special effects and higher form of literacy influenced later comedy programmes including *Rowan and Martin's Laugh In* and *Saturday Night Live*. Kovacs, with his signature cigar, was as much a disrupter of television conventions as Jacobs, Boorstin, Carson and Nader had been disrupters of town-planning orthodoxies, media flim-flam, corporate ethics and consumerism. The Pulitzer Prize-winning television critic William Henry III called Kovacs the 'first significant video artist'. Before electronics and apps made it easy, Kovacs extended the reach of television as a medium.

He was born in an impressive house in Trenton, New Jersey, made possible by his father's unusual double-life as a policeman and a bootlegger. The end of Prohibition in 1933 meant a dilution of the Kovacs family fortune, so Ernie began a rackety career as an actor and a disc jockey. At WTTM Radio he became the station's Head of Special Events and one of these was his bizarre routine where he speculated on what it might be like to be hit by a train.

He moved to television in 1950 where his *Three To Get Ready* became the first popular early morning show. This was a theatre of many capers. Typical Kovacs stunts were pouring a bucket of water over a weatherman forecasting rain, running through a Philadelphia restaurant in a gorilla suit while a camera crew recorded the shocked responses of diners, wrestling a live jaguar, and hosting Howard, The World's Strongest Ant. Another typical Kovacs stunt was turning up for his own interview wearing a barrel.

In one show, a homeless man was invited to the studio and televised as he slept. In another, *Swan Lake* was performed by gorillas and a poker game was set to Beethoven's Fifth. Kovacs dared to play *Mack the Knife* in the original German as Mackie Messer. Under Kovacs, Bartók, Prokofiev and Stravinsky were give airings on prime-time US television. In 1957 he wrote a novel called *Zoomar* – a sophisticated novel about love and TV – in a mere

thirteen days. In the same year, Kovacs and his wife, Edie Adam, were the last guests on the *I Love Lucy* show. He also wrote for *MAD* magazine. All of this upper-middle-brow, good-natured performance art endeared him to critics.

In 1957 Kovacs moved from the East to the West Coast, where television mingled with movies. As soon as he arrived in California, Kovacs enrolled in the popular sports car cult and bought a Jaguar, but by 1962 his regular ride was a Chevrolet Corvair Lakewood, the station wagon variant of the troublesome sedan. This was a handsome car, but the additional weight over the rear emphasised the pendulum-effect oversteer that plagued the regular saloon.

On 13 January 1962, Kovacs left his studio late, rushing to the baby shower given by director Billy Wilder for comedian Milton Berle and his wife, where he joined Edie who had travelled there in her own car. There had been a light rainstorm before Kovacs and the Chevrolet left the party in the early hours of the morning. At the junction of Beverly Glen and Santa Monica Boulevard, Kovacs evidently lost control of the Corvair and T-boned the driver's side of the car into a telegraph pole. He died instantly, Hollywood fashion. The crash was photographed and widely reported, Hollywood fashion. Actor Jack Lemmon made the formal identification at the morgue, Hollywood fashion. Frank Sinatra and Dean Martin joined Lemmon as pallbearers at a funeral that the local press described as a 'simple ceremony', Hollywood fashion.

An unlit cigar was found in the wreckage, prompting speculation that Kovacs was distracted from the road by trying to light it. But photographs of the wreckage clearly show that the right rear tyre has separated from the rim, exactly as you would expect if the wheel had tucked under during fast cornering or if the tail had slid. What a nice irony that America's most sophisticated comedian proved America's flawed, but most sophisticated car to be a death trap. And this in a fragile Californian dream world of wealth, comfort and celebrity.

PORFIRIO RUBIROSA 1965

Mr Ever-Ready

Porfirio Rubirosa was a political fixer, a jet-set pioneer, gambler, charmer, seducer, gigolo, smuggler, racing man, mythologiser and a wonderful liar. Newspaper diarists routinely clichéd him as a 'swarthy international playboy'. Of most interest was his sexual prowess, which became legendary, his penis achieving a celebrity of its own. By many accounts it was as large as one of the over-sized pepper mills appearing in old-fashioned Italian restaurants. Several trattorias still refer to these impressive grinding machines as 'Rubis'.

In *Answered Prayers*, Truman Capote's unfinished and posthumously published novel on New York's high life and low morals, there is the following description of Rubirosa's *membrum virile*: 'an eleven-inch café-au-lait sinker as thick as a man's wrist'. But mere size alone did not distinguish this famous literary penis. It was also alert. Accordingly, he was known as 'Mr Ever-Ready', or 'Toujours Prêt' when at work or play in France. One slow, smoochy dance with Rubi, it was said, and any woman would recline not decline.

Rubirosa described his continuous sexual urge as *le petit cochon* (a little pig that started grunting at two in the morning). However, he had a nice and rather gentlemanly reluctance to discuss his penis, still less get it out in public even when fascinated voyeurs requested such a thing, as they occasionally did. Claude Terrail, owner of the legendary La Tour d'Argent restaurant, testified to Rubi's tact and discretion. Another friend helpfully denied the inflammatory story that Rubirosa was able to balance a small table

on the end of his penis (when erect). In Bret Easton Ellis's *American Psycho*, the depraved, murderous narrator wears a rose-gold Rolex said to have belonged to Rubirosa.

Rubirosa was born in the Dominican Republic, but he was at home everywhere. His father, Don Pedro, was one of the beneficiaries of the Era de Trujillo, when the country enjoyed great prosperity under Rafael 'El Jefe' Trujillo but did not reap similar riches in the matter of civil liberties. Indeed, the Dominican Republic of this era was notably bloody and corrupt, even by South American standards. Don Pedro Rubirosa was eventually promoted to the Dominican Republic's embassy in Paris where Porfirio grew up.

So Rubirosa Junior met Trujillo at a country club and was soon invited to join his retinue with a position in the Presidential Guard. In this way he became a Trujillista diplomat himself and served in Vichy France, Rome, Havana, Buenos Aires and Brussels. Of his technical diplomatic skills, little is known, although his informal charm was always highly rated.

Trujillo specially admired Porfirio's easy way with women. This Porfirio demonstrated by introducing the President to a woman selling souvenir stamps on the Eiffel Tower, an introduction that resulted in a hurried, but evidently gratifying, aerial sexual encounter for the President. As a thank you, Rubirosa was made Commercial Attaché, although *Vanity Fair* reported that when an embassy employee researched the files, it was evident that Rubirosa never actually did any work, at least of the sort that can be documented. 'I have no spare time to work,' he once, magnificently, said. Instead, he made a little money with smuggled jewellery and had a nice business selling Dominican visas to Jews anxious to leave Nazi Germany. But, as La Rochefoucauld said of all diplomats, he was a wonderful liar.

This easy way with women extended to Trujillo's own daughter, Flor de Oro, who first encountered the café-au-lait sinker in a telephone booth. A courtship followed this confined coupling. El Jefe apparently had mixed feelings about his daughter's amorous arrangement with one of the staff, but their eventual wedding was nonetheless declared a national holiday. Yet the marriage soon collapsed with unusual levels of infidelity on each side. Flor herself

eventually married eight times. Meanwhile, Porfirio graduated to further well-publicised affairs with Dolores del Rio, Marilyn Monroe, Ava Gardner, Danielle Darrieux, Eartha Kitt, Veronica Lake, Eva Peron, Judy Garland, Doris Duke, Barbara Hutton and Zsa Zsa Gabor. Five of them detained him long enough to contract marriages.

Trujillo, the great assassinator, was himself assassinated in 1961 and the following year Porfirio lost his position as Inspector of Embassies as well as the diplomatic immunity that went with it. Thus freed from even the lightest semblance of professional employment or obligation, Porfirio was able to spend his later years cultivating the arts of pleasure, which he had been essaying all his life.

Rubirosa's aptitude for pleasure was as extraordinary as his great good fortune. He was ever resourceful as well as ever-ready. When interned in Vichy France, he used the five months to improve his skiing technique. After 1945 he began to add polo and motor racing to his portfolio of interests. He flew everywhere. After his divorce from tobacco heiress Doris Duke, the settlement gave him a civilianised Boeing B-25 (as well as an annuity of $25,000, an African fishing fleet and a *hôtel particulier* in the rue de Bellechasse). When he divorced Woolworth heiress Barbara Hutton (who had carried a whisky and soda down the aisle), Porfirio received another B-25 (the provision of bombers seems to have been a part of some kind of prenuptial arrangement) as well as $2.5m and some fresh ponies to add to his Cibao-La Pampa polo team.

When horses or women ever so briefly tired him, he liked to fight with men. Macho was the term (although, in a charmingly effeminate detail, he liked to use honey as a skin conditioner). Thus, Rubi had a boxing ring installed in his Paris house. Here he held parties that ran through the night with guitarists from the local club playing while guests ate tortilla and drank scotch or beer in prodigious amounts. He went out on *parrandas*, a sort of swarthy playboy's pub crawl. He never rose before midday and spent afternoons with his horses in La Bagatelle. Night was his time. And pigs were not the only

Overleaf: A 1959 Ferrari 250 GT Series II Cabriolet photographed in the Pininfarina factory, Turin. A solid majority think this the most beautiful motor car ever made.

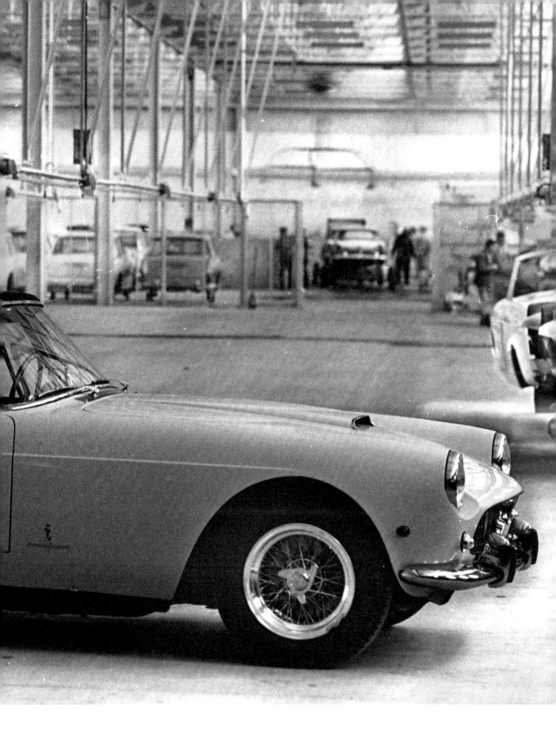

feral metaphors he used to describe his instincts. After midnight he said that: 'the lizard that sleeps in every man's brain comes out to play'.

Latin Lover for once a justifiable tag. But it was not only the technique of love but also its philosophy that fascinated him. Porfirio had useful advice for his many would-be imitators, recommending men to jerk off in the afternoon so as to increase their endurance at night. Rather more elegantly he sent conquests a morning-after single rose with a card inscribed 'A las más bella de las mujeres'. 'Most men's ambition,' he said, 'is to save money. Mine is to spend it.' One of the things he spent money on was a Ferrari 250 GT which he used for his frequent journeys to the Paris nightclub Jimmy's, although normally he had a driver.

Before his fatal crash his career had entered an unsettled, not to say rackety, phase. He was fifty-six. Some thought he was tired. Oleg Cassini believed that Porfirio's wife Odile Rodin was controlling and inspired his jealousy. He might have even thought himself tired, spending time with his garden at Marnes-la-Coquette with only occasional outings to Paris brothels. He tried and failed to write his memoir. He was invited to be the PR for a Florida hotel, but declined. With Opel heir Gunter Sachs he launched a scent called MicMac, but that failed too. Everyone thought it should have been called Rubi, then people would have understood. He told friends of his fear of getting old.

'I would prefer risking everything instead of being bored,' he insisted. Indeed, Rubirosa was the inspiration for Harold Robbins' 1966 *The Adventurers*, a ludicrous bonkbuster with Dax Xenos cast as hero. In 1970 the book was turned into a film by Lewis Gilbert, starring Charles Aznavour and Olivia de Havilland. It was later voted one of the top ten Best Bad Films Of All Time.

In June 1965, Rubirosa had been on Stavros Niarchos's yacht and a Gunter Sachs film exists showing the party doing charades of James Bond's *Goldfinger*, a case of life imitating art, which

Porfirio Rubirosa was driving through the early morning gloom of the Allée de la Reine-Marguerite in Paris's Bois de Boulogne on 5 July 1965. Perhaps groggy after a night at Jimmy's, a favourite *boîte*, he clipped a parked BMW, swerved violently, hit a tree and died.

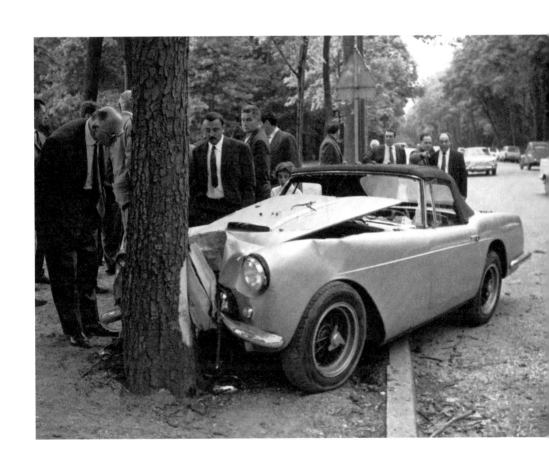

had imitated life, because Porfirio was often said to have been one of the inspirations for Ian Fleming's Bond. Three weeks later, on 4 July, he was back in Paris to watch his polo team winning the Coupe de France at the Bagatelle where he beat Elie de Rothschild's Laversine team. Naturally, he drove to Jimmy's to celebrate. This was an evening of the type Rubirosa called '*todo liquido*' which is to say all boozing and no eating.

At seven in the morning he ate some ham sandwiches and drank a beer and set off for home in the Ferrari. A waiter asked 'Rubi, don't you want to go to bed?' His metallic grey 250 GT Series II Cabriolet was by no means the most demanding car he had ever driven. Rubirosa had competed in the 24 Hours of Le Mans in 1950, sharing a Ferrari 166 MM with Pierre Leygonie. He even entered a Ferrari 500 (the Formula Two car that Alberto Ascari made famous) in the 1955 Bordeaux Grand Prix, but did not start because of illness.

Despite the exhilaration of a big polo win and the effects of a long *todo liquido* session, his thoughts may have been ruminative. Rubirosa had been upset by Aly Khan's death. But he said, 'When I die, it won't be in a Lancia Flaminia … it would have to be at least a Maserati or a Ferrari.'

An hour after the ham sandwiches, at speed along the Allée de la Reine-Marguerite in the Bois de Boulogne, the car jumped the kerb and hit a chestnut tree. It was raining. An eyewitness said the Ferrari, estimated to be travelling at 160kph was trying to avoid a collision with a parked BMW 1500 belonging to an engineer called Yves Ricourt, whose early morning habit it was to read a newspaper on a park bench in the Bois du Boulogne. The Ferrari clipped the BMW and span out of control.

Photographs of the crash scene show that the Ferrari hit the tree front and centre, but at an oblique angle. The 250 does not appear to be sensationally damaged, but the bonnet has been displaced and, judging by the angle, the steering column would have penetrated the left-hand-side of the cockpit where Rubirosa sat. The *New York Times* drily reported that he died exactly half way between the Bagatelle Polo Cub and Longchamp Racecourse. It is a nice irony that the errant BMW was that manufacturer's

defining 'Mittelklasse' offer, the solid, *bürgerlich*, modern saloon – designed on Bauhaus principles – that built the company's reputation. Rubirosa's Ferrari was, of course, more aristocratic, special and rare.

What was on his mind that last hour driving fast through a wet Paris dawn? At this time of day neither the Petit Cochon nor the lizard were regularly active. Be that as it may, his last words were 'Zsa Zsa! Zsa Zsa!' Although others say they were 'Odile, Odile. Where are you?' Gabor's own 1991 biography was published when she was seventy-four. It was titled *One Lifetime Is Not Enough*, but at fifty-six, Porfirio Rubirosa had already run out of time. The Latin Lover's 'Verano Eterno' had come to an end in the wet. Hearing of the crash, his second wife, Danielle Darrieux, said his death was like his life: 'violent and fast'.

The *Times* described Rubirosa's crash as: 'the mundane death of a minor diplomat from a tiny country'. Odile Rodin told Shaun Levy: 'It was fate. He believed in fate and I do too.'

GIUSEPPE FARINA 1966

The professor of speed

Racing-drivers, like rock musicians, should never retire. The performance, danger and adulation become addictive. Without these stimuli, life seems pale and without focus. Giuseppe 'Nino' Farina was the very first Formula One World Champion in 1950. At the first race of the series, the British Grand Prix at Silverstone, he won pole position, fastest lap and the race itself in his fabulous Alfetta 158. But his celebrity was soon eclipsed by the incomparable Juan Manuel Fangio. Perhaps the slight stayed with him, nagging at his impeccable persona.

His second language was Alfa Romeo and Ferrari; he was an archetype of distinguished, sometimes callous, bravery. But Farina always raced with impeccable, patrician style: they called him *Il Grande Farina*. He handled his howling, petulant cars with an impressive straight-armed driving style. People said he seemed to make these brutal cars dance. This straight-armed style had an Italian *sprezzatura*, especially when compared with the hunched-up aspect of the contemporary German drivers who seemed to be roughly wrestling their cars more than delicately orchestrating their movements. The great, unbeatable Tazio Nuvolari had told him: 'Not for one second must your car hang dead.' No: the car had to be alive. It had to dance.

Farina was a driver with an intimidating competitive reputation who risked his own life – and spent others' – on circuits all over Europe and America. This most aristocratic racer died when his plebeian Ford Lotus Cortina hit a telegraph pole in an Alpine ski resort. It was Aiguebelle, Savoie, 1966, and the road was icy.

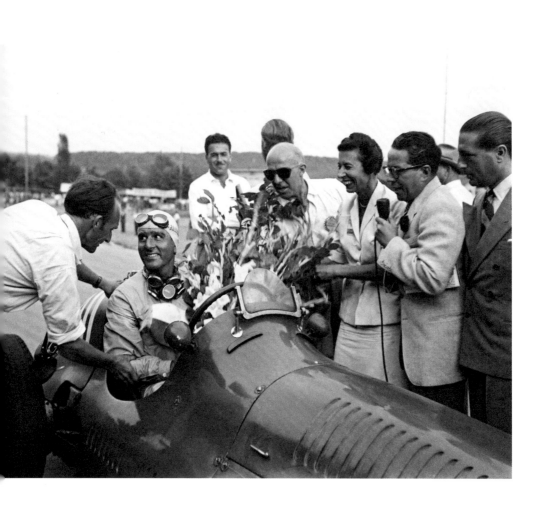

He was, one imagines wistfully, making his way to Reims to the French Grand Prix where a Ferrari driven by one of his successors, Lorenzo Bandini, was on pole position. The race, on 3 July, was won by Jack Brabham. The following year Bandini died in a fiery crash at the Monaco Grand Prix. Brabham's car had an Australian-built Repco V8, based on an Oldsmobile cylinder block. It almost seemed that the aristocratic, Italian hegemony in Grands Prix was coming to an end.

On the day Giuseppe Farina was born, 30 October 1906, his father, Giovanni, funded Stabilimenti Farina. This matured, under his uncle Pinin, into the great family of coachbuilders whose glorious designs created the visual language by which road-going Ferraris were understood. Perhaps no business ever has created so much mechanical beauty. Thus, Farina was a member of Turin's industrial aristocracy. He married Elsa Giaretto, a Torinese fashion entrepreneur who disapproved of racing. Three days after their wedding, ignoring her objections, he flew to Argentina to compete.

Aged nine he was driving a voiturette made by the Temperino brothers, a tiny car with an air-cooled V-twin engine and bodywork by Farina. As he worked on his law doctorate, he was competing in the Aosta-San Bernardino Hill Climb in an Alfa Romeo 1500. Like many of his upbringing, Farina was intended for the cavalry, but by 1933 had become a professional racing-driver. His first drive was with Scuderia Subalpina, but he joined Enzo Ferrari's Alfa Romeo team in 1936. Here, Tazio Nuvolari was his teammate and mentor.

People commented on how Farina's ruthlessness and bad temper behind the wheel contrasted with his courtly and patrician manner when out of the car. And Farina had a reputation for belligerent disaster. His career is a repertoire of accidents as much as achievements. At the 1936 Deauville Grand Prix his Alfa Romeo 8C-35 collided with the car of Marcel Lehoux, who was killed. Two years later he was in another fatal accident when

Giuseppe 'Nino' Farina wins the Lausanne Grand Prix, Switzerland, 27 August 1949 in a Maserati 4CLT-48. The following year, this Italian aristocrat became the very first World Champion.

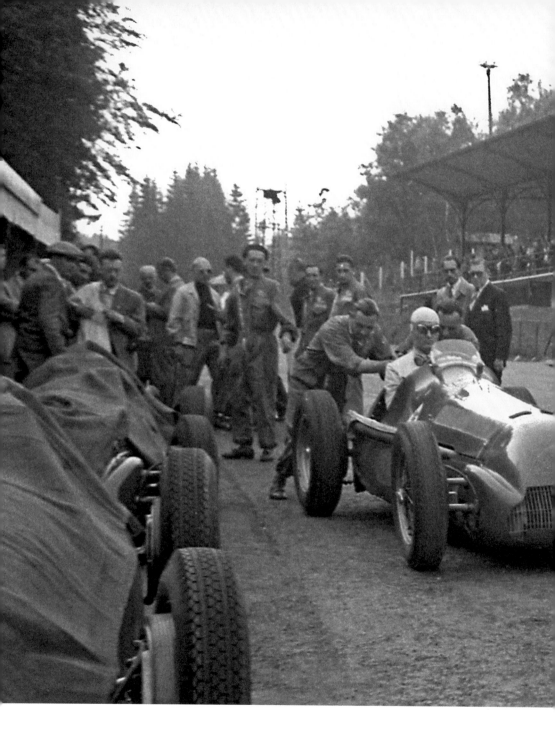

László Hartmann was killed in a collision in Tripoli. In the 1953 Argentine Grand Prix, avoiding a child who had strayed on to the track, Farina crashed into the crowd, killing seven spectators.

The 1953 German Grand Prix was his last win, in a Ferrari. The next year he became, and remains, at forty-seven the oldest driver ever to claim pole position. But at a sports-car race in Monza later that year, the prop shaft of his Ferrari Mondial broke on the start line. This ruptured the fuel tank and led to a blaze in which Farina was badly burnt, although he insisted on racing after being anaesthetised by morphine shots. At Indianapolis in 1956, he broke his collarbone in a Kurtis-Ferrari. The following year at Indy, his teammate, Keith Andrew, was killed while qualifying Farina's own Kurtis-Offenhauser. Now, at last, after one crash too many, Farina gave up racing.

But the real tragic arc in Farina's career was one that reached over tearing metal or oil fires. It was rather one of reputation. This arc covered Homeric repetitions of setbacks and comebacks, often heroic. But despite being the original and defining World Champion, Farina was always eclipsed by his teammates and never won the absolute esteem of the public. First it was Nuvolari, then Juan Manuel Fangio. But Piero Taruffi and Luigi Villoresi also outshone him. Farina never, despite his achievements, felt established as a true champion.

After his retirement Farina built up his Jaguar and Alfa Romeo dealerships and remained involved in Formula One as a suave, travelling ambassador for the sport. It was in this role that Il Grande Farina was driving a humble Lotus Cortina. Since the early Sixties, under the inspiration of its public-relations chief, Walter Hayes, a close confidant of Henry Ford II, Ford had begun investing in motor racing to enhance its corporate image.

Although the motive was public relations, Ford became systemically involved with racing. Indeed, it was one of the most successful campaigns of its sort ever, beginning with victories for a Ford-powered car at Indianapolis in 1965 followed by a

Previous pages: Nino Farina in an Alfa Romeo 158 Alfetta at the start of the Belgian Grand Prix, Spa, 1950. Farina had been told to make the car 'dance' and drove with fabulous *sprezzatura*.

Ford GT 40 humiliating Ferrari, as was the intention, by winning the 24 Hours of Le Mans in 1966. In 1967, the Ford-sponsored Cosworth DFV Formula One engine won on its first time out in a Lotus 49 driven by Jim Clark at Zandvoort. Subsequently, the Ford-badged DFV became the most successful engine ever to compete in Formula One.

A collaboration with Colin Chapman's Lotus had been the foundation of Ford's adventure in motor sport and the 1963 Lotus Cortina was its first fruit. This was a high-performance development of the original Cortina, the famous 'Dagenham Dustbin'. The car featured light alloy panels, a close-ratio gearbox, lowered and modified suspension, together with a lively twin-cam engine, which Cosworth's Keith Duckworth had helped engineer. These ambitious changes turned the rather cheesy Cortina into a sports-saloon comparable, even superior, to Alfa Romeos and BMWs. It was a wonderful machine, but wonderful marketing too.

An important element of Ford's strategy was to get its products into the hands of celebrities who might cast an aura of credibility over its arriviste products. This is how Farina, World Champion, Doctor of Law and Torinese aristocrat, found himself driving a car familiar on council estates and mocked by the poet John Betjeman who wrote: 'I am a young executive, no cuffs than mine are cleaner/I own a slim-line briefcase and I drive the firm's Cortina.' But in its Lotus version, the Dagenham Dustbin had handling which allowed a skilled driver to make the car dance, hanging its tail out on full opposite-lock, beautifully controlled powerslides.

However, since Nature demands some equilibrium, the Lotus Cortina had some faults. Colin Chapman advocated 'simplify and add lightness'. His attack on weight made some of his Grand Prix cars notably fragile, even as they were notably spare and beautiful. He was also interested in sophisticated suspension systems. The standard Cortina's crude, but serviceable, leaf spring rear suspension was thrown out and replaced by a complicated set up with trailing arms and coil springs located by a large 'A'-bracket. While creating a more responsive and effective suspension, the problem here was that the 'A'-bracket tended to cause the axle casing to separate which led to a complete loss of oil and, therefore,

to catastrophic failure. The Lotus Cortina that *Autocar* magazine had on long-term test experienced six such failures in 29,000 miles. Such a failure would lead to a car travelling at speed to spin out of control, the more so on icy mountain roads.

Farina set out for the French Grand Prix on 30 June 1966 Perhaps to amuse himself on the 800-kilometre journey from Turin to Reims, Farina was making the Cortina dance. And then it stepped out. In all his racing crashes, Farina tended to blame the car or circumstances, rather than himself. Fangio had always said Farina drove under the protection of the Virgin Mary, but on this occasion, in Savoie, the Holy Mother was looking the other way. Enzo Ferrari was never notably sympathetic to his drivers, but said of Farina: 'A man of steel, inside and out. But I could never help feeling apprehensive about him. He was like a high-strung thoroughbred, capable of committing the most astonishing follies.'

Farina was one of the consultant drivers advising on and contributing to John Frankenheimer's 1966 movie, *Grand Prix* (with music by Maurice Jarre). His journey to France for the Grand Prix had included a meeting with the director. Farina never made it to the meeting, still less to Frankenheimer's credits list, although Fangio did (rather confirming, post-mortem, his paranoia about status). 'Cortina', incidentally, is Italian for 'curtain'.

A joke in poor taste about final curtains is waiting here.

A sales brochure for the Ford Cortina Lotus, produced from 1963 to 1966. This was a suburban saloon highly modified by Lotus's tricky genius, Colin Chapman. It was fast, sure, but delicate. Farina was driving one to meet movie producer John Frankenheimer when he crashed in the snowy Alps.

CORTINA DEVELOPED BY LOTUS

TARA BROWNE 1966

He blew his mind out in a car

Nineteen sixty-six was the defining moment of Swinging London. *Time* magazine's famous article of April that year – 'Great Britain: You Can Walk Across it on the Grass' – coined the term and is its scriptural source, although Diana Vreeland had, with settled gravity, declared London to be swinging in US *Vogue* the year before. Swinging, of course, took many forms, but sex, drugs, fashion, pop and fast cars were often a part of the mix. The *Time* journalist caught the mood of a nation just liberating itself from the practical and moral constraints of Empire. He found a lot to describe and took four thousand five hundred words to do so.

That year was a sort of climacteric: the Sixties existed before and continued afterwards, but the hypocrisies and glories were unforgettable. Referring to drug-fuelled orgies he had enjoyed with prostitutes in the company of a Russian spy, the Conservative minister John Profumo told the House of Commons 'There was no impropriety'; the theatre critic Kenneth Tynan, a vocal campaigner against censorship, became the first person to say 'fuck' on live television; Jim Clark and Graham Hill won the Indianapolis 500 in successive years, in a Lotus and a Lola, respectively.

Colin MacInnes's 1959 novel *Absolute Beginners* had anticipated the liberated psychology of the era, as did Dolly's Disco on Jermyn Street after its own fashion. Bernie Ecclestone's car dealership on Bexleyheath Broadway was an incongruous pioneer of architectural minimalism – all white with spotlights – where customers included Twiggy and Lulu. Then there were the Chelsea and Kensington boutiques and restaurants: Biba on Kensington High Street and

The Pheasantry, Granny Takes a Trip, Casserole, Le Reve, Hung on You, Guys & Dolls, Bazaar, Top Gear, Countdown and the Chelsea Drugstore on King's Road.

This last was inspired by Le Drugstore on Paris's Boulevard Saint-Germain, but employed its own distinctive 'flying squad' of delivery girls in purple catsuits who rode around London on scooters. The Chelsea Drugstore appears in The Rolling Stones' song *You Can't Always Get What You Want* as well as Stanley Kubrick's film of Anthony Burgess's *A Clockwork Orange* where Alex picks-up two girls for a bit of high-speed 'in and out'. There were endless 'happenings' and lots of nudity culminating in David Montgomery's *Electric Ladyland* album photograph for Jimi Hendrix. Brooklyn-born photographer Montgomery had visited various King's Road bars and cafés and offered every woman who caught his eye ten shillings to get their kit off and pose. And a quite extraordinary number did.

There were models, magazines and galleries. A stream-of-consciousness recollection would be: *Queen* magazine, Robert Fraser Gallery, Tiberio, Annabel's, The Clermont, Kasmin, Le Caprice, L'Etoile, Foale and Tuffin, The White Tower, Carnaby Street, John Stephen, dolly birds, kinky, The Kinks, super, Jean Shrimpton, David Bailey, Terence Donovan, Terry Southern, plastic furniture, La Trattoria Terrazza with its white tiles and Chiavari chairs and Richard Seifert's skyscrapers. There was the musical *Hair*. There were haircuts and the hairdressing Schumi brothers. There was a blonde Australian stripper at Raymond Revuebar who used a live cheetah as a prop. There were Arabella Boxer cookbooks and Mark Boxer's *Sunday Times Magazine*. Robert Brownjohn's graphics and Zeev Aram's Modernist furniture. And then, of course, in 1967 there was The Beatles' *Sgt. Pepper's Lonely Hearts Club Band*, for many the greatest album ever made.

And in this world of stylish licence and polychrome hedonism, what Eve Babitz called 'sordid over-boogie', Tara Browne was a fixed point, although perhaps not as firmly fixed as security might demand. Browne was the son of the 4th Baron Oranmore and Browne who, when he left the House of Lords in 1999, was Britain's longest-serving peer. His mother was Oonagh Guinness, one of the

famous Guinness Girls, a heroic partygoer and heir to the brewing and drinks fortune. His brother, Garech Browne, was a founder of the muscular Irish folk band, The Chieftains. At Browne's twenty-first birthday party, John Paul Getty, Mick Jagger, Paul McCartney and John Lennon were among the guests at the enchanting Guinness country house, Luggala in County Wicklow.

At twenty-one, he had set himself up in Belgravia's Eaton Row, just off King's Road, with his companion, Suki Potier, a model who had worked for Ossie Clark, the most celebrated fashion designer of the day. Suki was not Browne's wife. That was Nicky, once described as a 'hippie-babe par excellence'. The Eaton Row property had acquired a druggy reputation and on the night of 18 December 1966, Marianne Faithfull said Browne had been taking LSD – a powerful hallucinogen whose psychedelic effects either burnt or illuminated many in his circle. It was Browne who introduced Paul McCartney to LSD.

The physical effects of LSD include numbness, weakness, nausea, hypothermia, elevated heart rate, and jaw clenching. The perceptual effects of an LSD trip include distortions in a sense of time and space, surreal image and eidetic effects when the eyes are closed. Nonetheless, Browne chose to go on another sort of trip: a drive in his new turquoise Lotus Elan.

Along with the Mini and Jaguar E-Type, the exquisite little Lotus is a car by which the Sixties will always be remembered. Officially the Lotus Type 26, it was a perfect expression of Colin Chapman's engineering philosophy, being sophisticated, light and, perhaps, a little over delicate. The Lotus designer responsible for the Type 26 was Ron Hickman, who, in the days when DIY was still a national preoccupation, went on to enrich himself greatly with the design of the Black & Decker Workmate.

With its backbone chassis and plastic body, the Elan weighed a mere 1,500lbs, thus its 1.6 litre double-overhead-cam engine, powerful for its day with 105bhp, gave it exceptional performance, which was reined in by four-wheel disc brakes. Every road-tester in every motoring magazine commented on its agility and fine handling. So much did this car express the spirit of the age, that it was chosen as the on-screen vehicle for Diana Rigg's character

Emma Peel in *The Avengers* television series. In this matter, the modern Elan was intended to make a counterpoint to the stately Bentley used by Mrs Peel's on-screen colleague, John Steed. Throughout, Mrs Peel chases villains in her nippy Elan while wearing remarkable mini skirts or stretch-jersey catsuits.

During his last drive around Kensington and Chelsea in the Lotus Elan, no one knows whether Tara Browne was experiencing numbness, weakness, nausea, hypothermia, elevated heart rate, jaw clenching, distortions in his sense of time and space, surreal imagery and eidetic effects, or what Tom Wolfe called 'eyelid movies'. What is known is that at the junction of Redcliffe Square and Redcliffe Gardens, about two miles from the house in Eaton Row, he failed to stop at a red light, hit a parked truck and died in a Fulham hospital a few hours later as a result of his injuries. He was twenty-one. He had been scheduled to inherit a million pounds on his twenty-fifth birthday.

Photographs of the crash show a shattered car. Charles Corneille, manager of the Phoenix Theatre, told the press agencies that he heard the crash as he lay reading in bed in his flat. 'I saw the driver pinned like a doll in the wrecked car', he said. 'There was not much we could do for him.' Another neighbour said Suki was 'running about in the road, waving her arms. The car virtually disintegrated. The steering wheel was bent like a flower stem.' Suki, nineteen at the time, was uninjured and explained that Browne had swerved at high speed to prevent a collision.

On 17 January 1967, John Lennon was sitting at his piano in Kenwood, the splendid joke-oak Weybridge home incongruously sited in what used to be known as the 'Surrey Stockbroker Belt'. He was, presumably, working on material that would appear in *Sgt. Pepper*, which was to be released on 1 June. Taking a break from composition, he picked-up a copy of the *Daily Mail*, which was sensationalist then as now, and read the report on the custody action for the two sons of Tara Browne's estranged wife, Nicky.

Two historic messengers from Swinging London: Diana Rigg, in character as Emma Peel in *The Avengers* television series, climbs into her Lotus Elan. Like the Jaguar E-Type and the Mini, the delicious little Lotus became a symbol of the Sixties.

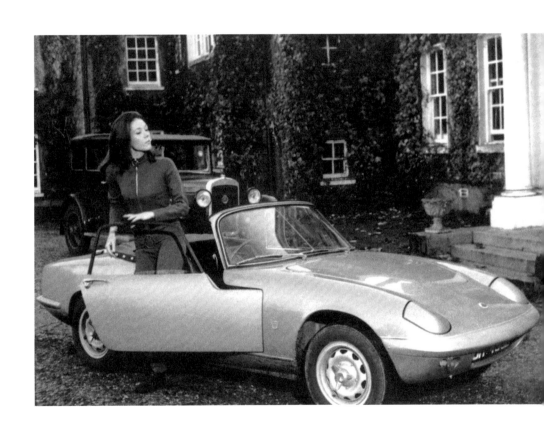

Hence, the mordant first line 'I read the news today, oh boy,' perhaps the first time the *Daily Mail* has inspired poetry. The song develops with clear references to the Redcliffe Square crash:

He blew his mind out in a car
He didn't notice that the lights had changed
A crowd of people stood and stared
They'd seen his face before
Nobody was really sure
If he was from The House of Lords

But Lennon explained 'I didn't *copy* the accident ... Tara didn't blow his mind out, but it was in my mind when I was writing that verse.' The details of the accident – not noticing traffic lights and a crowd forming at the scene – were similarly part of the fiction. Paul McCartney contributed the 'beautiful little lick' of 'I'd love to turn you on' whose apparent advocacy of recreational drugs resulted in *A Day in the Life* being banned by the BBC in one of its routine fits of preposterous puritanism.

After Lennon's death, McCartney disputed any association with Tara Browne in Lennon's lyrics, claiming a generality rather than a specificity as a source of the imagery, but the balance of evidence suggests that the son of a member of The House of Lords did, indeed, not notice that the lights had changed. Whether his mind was at the time blown no one can now say. It was beautifully and tragically appropriate that the last haunting track on *Sergeant Pepper*, the sound of Swinging London, was inspired by the crash of a Lotus Elan by a mercurial rich boy.

After Browne's death, Suki Potier began a romance with Brian Jones of The Rolling Stones, who died in a swimming pool accident in July 1969. Suki was killed in a car crash in the Portuguese resort of Cascais in June 1981.

Guinness heir Tara Browne 'didn't notice that the lights had changed' and crashed his tiny, fragile, fast fibreglass Lotus in Redcliffe Gardens, London, 18 December 1966. His friend John Lennon made the accident a motif in the *Sgt. Pepper* song *A Day in the Life*.

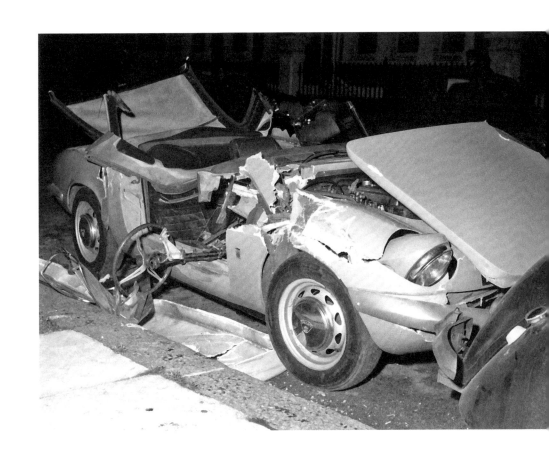

JAYNE MANSFIELD 1967

Blonde bombshell in a Buick

With her improbably huge, cantilevered bust, reputedly forty inches although mere dimensions tell only half the story, Jayne Mansfield made the most unsubtle of appeals to male desire in the Fifties and early Sixties. In those more innocent days, women were routinely described and calibrated by chest, waist and hip measurements. She was 40-21-35. Audiences gasped approvingly, following every wobble. Every provincial secretary wanted to look like Jayne Mansfield. And every provincial manager wanted them to behave like her.

Wriggling, thrusting, beaming, pushing and pouting, in states of near undress she addressed a generation of adoring men who were located in that strange moment of history between Hays Code rectitude (a mandatory foot on the floor in bedroom scenes) and the full-frontal realities of the sexual revolution to come (when Marlon Brando, assisted by some butter, had anal sex with Maria Schneider in 1972's *Last Tango in Paris*). Jayne Mansfield's dentistry was as impressive as her poitrine: she was a complete erotic prosthesis.

'Blonde Bombshell' was a term coined for her, although, naturally, given this is fifties America, that blondness was not natural, but chemically assisted. Hidden dark roots might even be a useful metaphor to describe her stellar, but disappointed, life. No authoritative record exists, but it is reasonable to speculate that Mansfield's extraordinary profile was itself also influenced by forces beyond those of Nature, not excluding rubber and silicone. Her bust was the very symbol of American excess, a diagram

of the Eisenhower Years. But this bust she exploited with great and systematic professionalism. Mansfield was coeval with *Playboy*, the artistically and intellectually ambitious girlie magazine founded in Chicago in 1953. On these pages she was a bunny girl – Playmate of the Month in 1955 – who did a splendid predatory crawl and snarl in a tumble of dazzling Clairol curls. She advertised sex as if it were a consumer product.

In 1957, Mansfield arrived in France and an admiring crowd met her at Le Bourget with placards saying *Paris embrasse Jayne Mansfield* and *Quelle Femme!* Certainly, there was a fine and welcome contrast with France's own leading lady of the day, the unbending and unsmiling feminist Simone de Beauvoir. Looking at the old newsreels now, you suspect that these placards with their suspiciously neat signwriting were professionally prepared, the admirers participating in an organised publicity stunt.

Daniel Boorstin, the Librarian of the United States Congress, in his book *The Image* (1961) later described publicity stunts as 'pseudo-events', but Jayne Mansfield made stunts into a bright version of reality, at least for a moment. She posed with a milk bottle not at all subtly held against each breast. Her favourite chihuahuas, canine miniatures in a world of human maximums, were similarly positioned in memorably tacky agency photographs.

Most remarkably, in the same year as the Paris trip, Mansfield was photographed at dinner wearing a low-cut dress. Her companion, Sophia Loren looks appalled as Mansfield, leaning forward, exposes a nipple to the photographer and threatens to spill the entire contents of her not-at-all-constraining *corsetage* over the place setting.

Mansfield was born Vera Jayne Palmer in Bryn Mawr, Pennsylvania, in 1933. Her father was a well-to-do lawyer with political connections and her mother a teacher. This background was blameless. She did well at school, learnt five languages, played classical piano, viola and violin and was said to have yet another impressive statistic in an IQ of 163. In the fifties, numerical measurement of intelligence was as familiar as numerical measurement of sexual allure. In 1950 Vera Palmer married Paul Mansfield. When Paul went to serve in Korea,

Jayne moved to California, as many like her had done before, to follow a dream.

She enrolled as a student at UCLA and started looking for work in the theatre. This began modestly as a cigarette girl in cinemas, but she was soon noticed by MGM scouts and progressed to a bit part in 1950s sci-fi romparama *Prehistoric Women* ('savage, primitive, deadly' according to the posters). Her hair now dyed an emphatic blonde, Mansfield's next films were *Female Jungle* in 1955, *The Girl Can't Help It* in 1956 and *Kiss Them For Me* in 1957. The titles may be revealing of an underlying psychology: the 'Girl' cannot help exactly what? And is it a who or a what that the 'Them' refers to? Her masterpiece was, however, the sophisticated media satire *Will Success Spoil Rock Hunter?* of 1957, a film which includes a cameo appearance by Groucho Marx.

Jayne separated from Mansfield in 1958 and married Mickey Hargitay, a Hungarian body-builder and rentable Hollywood hunk. One of the most famous images from the book, *La Dolce Vita*, the press picture iconography of Italy in the fifties, is of Mansfield and Hargitay on board a bobbing Riva Aquarama anchored somewhere off the Italian coast. Whether this adventure occurred on the same trip as the Sophia Loren nipple incident is not known, but the sensibilities involved here are unquestionably similar. With Hargitay, she built a nipple-pink hacienda-style home at 10100 Sunset Boulevard, which featured a heart-shaped pool where photographs were often taken. These were not poolside pictures with Slim Aarons' wit and detachment, but altogether more visceral images intended to promote, I think, lust and envy. (The house was subsequently bought by Ringo Starr of The Beatles and Mama Cass of The Mamas and the Papas before finally being demolished in 2002.)

Several dark disruptions now occurred in Mansfield's hitherto bright career. Although Twentieth Century Fox signed her as a replacement for their biggest star after Marilyn Monroe's suicide in 1962, the moment for bottle-blonde sex bombs was passing:

Overleaf: The 1966 Buick Electra 225, a classic from the period when Bill Mitchell headed General Motors' design department, was one of the last great American motor cars.

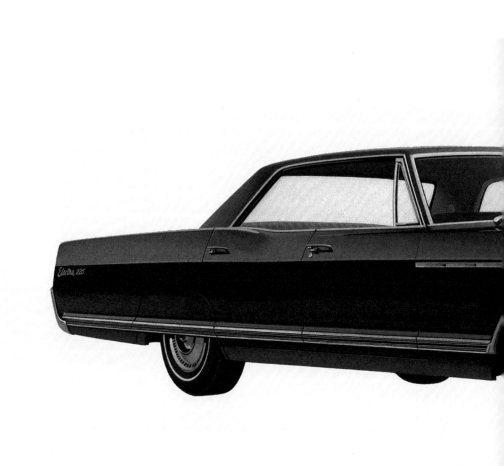

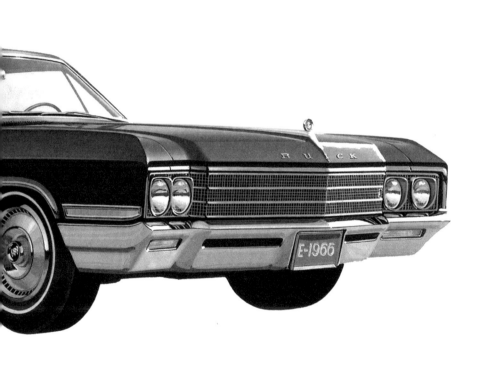

very soon consumers would crave flowers in their hair, not boobs in their face. Hollywood's stereotype of a desirable woman was to change. Mansfield said: 'A woman should be pink and cuddly for a man.' Many will find that admirable, but in the decade of Women's Liberation, it suddenly seemed quaint and dated.

There were divorces. With Hargitay gone, Mansfield married a director called Matt Cimber and then began an affair with a San Francisco lawyer called Samuel S Brody. People said she started drinking and brawling, as she perhaps did. Indeed, an image of a partying Mansfield is on the jacket of Kenneth Anger's notorious muckraking book *Hollywood Babylon*. Mansfield is leaning forward, roaring with laughter above mightily pendant breasts, which are scarcely covered by the plunging neckline of her cocktail dress. She is the very picture of decadence, although not, perhaps, of a very threatening sort. The image is one of tipsiness rather than of nastiness.

Anger, however, was a weekend hobbyist Satanist and so too was Anton LaVey, founder in 1966 of Los Angeles' Church of Satan. LaVey, it is said, had an affair with Monroe. It is also said that Jayne Mansfield worshipped him. The better to announce his close collaboration with the Devil in terms that his congregation could construe, LaVey shaved his head (like an 'executioner' in his own word), cultivated a strange goatee, practised grimacing in a mirror and wore distinctive heavy jewellery. Like her own breasts, Mansfield's fascination with this ludicrous, posturing charlatan may be evidence of her commitment to extremes. She used to say, hinting at a profession of mild wickedness: 'If you're going to do something wrong, do it big, because the punishment is the same either way.'

With her Hollywood career stalling, Mansfield began to work the cabaret circuit where a Hell more provincial, but no less harrowing, than the Church of Satan's might reliably be found. On the evening of 28 June 1967 she was playing at The Gus Stevens Supper Club in Biloxi, Mississippi. She had hired from

Jayne Mansfield's death is announced on the front page of the *Daily Mail*, Hagerstown, Thursday 29 June 1967.

Daily THE Mail.

ON INSIDE PAG
Eisenhower comments
MacArthur. Page 12.
More nurses needed
care here. Page 4t.

Amusements 26 Opinio
Classified 36-39 Society
Comics 24 Sports
Obituaries 2 TV Pre

VOL. CXXXIX, No. 152. HAGERSTOWN, MD., THURSDAY, JUNE 29, 1967. PRICE F

Israel Pressed To Withdraw

By CHARLES STORER

UNITED NATIONS, N.Y. (AP) — Pressure mounted on Israel today at the emergency session of the U.N. General Assembly to reverse its annexation of the Old City of Jerusalem.

Fifteen nonaligned nations submitted a resolution to the Assembly Wednesday calling on the Israeli government to withdraw its troops from all the territory seized from Egypt, Jordan and Syria in the six-day war that began June 5.

But meanwhile the Israeli government accomplished the integration with a proclamation nothing further to prejudice the future status of the Old City.

Introducing the resolution, Ambassador Danilo Lekic of Yugoslavia said the Old City was threatened with full integration into Israel and called for the 122-nation Assembly to adopt his resolution by Friday.

Israelis have taken regarding the Old City, declaring these invalid, and calling on Israel to do enlarging the city limits of "Israeli Jerusalem" to include the Old City and some adjacent territory seized from Jordan.

Under the original U.N. partition plan for Palestine, Jerusalem was to be an international city, but Israel took the new part of the city during the 1948-49 Palestine war and Jordan drove the Jordanian army from the Old City — which contains the bulk of the Christian, Jewish and Moslem holy places — at the start of the June 5-11 war.

In a statement issued late Wednesday night, Jordan's King Hussein said his government viewed "with utmost concern the arbitrary measures taken by the Israeli authorities to effect the annexation of the Jordanian part of Jerusalem." He called these steps "unacceptable and intolerable" and said "the whole world should stand firm" against them.

The U.S. State Department in a statement also warned Israel that its "hasty administrative action cannot be regarded as determining the future of the Holy places or the status of Jerusalem in relation to them." The nonaligned resolution submitted by Yugoslavia would intended as a compromise to supplant a Soviet proposal to condemn Israel for aggression and demand forces and re property de

The new w the provisions reparation Security Cou after the vot troops, "ques the situation e

Actress Jayne Mansfield Dies With Two Others In Car Crash

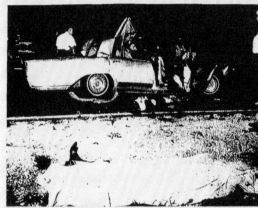

ACTRESS KILLED — A sheet in foreground covers body of Hollywood actress Jayne Mansfield, killed today when car in which she was riding smashed into truck in eastern section of New Orleans.

NEW ORLEANS (AP) — Beautiful Jayne Mansfield and two men were killed early today when their car rammed the rear of a truck slowed by a cloud of mosquito fog across the highway.

It happened on a U.S. 90 curve near the Rigolets, the waterway connection between Lake Pontchartrain and the Gulf of Mexico, in New Orleans. It was about 2:25 a.m.

Killed with the voluptuous 34-year-old Hollywood actress were Samuel S. Brody, who was her lawyer and companion, and the 29-year-old chauffeur, Ronnie Harrison of Mississippi City.

Police said three of Miss Mansfield's children, asleep in the back seat of the big gray car, were injured. Physicians said they were in fair condition. They are Marie, 3, Mickey Jr., 8, and Zoltan, 6, her children by muscleman Mickey Hargitay.

Two of Miss Mansfield's four Chihuahua dogs also died in the shredded auto, which jammed up under the back of the truck trailer.

"It was the most dreadful thing I've ever seen," said George Carmichael, head of the New Orleans mosquito control unit, who was called to the scene by the driver of the insecticide fogging truck.

Miss Mansfield had left Biloxi, Miss., about midnight and was en route to New Orleans where she was scheduled to appear on a television program at noon.

Police said the actress was decapitated.

The accident happened about 30 miles east of downtown New Orleans on a winding, narrow stretch of the two-lane route known as the Old Spanish Trail.

A doctor at Charity Hospital said Miss Mansfield's children were undergoing X rays.

Miss Mansfield was born April 1933, in Bryn Mawr, Pa., and grew up in Phillipsburg, N.J. Her real name was Vera Jayne Palmer. Later she moved to Texas and was graduated from Highland Park High School in Dallas and attended the University of Texas and the University of California at Los Angeles.

Her ascent to fame came accidentally when a press agent managed to get her on a publicity junket to Florida for a Jane Russell movie. She happily posed for photographers in a skimpy red bikini and stole the show from Miss Russell and other glamour girls on the trip. This brought her a contract at Warner Bros.

Jerusalem Now One Israeli City

By ERIC GOTTGETREU

JERUSALEM (AP) — The Israeli sector of Jerusalem and the Arab Old City which Israel seized from Jordan in the six-day war became one Israeli city today.

Interior Minister Moshe Shapiro issued a proclamation reuniting the Israeli and Arab sectors of the 3,000-year-old City of David for, the first time since the Jordan seized the walled Old City and Israel occupied the new sector in the 1948 Palestine war.

"Let us see to it that peace and mutual understanding shall prevail among all the city's residents," Shapiro said.

Israel acted despite warnings from the United States, the Soviet Union, Britain and the Vatican and increasing pressure at the United Nations.

The State Department said the United States does not recognize Israel's assertion of administrative control over the Jerusalem and its shrines of Christianity, Mohammedanism and Judaism.

"The hasty administrative action taken today cannot be regarded as determining the future of the holy places or the status of Jerusalem in relation to them," the State Department said.

Earlier Wednesday, the White House made a public appeal to Israel to avoid any quick annexation of the old section of Jerusalem.

King Hussein of Jordan called the Israeli action "unacceptable and intolerable." Christian religious leaders in Amman, the Jordanian capital, protested.

Yugoslavia and 14 other nonaligned members of the United Nations rushed a resolution into the emergency General Assembly calling on the Israelis to pull their troops back from all territory wrested from Egypt, Jordan and Syria in the six-day war. The sponsors called for action by Friday.

Israeli Foreign Minister Abba Khan countered with an announcement that his government would keep Jerusalem united and would administer the holy places with scrupulous respect to all faiths.

Weather

SHOWERS

Mostly cloudy today with scattered showers or thundershowers likely. High in upper 70s and 80s. Partly cloudy tonight, low in 60s and upper 50s. Friday partly cloudy and continued warm with chance of a few showers, high in 80s. Winds south to southwest 5 to 15 mph today and tonight.

Old City Annexa Sours Hussein M

By ENDRE MARTON

WASHINGTON (AP) — U.S. official ly the Israeli annexation of the Old Ci soured the atmosphere of President Joh ference with King Hussein of Jordan nation lost its war with Israel.

Officials also said they believed the annexation of the Jordanian sector was timed to coincide with the meeting Wednesday. Whether deliberately timed or not, it reportedly cast a pall over the Johnson-Hussein talks despite two U.S. warnings during the day against the annexation.

About the only public report of the meeting came from George Christian, White House press secretary, who said the two leaders reached "no identity of views" at their working luncheons.

Officials also said they expect neither warning to have much effect on Israeli leaders. The annexation, they added, proves that hawks dominate Israeli political life.

The first warning, issued by the White House, urged Israel to avoid any quick annexation of the Old City, which it occupied during the Arab-Israeli war earlier this month.

Shortly after the annexation, the State Department denounced the merger as a "hasty administrative action" and served notice the United States would not recognize it.

Both statements referred to Johnson's June 19 speech on the Middle East which counseled

"adequate a special inter great religio places of Jers This view, been made o government sions. Hussein, w York late W statement he the United Na jan. Urging the firm against statement ar accept any ar secure any aggression." What prom diplomatic W is a matter Christian said Those who w total victory continue to c government, prise the vast complished v not do attrac victories in 19 The hawks here it, was before some United States or at least re of such action

County Liquor Boar License For Colonial

The Washington County Liquor Board today approved the granting of a beer license to the Colonial Motel and Restaurant at 2749 Pennsylvania Ave.

The Class B, hotel and restaurant, on and off sale, beer, wine and liquor license was given to John H. Koob, R. Neal Spence and Ida T. Koob for the use of Colonial Motel, Inc.

The Liquor Board, through its chairman, J. Richard Rauth, stated that the applicants were well-known and respected citizens and that the Colonial Motel and Restaurant has been operated as a restaurant for many years.

The board noted that the serving of liquor would be part of the service in the restaurant, which closes at 10 p.m. and is operated as a part of a 25-unit motel. Emphasizing the lack of any "nightclub" attractions at the restaurant, the Liquor Board discounted the idea that a traffic problem by the grant

The Liquor that the Ass which had a operated in no longer re Two transf proved. They —Transfer eral, on an cense from trading as and Restaur Righam, tras away, 19½ m Alice Hamm Ragland, tra taurant, 500 On July 6 will be held for a Class license to T the Mid-Tow N. Prospect

President Off To Texas Holiday

PHILADELPHIA (AP)—President Johnson flew to Philadelphia en route to a Texas holiday today to tour an antipoverty program and to sign into law the legislation extending the life of the National Teacher Corps.

Johnson arranged to tour facilities operated by Opportunities Industrialization Center—a locally-developed program to train jobless adults, most of them Negroes, in new skills.

The chief executive added signing of the Teacher Corps Bill to his schedule because Friday is the deadline for approving contracts, meeting payrolls and making new commitments before a supplemental appropriation expires.

The Senate passed the bill and sent it to the White House only Wednesday.

Johnson said in a statement that the idea for the teacher corps — designed to channel qualified teachers into some of the poorer schools — "was so sound that it has withstood the fiercest budgeting and the strongest challenge."

From Philadelphia Johnson was flying to San Antonio, Tex., to attend a funeral.

ACTRESS AND LAWYER — Actress Jayne Mansfield and her lawyer, Sam Brody, were killed in an auto crash early today when their car struck a trailer truck in eastern New Orleans.

(AP Wirephoto)

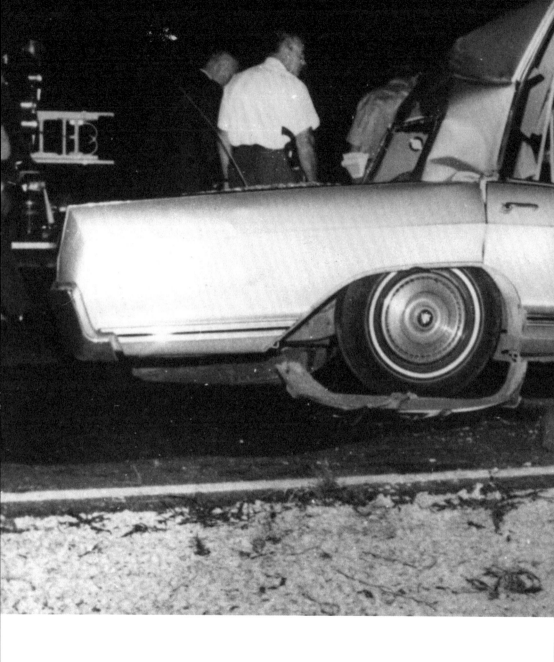

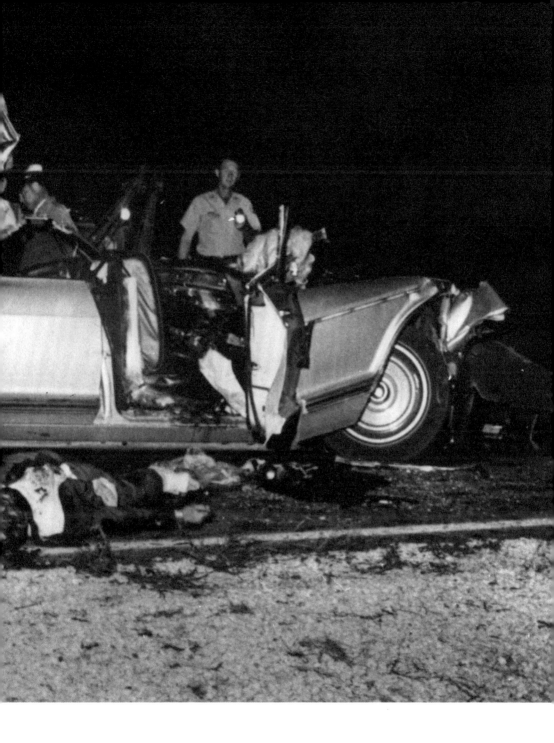

Gus Stevens an inexperienced student called Ronnie Harrison to drive her and four chihuahuas plus her lover Sam Brody and the three Hargitay children, Miklós, Zoltán and Mariska, back to the Cabana Courtyard Apartments in Biloxi, where they were staying.

The car was a 1966 Buick Electra 225, a classic General Motors design of the Bill Mitchell era. Vast in size, but handsomely restrained in detail, its cetacean elegance contrasted with the rococo style of its most famous passenger. It was a four-door coupé with frameless glass and an almost European restraint, although General Motors' marketeers could not resist the temptation of a little melodrama in calling the gearbox a Super Turbine 400 Automatic. The 'Deuce and a Quarter' was powered by vast V8s from six to seven and a half litres in displacement. In profile, like Jayne Mansfield herself, the Buick retained the gentle hip-line 'Coke-bottle curve' that had appeared first on the Roadmaster.

The route home was the Old Spanish Trail on US 90 between New Orleans and Biloxi, a pleasantly winding road that follows the coastline. At about 2.25am Mansfield's car was near Slidell, Louisiana on a stretch between the Rhodes Funeral Home and the Tokyo Restaurant. A truck spraying mosquito fogger on the road caused a Johnson Motor Lines truck travelling in front of the Buick to slow sharply. Harrison either did not notice or was so distracted by children and dogs, or perhaps by Mansfield herself, that he failed to brake.

The Buick submarined beneath the back of the truck, peeling off the car's roof and inflicting an avulsion of cranium and brain on Mansfield. She, Harrison, Brody and the chihuahuas were all killed instantly. By now customarily wearing a blonde wig, its separation from her head during the course of the impact gave rise to mawkish and sensationalist speculation that the Blonde Bombshell had actually been decapitated. Photographs

Previous pages: On the way home after a nightclub appearance, Mansfield's Buick rear-ended a truck on the Old Spanish Trail between New Orleans and Biloxi. The actress's blonde wig came off in the impact, leading to rumours that she had been decapitated.

of the accident scene showed an opened bottle of whisky next to a pathetic dead chihuahua. It is not unreasonable to speculate that alcohol played its part in the crash.

This was not the first time Jayne Mansfield had confronted death while driving: aged three, she had been riding in the car with her natural father when he died of a heart attack at the wheel. Coverage of her fatal crash was global and sensationalist, inspiring almost as many salacious rumours as Marilyn Monroe's overdose of five years before. All the elements of an authentic American tragedy were there: a second act that never came plus dark moments of disappointment, both overlaid with an ample gloss of sex. With pets and children added.

Mansfield's legacy included not only the enduring legend of the world's Most Publicised Sex Queen, a title since adopted by no one, but also legislation created by the US National Highway Traffic Safety Administration that all trucks should be fitted with a rear-mounted protective bar to prevent submarining. These safety bars became known to truckers as 'Mansfields'. Thus it is a nice footnote to a short, but coruscating, life that a name once associated with highly eroticised and inflammatory breasts instead became shorthand for road safety enhancements.

MARC BOLAN 1977

Purple haze

Marc Bolan is the reason we once wore indigo nail varnish, pink feather boas, black mascara, acid-Afro perms, cheekbone glitter and very tight trousers. Maybe his influence has been exaggerated, but for a glamorous moment Bolan represented the ultimate in telegenic pop music.

Despite or because of this, no one ever thought of Bolan as a musician or a lyricist of any very great talent. But he was a pouting performer, poetaster, sex god and self-invented glamour puss of consummate genius. His twin reference points were the classic rock of Eddie Cochran and the dream world of hippy warlocks and wizards, as seen from English suburbia. Accordingly, while a prolific writer (and a published poet), Bolan's expressive range is limited, even as it is eloquent of the abbreviated passions of his genre.

He writes (and reading it one can imagine a thumping bass playing an unheard melody): 'Well you're dirty and sweet/Clad in black/Don't look back/And I love you.' And then there was his Deb-o-ra who looked like a zeb-o-ra, whatever that means. The refrain to that song was 'Dug a re-dug a dug a re-dug re-dug.' 'Da-da-da-di-di-da, da-da-da-di-di-da' was another. That was on his 1970 breakthrough single *Ride a White Swan*. In a televised *Pop Quest* interview of 1975 Bolan says: 'I just do what I want to do and hope it works out.' In a lazy north London whine he also reveals: 'I don't like aeroplanes, you know. I don't like travelling.' But he did love to boogie on a Saturday night.

Anybody who has travelled from Putney towards Richmond in south-west London, along the Queen's Ride in Barnes, knows

the stretch of road after you pass Gipsy Lane, that blindly crosses the narrow railway bridge. Afterwards the road dips and veers slightly right and there is a thicket of trees on the left. Even driving cautiously, it is easy to make a mistake. Here enlivened occasionally by fresh additions, is a collection of tributes attached to what is now the stump of a sycamore tree.

A month after Elvis died, Marc Bolan was travelling from a party of Rod Stewart's at Morton's in Berkeley Square, a louche club, when his Mini hit that sycamore. He was on his way home to 142 Upper Richmond Road West, perhaps for a nightcap of hallucinogens. At this point, Bolan had recently returned from tax exile in the United States and Monaco. At twenty-nine, he was, by some accounts, looking to revive his career. By others, he had tired of urban life and was preparing to retire to his country house, The Old Rectory at Weston-under-Penyard, near Ross-on-Wye. Certainly, Bolan had begun to put on weight, his snake hips no more. It was the year after Punk and Bolan's glam-rock proposition of fabulous perm, eyeliner, stovepipe hats, tights and feathers was emphatically over, the more so now that he was dead. It was five in the morning. The sycamore became a shrine.

Bolan had spent time in Paris with a wizard who taught him to levitate, although before that happy moment his life had been more banal. He was born Mark Feld in gritty Stoke Newington Common in 1947, the son of a Russian-Polish Jewish truck driver whose own home had been the shtetl. The Felds won social promotion by moving to Wimbledon, although young Feld was not himself amenable to gentrification and his school efficiently expelled him at fifteen for bad behaviour.

He was, however, clever and pretty and in Sixties London that counted for a very great deal. There are features in *Town* magazine showing young Feld as an exemplary Mod. He modelled and acted bit parts in television and played guitar in a school trio that included the bluesy-pop singer Helen Shapiro. Soho became his milieu, hanging out at the 2i's coffee bar. At this time, Feld's role models were all American: Eddie Cochran, of course, Chuck Berry, and blues singer and guitarist Arthur 'Big Boy' Crudup. He adopted the stage-names Toby Tyler, then Mark Bowland. The final iteration

'Bolan' may have been a contraction of the first and last parts of 'Bob Dylan'. The 'c' in Marc is a nice, sophisticated touch.

Just moving into a celebrity of his own as Feld, flushed with Soho bravura, he released his first single, *The Wizard*, with Decca in August 1965. Bolan's group, Tyrannosaurus Rex, played (with Pink Floyd) at the first Hyde Park Free Concert in 1968 and it was at about this time, in an authentic stroke of creative genius, that Bolan wholly abandoned the Mod mode and began to explore the artistic possibilities of London's enlarging psychedelic hippie-subculture. An idea that was to become the basis of a more streamlined T-Rex was beginning to form in his mind. In 1969 he published a volume of poetry called *The Warlock of Love*. It sold an astonishing 40,000 copies. He painted a paisley motif on his Fender Stratocaster and glam rock was his new territory to exploit.

Ride a White Swan was followed in 1971 by the edgier *Hot Love* and *Get It On*. When T-Rex performed *Get It On* on the BBC's *Top of the Pops*, girls in ribbed sweaters and firm underwear danced demurely while acid Afro Bolan snarled and pursed his lips, with his guitar thumping a copulatory rhythm. Wearing glitter on his sculpted cheekbones, and with his hips kicking out the tails of his silver satin jacket, he sang: 'You're built like a car/You got a hubcap/Diamond star halo.' These are brilliant lines.

Many of Bolan's lyrics refer to cars. An early song was *Mustang Ford* and he wrote *Jeepster*, the reference being to designer Brooks Stevens' domesticated military Jeep. Bolan's Ford Mustang, perhaps articulating the consumerist fantasies of a boy from Stoke Newington, was 'all put together with alligator leather' (while the actual car had plastic upholstery). And In *Jeepster* we can hear: 'Just like a car/You're pleasing to behold/I'll call you Jaguar/If I may be so bold.' He continues: 'Girl I'm just a Jeepster/For your love …' culminating in: 'I'm gonna suck you.' This is bold, unambiguous, material, but the real-life Bolan was a little more timid. He had no licence and was afraid of driving.

Overleaf: Marc Bolan loved cars, but never learned to drive: glam rock was happy with symbols alone. Here he is at the wheel of a cherry red convertible on the set of *Born to Boogie*, 1972.

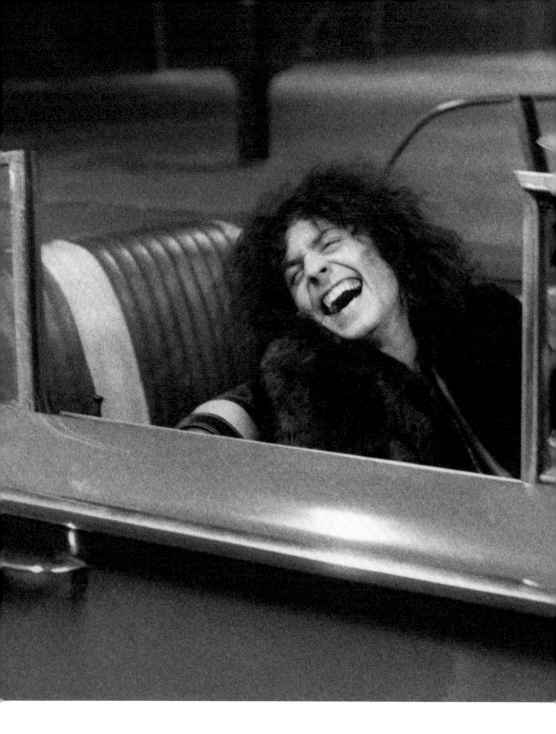

At one point, The T-Rex Wax Company, the label EMI had given Bolan, accounted for 6 per cent of national record sales, but by the mid-Seventies his art and his life were in disarray. In 1975 he had left his wife and married his backing singer Gloria Jones, herself the author of a Motown style thumper called *Tainted Love* (whose flipside was *My Bad Boy's Comin' Home*). Jones was the mother of Rolan Bolan, Marc's son.

On the night of the accident, Bolan and Jones, the latter driving and neither of them wearing seat belts, left Rod Stewart's party in a purple Mini 1275 GT, registration number FOX 661L. Bolan also owned a white 1960 Rolls-Royce, but the Mini was evidently preferred for city work. This 1275 GT was not the famous Mini Cooper, but a curious facelifted variant which traded some of Alec Issigonis's original Fifties austerity for a bit of cack-handed Seventies styling.

The designer was Roy Haynes, who at Ford had created the handsome 1966 Ford Cortina. Like the Cortina, the 1275 GT had a squared-off front end, a meretricious bit of nonsense which added weight, ruined proportions and traduced the integrity of the original Issigonis concept. A gutsy little engine gave the 1275 GT decent acceleration, but the silly nose job compromised aerodynamics and left the car struggling to reach ninety miles an hour.

Several days earlier, a wheel had been removed from Bolan's Mini in order to repair a puncture and there is speculation that the repaired tyre was under-inflated or, perhaps, that the wheel itself had not been securely re-attached to the hub. For whatever reason, the Mini left the road just after cresting the rise of the railway bridge, hit a steel crash barrier, and came to rest against the sycamore tree.

Bolan received fatal head injuries, perhaps from an eye bolt in the crash barrier. A London fireman, Chris Watts, was on his way to a blaze in Kingston upon Thames when he came upon the crash

The Mini 1275 GT, manufactured between 1969 and 1980, was a market-led variant of Alec Issigonis's classic Mini and a travesty of the original's purity. It was 'styled' by Roy Haynes, who had previously worked for Ford. It replaced the classic Cooper S, but had none of that car's dignity.

scene. Having at the time no idea of the victim's identity, Watts said 'It was pretty obvious there was no rescuing to be done ... A woman, who had been driving, was standing by the vehicle.' That was Gloria Jones. Bolan was declared dead on arrival at the local hospital.

During the day after the crash, Bolan's house at 142 Upper Richmond Road West was looted for souvenirs and some master tapes remain missing. Several ironies and curiosities attend the crash. In his 1972 song, *Solid Gold Easy Action,* Bolan writes of 'picking foxes from a tree', seemingly an apprehension of the Mini FOX 661L and its collision with the sycamore. However, even more inspiring for conspiracists, fabulists, occultists, romantics and demented fans is this. Bolan had a flower-powered crush on the art of René Magritte, the popular Belgian Surrealist. Then as now, one of Magritte's most popular pictures (widely available as a print) was *The Sixteenth of September*, an image of a sycamore tree painted in 1957. The 16th of September was the date of Marc Bolan's fatal crash.

In 2015, The Bolan Tree, as it had become known was, and it is not at all difficult to see irony here, felled for reasons of health and safety and a capping barrel was put over the raw stump. The work was undertaken by Bartlett, the royal warrant-holding tree surgeons under contract to the vigilant T-Rex Action Group, the protective guardians of the site. The Bolan Tree remains a place of pilgrimage, and Marc Bolan's legend is nurtured by adoring, ageing hipsters all over the world.

Marc Bolan was being driven home by his girlfriend, Gloria Jones, from a Mayfair party thrown by Rod Stewart. Just after cresting a railway bridge in Barnes, south-west London, Jones lost control and the purple Mini 1275 GT left the road and collided with a sycamore tree. Jones survived without serious injury. The crash site is now a place of pilgrimage for T-Rex fans.

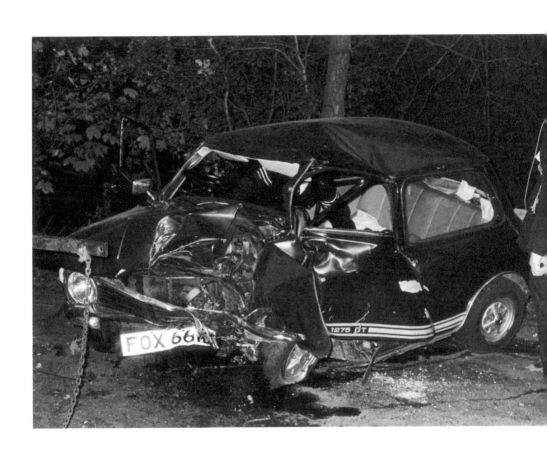

MIKE HAILWOOD 1981

Just a bloke who rides bikes

In 1993 New York's Guggenheim Museum held a curatorial meeting to discuss a planned exhibition about motorbikes. Thomas Krens, its Director, preserved his notes from the meeting: 'The motorcycle is a perfect metaphor of the twentieth century ... its evolution tracks the main currents of modernity.' Five years later, the Guggenheim opened its *The Art of the Motorcycle* exhibition. In an installation designed by Frank Gehry, up and down the Guggenheim's amazing helical ramp, machines were displayed instead of paintings. Not since Pontus Hultén's 1968 exhibition at New York's Museum of Modern Art, *The Machine as Seen at the End of the Mechanical Age*, had art and machinery been so gloriously conflated.

It is true that the motorbike is a beguiling aesthetic proposition. Within the simple template of two wheels and an engine, the variety of formal solutions seems virtually infinite. A motorbike design is a diagram of powerful forces, constrained by the intellect. One principle, almost a paradoxical one, connects the philosophy with the mechanics: for a motorbike to become stable, it needs to be travelling fast.

Additionally, for Machine Age Romantics, a motorbike's details are expressive and beautiful, frank tributes to the beauty of form following function. Krens became almost carried away with the possibilities of his subject: 'As a form class at the end of the twentieth century [the motorbike] embodies its own end-game paradox. Logic and physics suggest it has reached the end of its evolutionary potential, but somehow we know that cannot be completely true.'

But motorbikes are something else as well. They are dangerous and subversive, fascinating and fearful. As Dennis Hopper wrote: 'Crash and burn/Outlaw glory/Motorcycle mama/Tits to the wind.' From the infamous Hollister Motorcycle Riot of 1947 we derive the popular depiction of Hell's Angels. From Marlon Brando's Johnny on his Triumph in 1953's *The Wild One* we take the lasting image of two-wheeled rebellion. And in Mike Hailwood we have the greatest motorbike racer of them all.

Stanley Michael Bailey Hailwood was the son of 'Old Stan Hailwood', a prosperous Midlands motorcycle dealer and a rider himself. The family home was a house of some standing in the pretty Oxfordshire village of Great Milton, although the young Hailwood did not dally much with gentility and its diversions. He wanted to race bikes and did so with more success, bravura and style than any rival before or since.

'Mike the Bike' won the notorious Isle of Man Tourist Trophy race twelve times. This is routinely, and quite correctly, regarded as the scariest race in the world. To ride the circuit at ordinary speeds would be testing to most individuals. To win it once in competition would be heroic. To win it twelve times was to invite comments about infallibility and therefore, perhaps, to anger the gods. But there was more: between 1961 and 1967 Hailwood won nine GP Motor Cycling Championships. His achievements were consummate and his reputation unsurpassed, but by the later part of his career, the politics of the sport had become fatiguing.

Hailwood had begun to ride at the age of ten. By 1961 he was riding for Honda, when the Japanese company was still a parvenu, both ambitious and unproven. Soichiro Honda said that having Hailwood in the saddle was worth an extra twenty horsepower. During a period in the late Sixties when Honda withdrew from racing, the company famously paid him £50,000 a year not to ride for another manufacturer.

Mike 'the Bike' Hailwood was one of the greatest motorbike racers of them all and a hard-partying, down-to-earth, gentlemanly type. He won nine world championships, seventy-six Grands Prix and fourteen Isle of Man TT races. 'For the love of sport' was painted on his fairing. Here he is on an MV Agusta, winning the Isle of Man Senior TT, 1964.

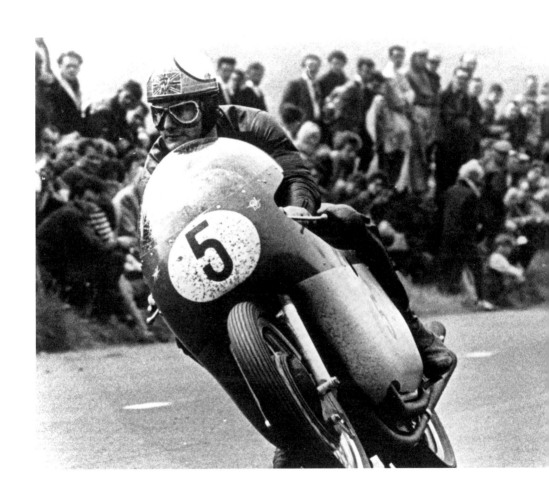

The New Tradition

3500

In 1962 Hailwood moved to the patrician MV Agusta – which had been founded by a Sicilian count – and subsequently became the first rider to win four consecutive 500cc World Championships. Throughout his career, Honda and MV Agusta contested his hand on the twist grip. In the last race of 1968 he was riding for MV Agusta. But there was a suspicion that the team had interfered with his bike so as to favour his teammate, Giacomo Agostini. Possibly it was a reprisal against Hailwood who, to the chagrin of the MV Agusta management, was still dallying with Honda. In the actual race, Hailwood chose to ride a Benelli, but fell off. Never seriously injured in a bike accident, this embarrassing tumble was symbolic of his growing disenchantment with the sport.

As early as 1964 Hailwood had raced cars, finishing a creditable sixth in a Lotus-BRM at Monte Carlo, but now he decided to commit himself entirely to four-wheel racing. He raced in a total of fifty-four Formula One Grands Prix, winning two podium places and a battling fourth in a Surtees at Monza in 1971, which impressed everyone. At Le Mans in 1969, he finished third in a Ford GT 40. Only by his personal standards were these achievements unimpressive. Instead, Hailwood made a new reputation for himself.

In 1973, Hailwood collided with the pugnacious Swiss driver Clay Regazzoni during the South African Grand Prix at Kyalami. The Swiss driver's car immediately caught fire. The marshals were slow with their extinguishers and it was Hailwood who went into the blazing wreckage to rescue Regazzoni. After a minute or so of tugging at the harnesses, a fire marshal arrived and extinguished the flames. When the air cleared, Hailwood returned. Anyone who has seen the video knows that he paid no attention at all to his own safety. His wife, Pauline, sitting in the pits, was entirely unaware of her husband's heroics until she saw it later that night on the hotel's television. Hailwood was awarded the George Medal, Britain's highest civilian award for bravery.

The 1976 Rover SD1 was a sophisticated design by David Bache and Spen King, who created the epochal Range Rover. Bache took styling cues from the Ferrari Daytona, but the Rover was a practical car. Fast as well, with its 3.5 litre V8 engine. With a nod to local loyalties, Midlander Mike Hailwood chose this Solihull product as his personal car in his retirement.

(Clay Regazzoni, who had been paralysed from below the waist in another accident at the 1980 US Grand Prix West, died in 2006 when his Chrysler Voyager tail-ended a truck at modest speed on the autostrada near Parma.)

A 1974 crash in a McLaren at the Nürburgring, led to Hailwood's retirement from a mixed experience of motor-car racing. In any case, an egalitarian who disliked cant and unearned privilege, he had complained of being socially uncomfortable in Formula One. He said: 'I am just a bloke who rides bikes,' and a bloke who preferred the company of mechanics to the society of millionaires. He chose New Zealand and a farming project as distraction, but soon became bored. Aged thirty-eight, and after an eleven-year absence from motorcycle racing, Mike the Bike made his comeback race in 1978. Against all expectations, he won the Formula One event in The Isle of Man TT riding a Ducati 900SS. This has often been described as one of the greatest moments in sporting history.

Riding a motorbike at any level requires extraordinary degrees of concentration and coordination not necessary when driving a car. On the road, accidents are rarely trivial. The consequences of an error are 'severe enough to make the game worth playing well' according to Keith Code in *A Twist of the Wrist* (1983). But professional motorbike racers have learnt how to take falls. They make their calculations: at a terrible moment when you are going too fast and you lose the precious control so patiently acquired, the racer needs to decide whether to let the bike go or attempt to change its lethal course.

Film exists from a camera mounted on Hailwood's bike as he rides the Isle of Man's terrifying Snaefell Mountain Course: thirty-seven miles of narrow, sinuous public roads with menacing rocks and man-made hard places everywhere. His mechanic Nobby Clark reminds us: 'Back in those days, suspension was just a word.' You see Hailwood push-starting a big bike: with the very high compression engines, this in itself was no small effort. As soon

Mike Hailwood's accident and the death of his daughter are reported in the local newspaper. He died in hospital, two days after the crash. An international hero who had never been seriously injured in a bike race died on a suburban bypass while going out to get fish and chips.

Hailwood's battle for his life

by NIGEL FREEDMAN

Mike Hailwood with his wife Pauline and children David, 6 and Michelle, 9.

Former world motorcycle champion Mike Hailwood was fighting for his life in a Birmingham hospital today unaware that his daughter was killed in the same crash.

The man who was ten times world motor cycle race champion and who won the George Medal for courage was "deeply unconscious and critically ill," at Birmingham Accident Hospital today.

The crash happened on Saturday night, two miles from the 40-year-old star's luxury Warwickshire home at Tanworth-in-Arden as he took his nine-year-old daughter Michelle, and six-year-old son David, to buy fish and chips.

Mike's 'S' registration Rover 3.5 was in collision with the back of a lorry on the A435 at Portway. The impact ripped the roof from the car and virtually demolished the driver's side.

Michelle died instantly from multiple injuries but David escaped with cuts and bruises. Their father was cut from the wreckage with severe head injuries.

At bedside

Mrs. Pauline Hailwood was at her husband's bedside today and was too upset to talk about the tragedy. With her was their close friend Mr. Rod Sawyer.

He said: "We are all shattered by what has happened. It has not really sunk in yet.

"Mike is a super guy. I was best man at his wedding and godfather to the children. This is a big blow for the whole world. He has some severe injuries."

Mike Hailwood, who won over 1,000 races in a 20-year career, retired in 1979 to concentrate on running his motor cycle business with partner Rod Gould in Birmingham.

He became a motor cycle

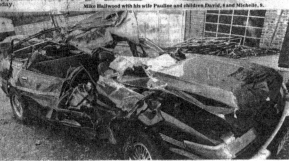

Hailwood's wrecked car after the crash.

as the engine fires, Hailwood, pushing from the left of the bike, leaps on sidesaddle. As the bike slowly gathers speed, one leg is slung over and the ride begins.

From Quarterbridge to The Nook, via Ballaugh Bridge and Stonebreaker's Hut, the circuit begins in town and opens out on to wild, bleak, forbidding mountainous country. The blurred speed, angles, drops, dips, descents, blind crests, bumps, shadows, mist and rain are terrifying. This, you think, is at the very limit of human achievement. Its demands are extreme bravery, exceptional perception and extraordinary balance. All the time, the rider is fractions of a degree and seconds away from violent death. And still the speed increases. The climb from The Bungalow to Brandywell is now called Hailwood Rise and the highest point of the course is Hailwood's Height.

Hailwood's heights were not to be repeated. At thirty-nine, he finally retired from all forms of motor sport, its dangers and its pleasures. The latter were not inconsiderable. People say it was Mike Hailwood who taught the libidinous and hard-drinking James Hunt how to party. Even the official McLaren website says the nicely cavalier Hailwood was a bit of a handful when he let his hair down. His wife admitted that: 'He was a little bit wild.' He liked to listen to jazz. He wore good clothes. He had nice cars. One of them was a Rover SD1.

This was, at least as understood in the English West Midlands in 1976 when it entered production, a very sophisticated automobile design. A large, five-door hatchback, it was drawn by David Bache (an exotic genius who lived in a bungalow in Solihull) who had earlier drawn the influential Range Rover and later drew the wretched Mini Metro. The SD1 had a modern, modular interior and an aspect that very consciously, if absurdly, recalled Pininfarina's Ferrari Daytona. Its engine, however, was less aristocratic: a punchy, lightweight 3.5-litre V8, derived from an Oldsmobile design. Nonetheless, the Rover SD1 was fast and competent for its day.

In retirement, Hailwood had become a motorcycle dealer in Birmingham. He had, blokeishly, dabbled in trade before: during a South African sojourn he was involved in a car spraying business, often featuring (wearing a crisp double-breasted suit) in ads

endorsing polymer paint systems. Anyway, in whatever delirium of provincial tedium he was experiencing, on the evening of Saturday 21 March 1981 Hailwood took his son and daughter out to fetch fish and chips. The banality of a takeaway tragedy in suburbia still astonishes.

Along a stretch of the A435 at Portway, near Hailwood's home at Tanworth-in-Arden, a truck crossed the central reservation in front of his car. Evidently, reactions that had kept him safe in the Isle of Man TT, flat-out on the Mulsanne Straight and through the treacheries of Monaco were not enough to avoid a collision. Hailwood's daughter Michelle, aged nine, was killed instantly. His son David, aged six, survived with minor injuries. Hailwood died in hospital two days later. The truck driver was fined £100.

In 1981, his lover Elizabeth McCarthy, who first met Hailwood at the Canadian Grand Prix in 1967, published her memoir. She said Hailwood predicted that he would not live beyond forty and had intimations that a truck would be involved in his demise. On the day of the crash, he was nine days away from his forty-first birthday.

Motorbike racers will all understand what Hunter S Thompson, himself a bike nut, said he wanted on his tombstone: 'It never got fast enough for me.' Indeed, Mike the Bike was always pushing. In February 1964, riding an MV 500, he set a one-hour speed record of 144.8mph at the Daytona banked oval circuit in Florida. *One hour!* On the public roads of South Africa, Hailwood routinely drove his Iso Grifo on the 870-mile journey from Johannesburg to Cape Town at an average above 85mph. No one knows what speed the Rover was doing at the time of the accident, although its wreckage is curiously similar to the remains of the Iso, which eventually, perhaps inevitably, collided with a cow on a country road. The headlights on the prognathous snout of each car are preserved, but the roof has been crushed. In the South African incident, Hailwood and his passenger escaped with superficial scratches …

At Hailwood's funeral James Hunt and his rival Giacomo Agostini were among the pallbearers. His gravestone says: 'Too good in life to be forgotten in death.'

PRINCESS GRACE OF MONACO 1982

Torrid, sex-crazed man-eater

The Corniche roads of the South of France are among the most romantic in the world. The coastal road is, nowadays, a sluggish procession through traffic lights, but passes through the famous old fishing villages, now matured into tacky yet still glamorous resorts, which made the Côte d'Azur an eponym for sun-drenched pleasure. But it is the middle and upper Corniches – the Moyenne and Grande Corniches – that dominate our imaginations. 'Corniche' means 'cornice' and these roads are literally cut into the mountain as if an architectural feature.

The views are sublime and the bends demanding. The Upper Corniche is often used for motor industry advertising shoots since the vistas available to the lens evoke powerfully the senses of freedom and opportunity which cars are said to offer. And the sunlight flatters their bodies.

The Corniche Inférieure is the eighteenth-century road that follows the coastline. It is now the D6098. The Moyenne Corniche, or D6007, was built between 1910 and 1928. Before the A8, La Provençale Autoroute was the main road from Nice to the Italian border. But the ultimate is Napoleon's Grande Corniche, the D2564. This follows the old Roman Via Julia Augusta and passes Col des Quatre Chemins, Col d'Eze and La Turbie before descending to Roquebrune. It was on the D37, the Route de La Turbie leading down to the Moyenne Corniche, that Princess Grace crashed her dark green Rover P6 3500 and died. She was returning to Monaco from her holiday home at Roc Agel. She had over-packed for the vacation and the car was so

overloaded with bags, hatboxes and dresses draped over the back seat that she dismissed the chauffeur and decided to drive herself.

Grace Kelly, the daughter of a prosperous Irish builder, an Olympic rower, from Philadelphia, had been the Princess of Monaco for a quarter of a century. 'Fairy tale' is the lazy tag attached to her life after Hollywood and she certainly maintained a fabulously starstruck and starry existence. But there were elements of nightmare mixed into the dream world. She claimed, for example, to have suffered psychological abuse as a child. Perhaps as a consequence of this, she was tough on her own children. She spanked Princess Caroline regularly and said of Princess Stéphanie 'I should have been beating her like a gong long ago.' Maybe another residue of her upbringing, her protective shield, is what her great director, Alfred Hitchcock, recognised when he described her personality as 'fire under the ice'.

Her passions were acting and men, a mixture of appetites that her chosen career in cinema was well able to satisfy. Out of school and away from interfering parents, while staying at The Barbizon Hotel for Women on New York's 63rd Street, a residential hotel for well-brought-up white women, she began affairs with the actor Clark Gable and the fashion designer, Oleg Cassini, who once wrote for her on a scrap of paper *Io ti amo e ti voglio sposare* – I love and want to marry you.

Kelly's first film appearance was in an insecticide commercial and as an agency model she also promoted cigarettes, dandruff shampoo, beer and moisturisers. But her career developed rapidly. She played in Strindberg on Broadway and auditioned herself restlessly until she won a career-making role in Fred Zinnemann's *High Noon*. At one screen test John Ford, no less, said 'That dame has breeding, quality, class.' Indeed she had.

She made eleven (mostly) great films in five years. Both *Dial M for Murder* and *Rear Window* were released in 1954. Hitchcock's masterpiece *To Catch a Thief* followed a year later. This last tile

Alfred Hitchcock's *To Catch A Thief* was released in August 1955. Its scenes shot on the Grande Corniche are among the most evocative in all cinema. In the film, Grace Kelly drives a bright red Sunbeam Alpine.

was shot in spectacular VistaVision and featured a perfectly cast Cary Grant as her elegantly mischievous companion. In 1955 Kelly won an Oscar for *The Country Girl*. And in the same year, at the Cannes Film Festival, she met a young Prince Rainier. His courtship rituals included showing her his private zoo. They married on 18 April 1956 and Grace Kelly of Philadelphia was translated into Princess Grace of Monaco.

There is now so much glitter attaching to Monaco with its hyper-yachts, oligarchs and Michelin stardust that it is almost impossible to imagine that sixty years ago it was an isolated and unventilated backwater: a 'sunny place for shady people' as Somerset Maugham described it. A French newspaper of 1929 said that Monaco was: 'a box of toys in which everything is brilliant and artificial and a little fragile, and must be carefully fitted into its place if it is not to be broken'. Kelly's father had to offer a dowry of $2 million. It was a simple transaction: the bogtrotter's daughter got a European title and Prince Rainier had the means to start rebuilding Monaco.

Rainier's ambitions for Monaco may be suggested by the anecdote that when he visited the Houston Astrodome, his response was 'we could be the world's only indoor country'. But as Prince Rainier set about modernising his pocket principality – perhaps, some speculate, with the assistance of unscrupulous business contacts – his princess was required to retire from Hollywood. She made one last bid for further stardom, pitching for the female lead in Hitchcock's *Marnie*, but Tippi Hedren was eventually given the role and Kelly settled down into her own fantasies as Monégasque image-builder.

Sex was, it seems, always important for Kelly. Certainly, as Anthony Lane noted in *The New Yorker,* 'the sex life of Grace Kelly, like the home life of the Incas, is one of those distant but down-to-earth matters which we can investigate in depth, and muse upon at length, but never really hope to understand'. Lane's reservations

Princess Grace about to get into her dark green Rover 3500, registration MC12, in Monaco, 1973. It was Grace's habit to drive a London black cab around the principality, but years before her crash she swore 'I'll never drive again' following a minor traffic accident.

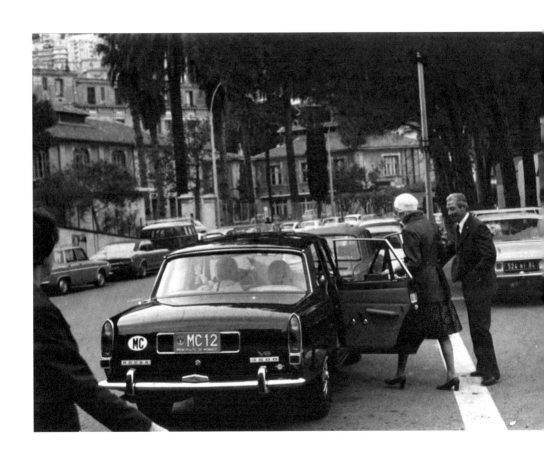

are sound and tasteful, but Kelly certainly had an extramarital affair with Frank Sinatra and probably with Marlon Brando. Grace was a home-wrecker and a nymphomaniac. Even Zsa Zsa Gabor, no one's idea of a reticent virgin, said 'Grace had more lovers in a month than I did in a lifetime.' All this was amplified by J Randy Taraborrelli in his book *Once Upon a Time* (2003), while Robert Lacey's 1994 biography *Grace* was described by Prince Rainier, something of a philanderer himself, as 'dirty and untrue'.

Thus, muckraking speculation of amazing vulgarity about the precise nature of Princess Grace's erotic interests has been vigorous ever since. The torrid, sex-crazed man-eater who was released when Philadelphia ice moved to the fiery Med is alleged to have been involved as a Priestess in the Order of the Solar Temple, a hilarious, eroticised Doomsday cult based in south-central France. Created by one Joseph Di Mambro and Luc Jouret, the Solar Temple was inspired by the ludicrous satanic posturings of Aleister Crowley, who styled himself 'the wickedest man in the world'. It is thought that the Solar Temple may have been a cover for the CIA's Operation Gladio, a Cold War initiative to provide resistance in Europe in the event of a Warsaw Pact invasion.

Whether geopolitics were of primary interest, we cannot say, but Grace, it is said, was inducted into the cult at a ceremony in the little Beaujolais village of Villié-Morgon. Candidates were required to disrobe and then to be acupunctured on meridians known to give intense sexual pleasure. After multiple orgasms enjoyed in this fashion, new inductees were given spiked drinks, dressed in a white Templar robe (with a natty red cross) and invited to lie upon an altar in the crypt, perhaps to be cooperatively enjoyed by cult affiliates, while Wagner played in the background. Clearly, Hollywood provided a sound preparation for such nonsense.

Grace's striking Irish-American beauty has a very obvious aesthetic appeal, but the intense erotic aura she generated both

On the morning of 13 September 1982, Grace crammed her Rover with hatboxes, suit-bags and suitcases. It was so overloaded, the chauffeur was dismissed and she decided to drive herself and daughter Stéphanie down the steep and sinuous descent from the holiday home at Roc Agel to Monte Carlo. The car left the road at a notorious bend known as The Devil's Curse.

on and off screen is sourced elsewhere. Despite her perfumed radiance and immaculate poise, an air of danger and darkness surrounds her. Perhaps sourced in childhood episodes of abuse, she flirted with, even embraced, the dark side. Even in her superbly elegant masterpiece, *To Catch a Thief,* the Cary Grant character is a cat burglar (admittedly, a burglar in silk socks). Then the suggestions of sexual success are evidence, of a sort, that she inspired in viewers intense speculation that her superficial perfection was just a disguise for earthy lust. And the whole question of Monaco's growth, over which she so regally presided, was, perhaps, based on mob money. Her daughters, Stéphanie and Caroline, have acquired some of this nostalgie de la boue, each, variously making inappropriate liaisons with adventurers, lion-tamers and slightly shop-soiled aristocrats.

The circumstances of Grace's crash on 13 September 1982 give spittle-flecked conspiracists ample ground for theorising. The road down from Roc Agel is difficult and has steep descents and blind turns. The distant, lovely vista of Saint-Jean-Cap-Ferrat serves only to contrast with what is a rather terrifying road. And Grace was reputedly a rather poor driver. In Monaco she used a black London taxi-cab until the day in the Seventies when an absurd collision in the centre of town made her say 'I'll never drive again.'

After her death, wild stories abounded. Was the Princess's mind distracted because Joseph Di Mambro was blackmailing her? Was the crash a hit by illegitimate Italian businessmen irked that Rainier had not paid his debts and dues? Was the notorious P2 Masonic Lodge, of which Rainier was a member, involved? Had she let the troubled under-age Princess Stéphanie drive? Was it sabotage? After the crash, the remains of the car were hurriedly taken to a police garage, far away from public view.

Reactions to Grace's death were astonishing. One US tabloid sent seventeen reporters. Her portrait appeared draped in black in vitrines. In the swirling purple mists of speculation, a few hard points are clear. As the Rover descended from Roc Agel, an eyewitness driving a truck along the same road saw the car

moving erratically as it approached an infamous bend known as 'The Devil's Curse'. The other driver blew his horn to attract attention, but the Rover accelerated rapidly, smashed through the retaining stone parapet and tumbled one hundred and twenty-feet down a precipitous maquis-covered hillside. Grace at first appeared in a survivable condition, having suffered a stroke, but later died in hospital of a brain haemorrhage. She was fifty-two.

Stéphanie was hardly injured at all, although neither she nor her mother had been wearing seat belts. Speculation that Stéphanie was driving ended when Jeffrey Robinson reported that she told her sister Caroline: 'Mummy kept saying: "I can't stop. The brakes don't work. I can't stop".'

Poetically, this terrible automobile dégringolade happened close to the D53 where in an earlier and less troubled life Grace Kelly had driven with Cary Grant in *To Catch a Thief*. Her car on that occasion had been a red Sunbeam Alpine and the cinematic journey one of elegant, joyful felicity. So here were two different lives, two different readings of Corniche byways and one life dramatically and elegiacally ended near to where its fairy-tale trajectory began.

One hundred million people watched Princess Grace of Monaco's funeral on television. British Leyland, manufacturers of the Rover P6, sent technicians to examine the wreckage, but if a fault was found, it was never published. The remains of the green Rover were crushed into a cube and unceremoniously dropped into the blue Mediterranean.

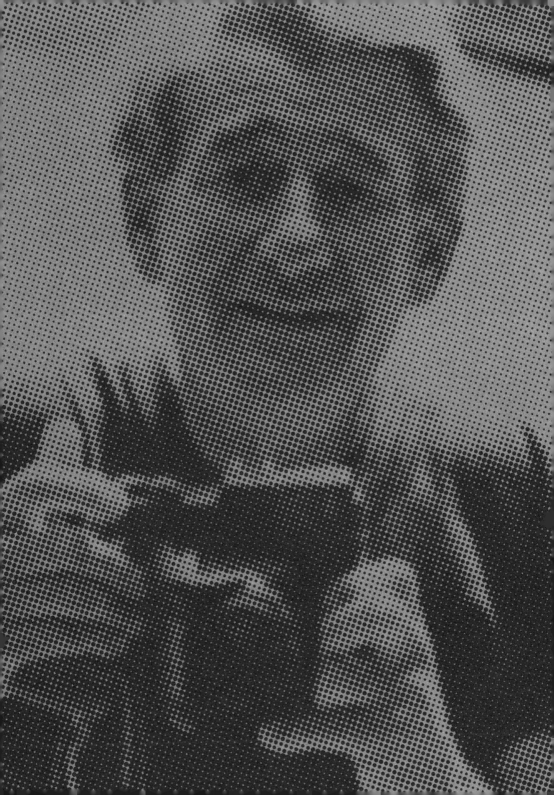

HELMUT NEWTON 2004

Me and my Caddy

Helmut Newton had been the last photographer to work with
Salvador Dalí. The great Surrealist showman died, just a few days
after the shoot, at his home in Figueres, Catalonia. Fifteen years
later, to the very day, Newton died in Los Angeles' Cedars-Sinai
Medical Center.

 No one reckoned Salvador Dalí to be the greatest Surrealist
artist, but he was undoubtedly the movement's best messenger,
providing ample, alarming, but undemanding images for a middle-
brow public. As a result, he achieved extraordinary popularity. Nor
does anyone reckon Helmut Newton the greatest photographer.
He was not even the greatest photographer of nudes. Newton
dealt with caricatures, not personalities. When men appear in his
pictures, they are passive. Just like crash-test dummies, someone
once said. Newton's medium was deluxe porn. His expressive
range was limited and he was not afraid of repetition. But what
he did do, with great style, was to gentrify erotica for the world
of fashion.

 Newton made sexualised images with the allure and sheen
of luxury products, or, indeed, great motor cars. A critic explained
that, while there was not much spiritual about his work, there
was quite a lot of occult content. A signature Helmut Newton
photograph usually has a dark and curious narrative, as well as a
dark, curious and handsome woman with grotesquely exaggerated
nipples or gloriously copious or self-consciously trimmed pubic
hair. As a result, he achieved extraordinary popularity. 'Iconic'
is an abused term, but Helmut Newton created iconic nudes.

211

Newton was born in Berlin in a household he described as being more German than Jewish. His first camera was a Zeiss Ikon Box Tengor, a semi-professional 120 film camera introduced in 1926, the same year as the more agile and modular Leica. He was taught the craft by 'Yva', the nom d'artiste of Else Neuländer-Simon, who specialised in dramatic compositions using the female body and was a very successful editorial photographer of her day. Yva died in the Sobibor extermination camp, a victim of the *Endlösung der Judenfrage* atrocities.

Berlin in its cabaret years was formative. Newton's first sexual experience was with one of his parents' maids, something that presumably influenced an explicit taste for women in uniforms, richly developed in his oeuvre. He admired Hitler's cinéaste, Leni Riefenstahl, who was herself no stranger to uniforms and body fascism. Newton's brother, Hans, introduced him to Berlin's red-light district where he was much impressed by a hooker called Red Erna who wore red boots and carried a riding crop. An image of the Über Fräulein, the dominatrix, the sexualised Super Woman, was with him ever after. In his *Autobiography* he wrote of one example: 'There was a girl, a printer, in the darkroom, who was an ex-Bauhaus student. She used to wear black velvet suits and a white shirt and collar. She also wore a monocle ... that just drove me sexually insane.'

Newton confessed that: 'Nazi images left an indelible impression on me.' Inevitably, he left Berlin in 1938 before the Nazis began on projects much more sinister than mere imagery. Seeing himself as a 'Rasender Reporter', a globe-trotting photo-journalist with a point-of-view, Newton found his way to Singapore where he kept a job for a mere two weeks before being fired. Then he moved to Australia before finding his way back to London and a job on UK *Vogue*. In 1958, he returned briefly to Berlin and found Yva's studio just as she had left it before the SS took her away.

After a year in London, Newton packed up his white Porsche and took himself to Paris. There he discovered Pauline Réage's *Histoire d'O*. Among many memorable images in this masterpiece of camp literary porn was the masochistic heroine being led,

with a mixture of pleasure and pain, by a chain attached to her labia. In Paris, Newton began working for French *Vogue* which, at the time, was the only mainstream publication prepared to handle his provocative nudes.

Of course, he travelled widely to locations for *Vogue* and later for his fashion clients, when he had become disenchanted with magazines. En route, he developed a passion, which some described as an obsession, for grand-luxe hotels. In the winter, he lived in a suite in Los Angeles' Chateau Marmont.

Many of Newton's shoots took place in sumptuous Paris hotel rooms whose fluff and stuff serve to emphasise the dramatic nakedness of his subjects. In one, a waitress walks in with a tray, disturbing a pair of crash dummies on the verge of delectation. The luxurious anomie of the suite seemed especially attractive. That's the occult feel you get in many of Newton's photographs, what Roland Barthes, talking of Greta Garbo, called a 'mystical feeling of perdition'.

Newton had a special affection for Los Angeles' Chateau Marmont, which he used as a set for his 1992 'Domestic Nudes' series. One mordant photograph of Sunset Boulevard was shot through a telephoto lens, which foreshortens the vista. The famous Chateau Marmont sign is immediately juxtaposed with a warning poster about the treacherous glamour of cocaine. Indeed, the Chateau Marmont was a hotel with a hinterland of celebrity indulgence. Robert Mitchum, a marijuana addict, Jean Harlow, whose reputation was trashed by Dorothy Parker, and Greta Garbo, sexually ambiguous, all enjoyed its facilities. The Doors' Jim Morrison liked to swing from the balconies and John – Blues Brother – Belushi died in one of its bungalows in 1982 after overdosing on speedball, a cocktail of heroin and cocaine.

Cars are not especially significant in Newton's photography. Usually, they are given less semantic prominence than the furniture. Instead, he treats women rather as if they are premium automobiles: desirable, lustrous and with no obvious flaws. But there are a few outstanding car pictures in his portfolio. In 1963 in Paris, Newton took an astonishing photograph of

Françoise Sagan in a Jaguar E-Type. He captures the car from the front, in a Bauhaus angle which serves to emphasise the enormous phallic bonnet of this most priapic of automobiles. Sagan, celebrity novelist of teenage anguish, is seen behind the wheel and peeking out of the driver's window. Thus the car is eroticised while she is not.

In most other Newton photographs, cars, or vehicles, are incidental. In 1974 he shot Jerry Hall in front of an Airstream trailer. A Karl Lagerfeld shoot has a (fully dressed) woman entering the back seat of an Alfa Romeo. In a shoot for Yves Saint-Laurent in Saint-Tropez in 1978, a Citroën Traction Avant and incongruously proletarian Opel Ascona are in the background. You see some yellow cabs here and there. And then there is a strange series shot in Paris's Avenue René-Coty in 1980. A woman (or is it a mannequin?) is chained to a railing between the nose of a Ford Granada and the tail of a Volkswagen Beetle. In 1986, Pirelli Italia commissioned an entire calendar from Newton, but the job actually went to Bert Stern separately commissioned by Pirelli UK, although Newton's originals, featuring women in Chianti and Monte Carlo, were revived for 2014.

However, there is one singular exception to Newton's apparent indifference to the automobile. This is *Me and My Cadillac*, a picture shot in a Los Angeles lock-up garage in 1987, which he later claimed in a video commentary to be his personal favourite. In the video, Newton drives a large American convertible through some unprepossessing Los Angeles back streets. He talks to-camera in an accent that, more than fifty years after he left Berlin, is still distinctively German-Jewish. Newton says he had been 'dreaming about a picture of a girl making love to a car … in a garage'.

In the video we see a naked girl, oiling herself in preparation for the picture. Her nipples are curiously emphatic. She moves slinkily

Newton chose for his personal transport a prosaic Cadillac SRX: a lacklustre crossover, at home in supermarket car parks. A great lover of grand hotels, he was leaving the Chateau Marmont on 23 January 2004 when he lost control of the SRX in the car park and crashed. He was taken to Cedars-Sinai Medical Center, where he died a short time later.

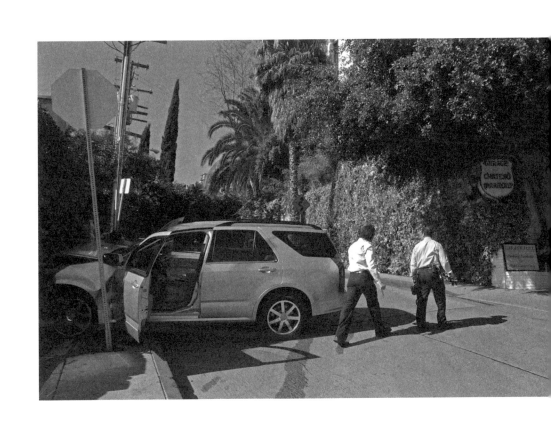

around to the rear of the car, a huge black Cadillac. It is not quite clear in either stills or video, but the car appears to be a 1970 model, one of the very last to retain a tiny memory of the sharp little tail fins above the rear lights. Assisted by a slight raise in the floor at the rear of the car, the girl grinds her crotch into the sharp chrome detail of the Cadillac and parodies grunting, hip-swivelling orgasm. *Me and My Cadillac* is both obscene and fascinating.

There is a steep drive out of the Chateau Marmont car park. Newton's custom was to sweep out of it without looking so as to join the traffic stream on Sunset Boulevard. Visitors to California will know those hilarious signs that say: 'You must join the freeway at 55mph.' Maybe that was his objective. On this day, witnesses say Newton sat for some time at the wheel of his silver Cadillac SRX Sports Utility Vehicle before the car suddenly accelerated up the ramp and hit a concrete wall. He was taken to Cedars-Sinai Medical Center where he later died.

What could be more glorious an end to the career of pornographer deluxe than, aged eighty-three, to crash your Caddy when leaving the glamorous Chateau Marmont? Had Newton been on a shoot? Had he just finished lunch or, perhaps, a romantic assignment? A post-mortem established that he had suffered a heart attack at the wheel, which doubtless caused the erratic trajectory of the car. There were no recorded last words.

Newton's choice of car is interesting. In 1961 he had owned that white Porsche, then quite an eccentric choice, since this was long before Porsche enjoyed popular esteem and was, rather, a statement of well-informed sophistication. In the Helmut Newton Foundation in Berlin there is a strange Volkswagen Touareg Concept, really just a motorised styling buck, which was given to the photographer by the great car designer, Giorgetto Giugiaro. The vehicle has the Monaco licence plate X298 dated 2004, the year of Newton's death. With incongruous vulgarity, the car has 'HN' monograms on its wheel centres. So he was not without vanity.

Someone described him as a mixture of self-regard and self-parody. And his final car – the Cadillac SRX? This was not

the flamboyant pink Cadillac, of legend, nor the black Caddy from his favourite photograph, but a modern mid-sized luxury cross-over (a 'light truck' in American-English), new to the market that year. Later, the Insurance Institute for Highway Safety would find that the SRX was the worst in its class for driver fatalities, with a mortal incident rate three times above the norm.

There is no moralising to be done about Helmut Newton. Nor did he do any himself. When asked whom he photographed, he answered: 'Those I love, those I admire, those I hate.' And he died after his Caddy crashed in a hotel car park. Glamour was, after all, his subject.

THE AGE OF COMBUSTION

I can think of few more lovely sights than a British Racing Green Jaguar XK120 arriving up the gravel drive of an English country house. It would have tan leather upholstery, with aero-screens and straps retaining the bonnet.

Except, perhaps, a rival sight would be a two-tone aqua-blue and ice-cream-coloured Chevrolet Bel Air parked outside an Art Deco South Beach hotel. Or, when you come to think about it, maybe a short-wheelbase navy blue Ferrari 250 GT fading into the sunset down the Moyenne Corniche, a dream of The South a virtual sounding board for its glorious V12 howl. And how could one not be impressed by a Citroën DS, rolling along the RN7 in dappled shadow past the plane trees on the way to dinner? The motor car does bravura performances in the theatre of our imaginations.

For a century or so, the motor car has been a symbol of pleasure and desire. Exiguously, the car remains the ultimate consumer product, even as it becomes ridiculous. For many of us still, a brand new car with its gloss and novelty smell is, for a desperately short moment, as close as we can ever expect to get to perfection on Earth.

But the motor car is now in historical decline as the Age of Combustion nears the end of its sometimes beautiful, often tragic and always expensive journey. It is entering what has been called the end-game paradox: as cars become less useful in congested

Previous pages: The Detroit Autorama, March 1957. This was the Age of Combustion at its indulgent, unreflective and utterly seductive peak. Mankind had never known such glorious and accessible excess.

cities and speed-restricted and congealed country roads, their specification and performance are enhanced. Cars have never been more competent than they are today … and never less useful. If you own one, you have bought a wasting asset.

Consumers are fatigued by the car's broken promises of freedom and pleasure. The last great innovation on wheels was not a car, but Robert Plath's 1991 patent for a carry-on wheeled suitcase. Accordingly, manufacturers in old Europe have looked to a newly prosperous Asia in pursuit of new, less disenchanted markets for their conservative products, as if bad dreams can be exported. But as someone at Bentley, dismayed at the softness of Oriental markets, privately explained with impressive frankness: 'China is fucked'. That is as may be, but the fact is that the semantic specifics making a fast and luxurious Bentley desirable in Europe are much less certain in the Orient.

Indeed, in 2015 the *New York Times* reported that these same fickle Chinese had abandoned the once popular late-model black Audi, collections of which, covered by desiccated guano and etched by acid rain, could, according to its reporter, now be found abandoned at car parks from Chengdu to Harbin.

Combustion was the first controlled chemical reaction that human beings discovered and then mastered. Technically speaking, it is a high-temperature exothermic reaction between an oxidant and fuel. Flames and heat are its expression. Like a caveman, you can enjoy combustion by rubbing two sticks together to make a blaze. Ever since troglodytes discovered the charms of fire, human beings have fussed and invented their way to extend combustion's potential.

The notable names in this history of profitable burning are Jean Joseph Étienne Lenoir and Nikolaus August Otto, early experimenters in the design of internal combustion engines. In 1869 Otto opened his Gasmotoren-Fabrik in Deutz, with Gottlieb Daimler as his technical director. Daimler's refinement of the crude Otto machine in the next decade gave us the essential motor car engine still with us, just, today. Somehow, the very name seems to contain a level of meaning: putting together 'internal' and 'combustion' suggests something of Man's arrogant

conquest of Nature. And internal combustion engines have given us wonderful metaphors for human aspiration and folly: misfires, governors, piston-slap, and hot-tube ignition. Even 'exhaust' applies both to machines and people.

When contained in a petrol engine, combustion follows the pattern that Daimler would have described as induction, compression, ignition, exhaust. This can more demotically be rendered as suck-squeeze-bang-blow which sounds like a description of sex. So that's another reason to account for the significance of this machine: internal combustion engines and the cars they power ape human behaviour.

This crazy process propelled the great cars. That it is crazy made it inspiring. The efficient hum of an electric motor will never drive anything as beautiful as a 250 GTO. The very irrationality of the power source has inspired designers' genius. Without internal combustion, cars can have no heart.

Combustion lends itself to travel, transporting us in every sense. Its age perhaps began with the Montgolfier brothers who famously launched their sackcloth hot-air balloon – the *globe aérostatique* – in front of the Château de la Muette in 1783. They discovered new worlds in the air. Soon came the coal-burning steam engine and legendary, but universal, romance of the railways. Later, Henry Ford democratised Daimler's engine.

In a car, anarchic propulsive energy directed towards rational goals of travel was the result of a sequence of more-or-less controlled explosions. It is a wholly analogue process that now seems precariously dated in a digital world.

So it is very easy to be sentimental about what will soon be past. The Age of Combustion also gave us radio, television, modern art and design, travel, pop music, movies, consumerism and celebrity. It gave us Naugahyde, chrome, candy-apple paint, a wooden steering wheel, white-wall tyres, straight sixes, V8s, V12s, contrasting piping on leather upholstery, crackle finish dashboards, floor shifts, exhaust notes, downdraught carburettors, Pininfarina and other details and finishes which now seem as glorious, absurd and arcane as Byzantine

incunabula. It gave us, for a while, freedom, squalor, chaos, pollution and glorious imagery. The Age of Combustion also gave us humane personal values, which are threatened in a world of limitless, click-through connectedness.

For example, an element of the car's appeal is the delicious sense of privacy it has afforded us, at least since closed bodywork became standard in the 1920s. The great architectural historian, Nikolaus Pevsner, spoke of cars as 'mobile controlled environments': essentially, architecture that moved. Today, architectural metaphors dominate any discussion of car design.

That the pleasures of controlling, to an extent, your own destiny by driving your own car are superior to the travails and frustrations the experience brings are demonstrated in every traffic jam in every city. If this is a delusion, many people are beguiled by it.

The privacy of a car allowed any driver to indulge in the elemental game of concealment and display: your car may be ostentatious, but you are hidden. That is an enigma that suits many personality types, famous and obscure. Thus, the special expressive power of a convertible whose folding hood exposes the otherwise occult driver. A fair balance between concealment and display has ever been the preoccupation of the rich and famous. When celebrities still travelled by road, their cars acquired special value.

If you are going to the Cannes Film Festival and you are not in a boat, you want to think very carefully about your ground transport. And Hollywood did. Ghosts of these rituals of display can be found today in the forecourts of the Martinez and Carlton hotels in Cannes, where Rolls-Royces and Lamborghinis are routinely cluttered while their owners pursue foreplay and more immediate fantasies on beaches or in bedrooms. But who now dreams of cars?

Still, no other product flatters and then betrays us as thoroughly as the motor car, whose historic promise of freedom has misled us. So far from liberating, the car daily strangulates cities and threatens users with criminalisation at every turn. Car ownership is rather as Lord Chesterfield said of sex: the position is ridiculous, the expense intolerable and the pleasure momentary.

For many years now, owning a car has, for city dwellers, been utterly irrational. Who wants a costly instrument of pollution, inconvenience and offence? Concepts of mobility today are not defined by nor limited to road journeys.

The Age of Combustion offered remedies other than the earthbound car. Alas, the often promised flying car never took off. One of the first was envisaged by Henry Ford, who promised in 1940: 'Mark my words: a combination airplane and motorcar is coming. You may smile, but it will come.' We are still smiling. Yet the vision persists.

Meanwhile, the new digital world offers the prospect of a driverless car, sometimes known as the autonomous vehicle. A driverless car will, in every sense, lack soul. Its essential problem is that technological autonomy ignores the psychological reality of the automobile. Who exactly is in the driver's seat? We either want to be there ourselves, or know exactly who is in charge. Having Google drive you home when drunk might be an advantage, but who would want Google to determine the vectors of a romantic road trip?

Cars became popular for reasons sunk very deep in the unventilated pools of the psyche: they are about property, social competition, sexual display, aggression, danger and rampant ego. As well as privacy, status and start-me-up convenience. The clean, intelligent, safe and innovative autonomous vehicle will drain all the risky enchantment from car use and ownership. A driverless car will be no more involving or expressive than using an ATM.

Combustion was an analogue experience ... driving was too. The chaos of the high-twentieth century with Eve Babitz's 'squalid over-boogie', or William Burroughs keeping barrels of methadone in his basement in case of shortage brought about by the Third World, or Jayne Mansfield's cantilevered bust, were further expressions of the absurd, but romantic, culture that gave us cars and driving. Probably, neither cars nor driving will survive the digital age and its own delusions of freedom or convenience. And something precious will have been lost. As a child, my perceptions were formed in the back of a car.

The world was viewed through Triplex toughened glass at 35mph. Notions of luxury and wellbeing were permanently influenced by the slippery leather chairs of a Humber or the curious ultraviolet light illuminating a Jaguar's walnut-veneered dashboard. Here, I was psychologically secure, my regular companions being a bag of crisps and a Penguin book as we motored stylishly into the 'country', wherever that used to be.

I come from the last generation to know the extraordinary institution of a recreational drive. My father, nattily dressed and moustachioed, would on certain fine days suggest an outing in the car that had no purpose other than to be an outing in the car, such was the pleasure involved for all participants. There was no destination, just a circular journey. It is a notion as deliciously paradoxical and absurdist as a play by Samuel Beckett. And just as historic.

The practical aspects of driving today are altogether less comforting. Suffocating legislation and predatory local authorities threaten to criminalise even the saintliest individual suddenly possessed by the anti-social chutzpah now required to own and operate a motor vehicle. The only rational response to confiscatory tickets and invasive speed cameras is either intense spasmodic psychomotor agitation or harrowing paranoia on a long-term basis. The only rational response to worsening traffic conditions is hysteria.

Under-thirties today regard cars as unnecessary and expensive encumbrances, not the status symbol or romantic attribute they remain for most of my generation. Roads too have lost their glamour. Like car design itself, the movies and rock music are the ultimate expressions of the last century's gloriously innocent industrial culture. And movies and rock music glorified some of the world's great roads: the Promenade des Anglais, Route 66, the Grande Corniche, Sunset Boulevard, the King's Road and the Pacific Coast Highway have become part of our collective dreamscape. Some delightful and deluded fiction of roads as romance may just survive, although it is difficult, surely, to experience anything other than terrible bathos on the M25 or the East Lancs Road.

The great pleasure of cars was equal and opposite to their great cost and their great, sometimes unpredictable, danger. This is what, at one level or other, the heroes, villains, celebrities and lost souls described in *Death Drive* knew and experienced. Their cars were a personal expression which almost retributively led them to their fatal destiny. In a way, Isadora Duncan, Albert Camus, James Dean and Princess Grace were betrayed by their cars. But that just prefigures the more general sense of betrayal we all have about the motor car: Man's most ingenious tool has also been his most destructive.

But celebrities do not drive any more. And soon we will all be stopping. No one is building roads nowadays. And cars are losing their potent heraldry as quickly as they are losing their functionality. But for the long, meaningful moment that was the Age of Combustion, things were very different.

Overleaf: As the private car nears extinction, tracking its own death drive, the wreckage that remains in the imagination becomes ever more evocative.

227

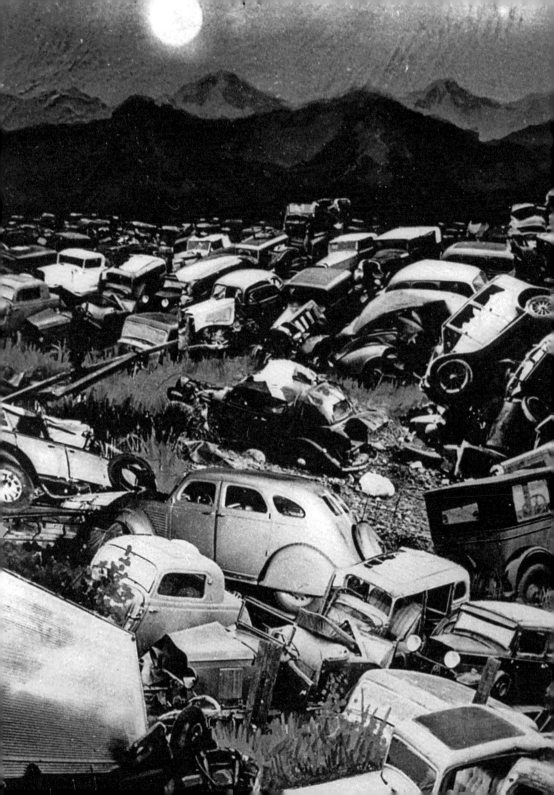

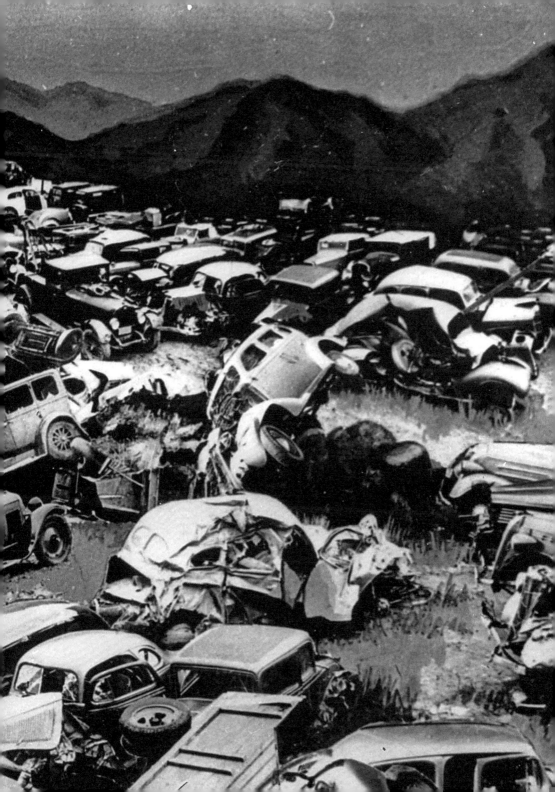

INDEX

Page numbers in *italics* refer to the illustrations.

CREDITS

The author is grateful to David Morys of the Bugatti Trust, who gave access to particularly interesting, unpublished documents about Jean Bugatti.

Every effort has been made to contact copyright holders. The publishers apologise for any omissions, which they will be pleased to rectify at the earliest opportunity.